Dedalus Original Fiction in Paperback

THE REVENANTS

Geoffrey Farrington was born in London in 1955. He has combined a career in the theatre with helping run the family business.

Geoffrey Farrington is also the author of *The Acts of the Apostates* (Dedalus 1990), a historical novel about the emperor Nero's last days and the editor of *The Dedalus Book of Roman Decadence: Emperors of Debauchery*.

He is currently working on his third novel.

Geoffrey Farrington

The Revenants

Dedalus

Published in the UK by Dedalus Ltd, Langford Lodge, St Judith's Lane, Sawtry,
Cambs, PE28 5XE
email: DedalusLimited@compuserve.com

ISBN 1 903517 04 4

Dedalus is distributed in the United States by SCB Distributors, 15608 South New
Century Drive, Gardena, California 90248
email: info@scbdistributors.com web site: www.scbdistributors.com

Dedalus is distributed in Australia & New Zealand by Peribo Pty Ltd, 58 Beaumont
Road, Mount Kuring-gai N.S.W. 2080
email: peribo@bigpond.com

Dedalus is distributed in Canada by Marginal Distribution, Unit 102, 277 George
Street North, Peterborough, Ontario, KJ9 3G9
email: marginal@marginalbook.com web site: www.marginal.com

Dedalus is distributed in Italy by Apeiron Editoria & Distribuzione, Localita
Pantano, 00060 Sant'Oreste (Roma)
email: grt@apeironbookservice web site: apeironbookservice.com

First published by Dedalus in 1983
Revised edition 2001
Copyright © Geoffrey Farrington 1983 and 2001

The right of Geoffrey Farrington to be identified as the author
of this work has been asserted by him in accordance with
the Copyright, Designs and Patents Act, 1988.

Typeset by RefineCatch Ltd
Printed in Finland by WS Bookwell

A C.I.P. listing for this book is available on request.

The Land of Darkness – Daniel Arsand £8.99
When the Whistle Blows – Jack Allen £8.99
The Experience of the Night – Marcel Béalu £8.99
The Zero Train – Yuri Buida £6.99
Music, in a Foreign Language – Andrew Crumey £7.99
D'Alembert's Principle – Andrew Crumey £7.99
Pfitz – Andrew Crumey £7.99
Androids from Milk – Eugen Egner £7.99
The Acts of the Apostates – Geoffrey Farrington £6.99
The Revenants – Geoffrey Farrington £7.99
The Man in Flames – Serge Filippini £10.99
The Book of Nights – Sylvie Germain £8.99
The Book of Tobias – Sylvie Germain £7.99
Days of Anger – Sylvie Germain £8.99
Infinite Possibilities – Sylvie Germain £8.99
The Medusa Child – Sylvie Germain £8.99
Night of Amber – Sylvie Germain £8.99
The Weeping Woman – Sylvie Germain £6.99
The Cat – Pat Gray £6.99
The Political Map of the Heart – Pat Gray £7.99
False Ambassador – Christopher Harris £8.99
Theodore – Christopher Harris £8.99
The Black Cauldron – William Heinesen £8.99
The Arabian Nightmare – Robert Irwin £6.99
Exquisite Corpse – Robert Irwin £7.99
The Limits of Vision – Robert Irwin £5.99
The Mysteries of Algiers – Robert Irwin £6.99
Prayer-Cushions of the Flesh – Robert Irwin £6.99
Satan Wants Me – Robert Irwin £14.99
The Great Bagarozy – Helmut Krausser £7.99
Primordial Soup – Christine Leunens £7.99
Confessions of a Flesh-Eater – David Madsen £7.99
Memoirs of a Gnostic Dwarf – David Madsen £8.99

Introduction

The sub-genre of vampire fiction, though it's such a vast field that it's hard to think of it as a sub-genre these days, has been dominated for a century by one book, Bram Stoker's *Dracula* (1897). Almost every vampire novel, film, TV show, opera, play, commercial or breakfast cereal is either an adaptation, imitation or mutation of *Dracula*, or defines itself by the way in which it differs from the Stoker uber-text. Even Anne Rice's *Interview with the Vampire* (1975), which plays a radically different game and created what might be classed as another school of vampire fiction, is compelled to keep referring to Stoker's rules of the undead even as it establishes its own, and draws at least as much – the key notion that vampirism is passed not merely by the vampire drinking the blood of the victim but the victim responding by tasting the blood of Dracula – from the book it tries to replace as it jettisons.

But there were vampire stories in English before *Dracula*, from which Stoker drew his own inspiration, most notably Dr John Polidori's *The Vampyre* (1819) and J. Sheridan leFanu's *Carmilla* (1871). In the novel you are about to read (or re-read), we are back in that world before Bram Stoker, before Nosferatu, before Bela Lugosi, before Hammer Films, before Dark Shadows, before Louis and Lestat, before Blade and Buffy. As the title establishes, the vampires of *The Revenants* haven't even

decided what they should be called yet, and their practices aren't yet set in the sort of stone required by a TV series Bible. Like the protagonist/narrator, we must feel our way in this world, never quite understanding all the ramifications of his post-death situation, apart from the rush of human history, always questioning not only what has happened but also what it might mean.

Geoffrey Farrington's novel begins in the mid-19th Century, and its style remains close to that of leFanu or Wilkie Collins, so that the mentions of white feathers in the First World War or motorcars as we near the present come as niggles that show how estranged from progress the revenant John LePerrowne has become. But this is not a comforting pastiche novel, an evocation of bygone sensational or gothic fiction designed to evoke a safer world bordered by oak panelling and the tidiness of the traditional fireside ghost story. The style is there to show how frozen the character is, and the incidents are more disturbing than exciting. Expectations that this might explore a vampire society as decadently attractive as the goth nightworld of Rice are interestingly frustrated by the thrust of the story, which keeps holding up exemplars of inhuman behaviour.

This slim, sharp novel is a major achievement in its field. And a welcome reprint.

Kim Newman, Islington, 2001

Prologue

As he drew the curtains he looked out into the dark and shivered slightly. He was unusually cold. The silence outside, the absolute stillness which normally he found so pleasant, put his nerves on edge. He almost felt that the night itself was watching him. Then he switched on the light in the kitchen, and the lamp on the table, though the main light was already on. The brightness gave some comfort.

He lit a cigarette, then turning around realised that he had one already burning in the ashtray. Tonight for the first time he did not care for the solitude he had come to this isolated cottage to find. It was making him morbid. It seemed he could not trust his own mind anymore. Perhaps it was time to leave this place.

He sat at the table staring at the bundle of papers that lay before him. He had found the manuscript that morning. It had been he who discovered that the old house had burned down. He was walking across the fields to visit the local village, when he had seen the smoke rising above the trees in the distance. He made his way to it as quickly as possible. There had been no one else around. There was no reason why anyone should be. It was early. And anyway, the old house was very remote, and to all certain knowledge had been locked up and deserted for years. Local people stayed clear of it.

When he had reached it the house was no more

than a smouldering shell. Most of the walls had collapsed, and what remained looked as if it would not stand long. It was all a chaos of charred scattered debris. It had been a large house, but nothing had escaped the fire.

He had stood there staring at it for a time, in the dull light of a cloudy autumn dawn, unable to imagine how the fire could have started in this lonely tranquil spot, amongst the tall trees, over-grown grass and bushes that had virtually hidden the house from all outside notice. In a more superstitious age it would probably have been supposed that the place was blasted by the hand of divine wrath, for some past unexpiated evil, for it had suffered a bad reputation locally, as old deserted houses often do. At last he had thought he should best go on to the village, where he could telephone the local police and inform them.

It was as he turned to walk away that it caught his eye. It lay on the cracked face of an ancient sundial that jutted above the forest of weeds which he supposed had once been a lawn, when the house had been inhabitated, and a very fine residence, long ago. An old black leather bag. Going to it, he found it did not seem very damp or weather beaten. He assumed it could not have been there long. Inside the bag he had found the manuscript, wrapped in a large cloth. At once it had struck him as odd. The pages were flimsy and yellow with age, the paper an odd assortment of different types and sizes, bound together, as if someone had ransacked a dozen old drawers or cupboards in a frantic, constant search for something

more to write on. Yet the writing itself, a small precise hand, was quite clear, unfaded as if written only yesterday. He sensed at once he had stumbled upon something very strange.

Standing there by the ruin he had read the first page, which he re-read now.

Narrative of John Richard LePerrowne

Here follows my story. If it is ever read I know it is unlikely to be believed. But that is nothing to me. I am alone now, as I have often been; alone with my thoughts and memories, and I would give these ancient companions some concrete form. I do not know what to do next, though I know what I should do and fear it is inevitable. But for now I shall write. Perhaps the past has yet some wisdom or strength to give me. And then when this document is completed perhaps I will leave it to be found and read. Why not? It shall be my legacy to mankind.

Let men make of it what they will!

And what happened then, as he had looked up from the manuscript, back at the blackened remains of the house; what he had seen – rather what he had *imagined* – he preferred not to think about. But he

told himself again that it was time for him to leave this place.

In spite of his unease his curiosity had been aroused enough to say nothing about his discovery of the manuscript to the police, or to anyone in the village, but to bring it home with him.

And now, as he prepared to read on, he grew suddenly more aware than ever how he was cut off from the world outside – as at first he had wished to be – his lonely cottage a single speck of light surrounded by several miles of black, wild and virtually uninhabited countryside.

He shivered again as he looked back to the manuscript, and read.

I

It started with a dream. A haunting recurring vision that pervaded the sleep of my youth.

I was a weak and sickly boy. It was thought remarkable that I ever survived to adulthood. My parents were wealthy, and I their only child, for they married late, my father having been married previously to a woman who bore him no issue and who died in middle age. When, in the year 1830, he and my mother discovered they were to have a child they were naturally delighted, for they both had long since resigned themselves to childlessness. But I gave my mother a troublesome pregnancy and an awkward painful birth – worsened by the fact that I was born feet first – from which she never truly recovered. The solitary child of elderly doting parents, feeble and much prone to all sorts of illness, I was kept sheltered and protected through my young days like some fragile, priceless piece of glass, and I grew up a lonely, withdrawn and rather sullen boy in the large and remote old house where we lived, in Cornwall, to the west of Bodmin Moor.

I was not sent to school. My parents considered me too delicate for the rigours of a public school education, and I daresay they were right. Instead they employed a tutor for me, an elderly and rather seedy looking man called Soame. He, and my nurse-maid, Sally, a plump jolly old woman with sparkling eyes, a thick Cornish accent, and perfectly white hair which

she wore in a huge bun, were the only real companions of my youth. But they were good companions, kindly and well meaning, and I found much in common with them both. Mr. Soame was a keen historian and classicist. He would sit for hours on winter nights and relate with relish countless exciting, abstruse or absurd anecdotes regarding great figures of the past. He must have told me hundreds upon hundreds of these stories – spanning the entire course of human history – but over a period of ten years I do not recall him ever repeating the same one twice.

But where Soame confined himself to the documented records of the history books for his stories of Alexander, Hannibal, Caesar, Constantine, Charlemagne and innumerable others, Sally would delight in telling me of those wonderful antique legends in which Cornwall is so rich, and all its simple inhabitants apparently so well versed. Tales of the ancient King Arthur and his knights, who sleep somewhere in a deep and hidden cavern, ready to rise again at the time of England's greatest need; of Woden, the pagan demon among whose descendants on earth was the great Christian King, Alfred, and who sometimes still rides by night in deep forests and over dark moors accompanied by a fearsome pack of devil dogs, pursuing the wretched spirits of those who were sinners in life. Like the notorious Jan Tregeagle, a Cornishman who, more than two centuries earlier, it was said, had sold his soul to the Devil, and whose ghost was now pursued relentlessly across the lonely wastes of nearby Bodmin Moor. Stories of warriors

and spectres, giants, heroes, faeries, changelings and kings; more stories than I could ever remember.

All this had a potent effect on the fertile mind of a bored young recluse such as myself. I grew to see the past as a rich tapestry of romance and excitement. I had little love for the world of the present, which to me consisted of my home, the countryside and the few villages surrounding it, and the bed to which I was so often confined. In childish simplicity I grew to love the ideals of heroism and justice, and to despise treachery and tyranny; to exalt virtue and disdain wickedness, although of course, I had not the remotest real knowledge of either. It became my delight to imagine that I had lived back in distant days: to suppose that I was with Alexander, defeating the Great King Darius at the battle of Guagamela; or alongside Arthur, locked in mortal combat with the villainous Mordred. Fantasies of this or a similar nature must be common enough in the young, but to me they were of special importance, for the strength of my imagination was my only defence against the weakness of my body. And the more I grew to love and admire those great and mighty men of history and legend, the more I grew to despise my own feebleness, and the dreariness of my existence.

I was twelve years old, and all the feelings I have described were still growing in me, when I first had the dream. From that time onwards it came to me at least once, sometimes twice a year. It was always identical in detail, and immensely vivid. But let me describe it.

At the start I found myself standing in a large,

crowded room – I had no idea how I came to be there – decorated all about with candles and the branches, leaves and berries of evergreens, hung from the ceiling and walls. There was a big table to one side, upon it dishes filled with all sorts of pies, cakes and comfits, and in the centre there was a huge silver punch bowl, filled with steaming mulled wine. A blazing log burned in the vast fireplace, and I was standing close to it, keeping warm. Outside the windows I could hear the shrill, chanting voices of children singing a Christmas wassail.

> We've been a long while wassailing,
> In the leaves so green-o,
> Now here we came a-wandering,
> Where we can be seen-o,
> For 'tis Christmas time,
> And we wander far and near,
> May God keep you and send you
> A happy New Year.

It was at this moment that I would glance about at the others in the room. They were all faceless. That is, their faces looked to me blurred and distorted, so that I could distinguish nothing about them; and their voices, although loud, were no more than strange indistinct mumbles. In such a homely setting this was disturbing, although for some reason I did not find it particularly frightening. My feelings were rather those of isolation and despair than fear. Desperately I would look all about for a normal human face somewhere in the room.

And then at last the doors would open and a figure would enter that was more strange and macabre even than the rest. It appeared to be no more than a shadow. A ghostly form shrouded in black, framed in the glowing firelight. I could make out nothing about it. I could not tell its size or shape, whether it was male or female: whether it was human at all, for mostly it seemed a shapeless mass. And yet its presence was overwhelming. It shone with a strange force that wholly entranced me. It stood on the opposite side of the room, surrounded by the others, who did not appear to see it, while it in its turn took no notice of them. And I gazed at the black mask that I believed to be its face, unable to see any eyes, yet in some way aware that its attention was focused on me. Until at last I was affected by a most strange sensation. The feeling that I was becoming somehow absorbed and lost in the blank, black depths of that face. And gradually a creeping numbness would start to spread through my body – and the singular thing was that although this always happened in exactly the same way, and I grew to expect it, it nevertheless startled and shocked me anew every time – until finally it left me paralysed. Rooted to the spot, unable to move or speak through the power of this dark presence.

Next there was a voice. It came from nowhere in particular, but would float gently into my head. It was very soft, a breathless whisper, and yet always I heard it quite clearly above the incoherent dronings of the faceless ones; as if someone spoke into my ear. And it said simply:

17

"Come to me, John LePerrowne!"

No sooner were these words spoken than I would feel myself begin to move slowly towards the figure – not through any effort of my own, for I was still incapable of controlling my actions – and I was drawn forward by some invisible and immensely powerful force. Frightened now, I tried to fight against it, to pull free first by struggling, and then by the exertion of my will. I attempted to recite the 23rd Psalm, because at the time it was all I could think of as a means to oppose the power that held me. But it was never any use, for I found that, try as I might, I could not speak. My jaw stayed shut and my tongue seemed swollen and rigid. Desperately I strove to speak the first line of the psalm, but all that came were slurred and frantic noises. As I came closer to the figure it moved forward and seemed to reach out, as if to embrace me.

Now I would stop fighting. It seemed at once inevitable that I should go to the figure. It was intriguing. It was mysterious and strangely powerful. And it called to *me*! Also, something else would suddenly occur to me. That if I did not go to it then I would be left alone, stranded amongst those mumbling, distorted figures. This thought filled me with horror, for the room about me at once grew dark, and its occupants now seemed to become somehow fearsome and hellish. So I reached out my arms and clung to the figure as it came to me, wrapping itself about me, engulfing me, so that my head grew light, and began to spin, and the room in which I stood along with its awful inhabitants faded from sight to

be replaced by a mist of inky blackness that crept all about me and entirely blotted out my vision.

Now I would be overcome by another remarkable sensation; a feeling of incredible energy and strength passing through me; a feeling that I, with my perennial bad health, had certainly never experienced in a conscious state. And when this sense of power attained its zenith I would feel myself begin to sink down and down; a slow, pleasant floating sensation. And it was at this moment always I awoke in my bed.

I never minded having this dream, though much of it was so disquieting. For me all its bad and frightening aspects were more than compensated by that enormous flood of power that came at the end. To feel strength and vigour was for me a remarkable and exhilarating experience. When young I dreamed often: many dreams other than the one I have just described; but none were remotely as vivid or had such a profound effect on me. In no other dream do I ever recall having known any real sense of physical feeling. Once I dreamed that my arm had been lopped off – I cannot remember how – and I stood, moaning in shock and horror as I watched the blood spurt in gushes from the ragged stump. But in spite of my very real fear, I felt no pain from the wound whatsoever. My recurrent dream was the only one where my senses operated as in consciousness. Indeed, even more so.

When I was fifteen my dear old nursemaid Sally died, which grieved me greatly; and then the following year my father suffered a stroke which left him partly paralysed. My mother was so shocked by the

suddenness of his attack that her own poor health deteriorated and she was henceforth confined to her bed for much of the time. Mine had always been an old and melancholy house. Now it seemed oppressed by an atmosphere of decay and death.

It was at this time, when I felt more bewildered and lonely than ever, that I had a most strange experience. It was on a very hot night in August, and I lay on my bed in my nightshirt, covered only by a single sheet; dozing but unable to sleep properly for the stifling atmosphere. Suddenly my drowsiness was dispelled by a faint scratching sound from some-where nearby. I sat up slowly, rubbing my eyes, and looked across the room to where a shaft of moonlight flooded through the window and glowed on the floor. Rising, I stumbled to the window and saw that the latch was rusty and loose, and rattled occasionally in the faint breeze. Because of the heat that night I had left the window ajar, which was not my usual cus-tom, even in summer, because of my weak chest. But now, in sheer annoyance, I just undid the latch and threw the window wide open. Then I returned to bed and dropped back into a light sleep.

I have no idea how long it was before I woke again with a loud gasp. I was shivering violently. The tem-perature inside the room had dropped considerably. Somewhere in the back of my half conscious mind I realised that I must get up and close the window; but for some reason I was unable to stir myself. My mind was now quite awake, but my body it seemed was still asleep; unable to move, as though a great weight was upon me, pinning me to the bed.

And then from the corners of my half-closed eyes I fancied that I saw some movement, swift and silent, in the shadows over by the wall. Eventually, with a great effort, I managed to turn my head and stared hard for what seemed like several minutes into the gloom. But I saw nothing. And at last, in spite of this strange and alarming situation and my intense physical discomfort I must have closed my eyes and fallen asleep again, for I next remember awakening with another start to see a figure standing over me. By this time the moonlight had faded and my room was in almost total darkness, so I could distinguish very little about the figure, even when very slowly it leaned over me, sinking down until its face was a few inches above mine and I felt the swish of long silk hair brush against my cheek. Gently now the figure placed its hand upon my chest as it moved closer still, and I was startled to discover that the intruder's body was deathly cold. I tried to speak, to cry out, but could not.

At once my head was filled with the forms and images of my dream; yet whether I dreamed the murky figure that loomed above me, I was not sure. Asleep or awake – dream or reality – I was certain of nothing.

Now my body grew tense, my temples began to pound and my heart raced uncontrollably. And suddenly I felt hot once more; unendurably hot. A great burning rose up inside me, so that my blood seemed as though it were boiling, and I felt streams of sticky sweat running down my face. The heat became so great I began to toss and writhe as if in the grip of a

21

mighty fever. It grew and spread rapidly through my limbs, affecting my whole body; overcoming me, smothering me, so that I lay, barely able to breathe; gasping, choking, and utterly helpless.

But now I became aware of a body pressed up against mine, soft breasts beneath a thin gown; strong, slender arms that encircled me, firm thighs that clung to me, and gentle lips that brushed against my brow, cheek and mouth. And the body was still cold: as cold as ice, only now its touch had become entirely pleasing to me, and I threw my arms about it and pressed it to me with all my strength; as if to immerse myself in its coldness and so extinguish the fire that raged inside me. Then I cried out softly and my strength dissolved as there came a burst of indescribable sensual pleasure: a thrilling, biting chill that raced and quivered through my veins, killing the heat inside me, overwhelming me with a feeling of immense strength and satisfaction. I lay, squirming and fighting for breath, until at last the sensation died and the coldness against me was no more. Again I felt myself sinking deeper into sleep. With a feeling close to panic I fought to wake myself. At last, with immense effort, I opened my eyes. The figure sat on the bed beside me, its features still lost in the darkness, looking more than ever like the shadow form in my dream. And it was as I lay staring that suddenly the room was lit once more, for just a few fleeting moments, by a faint beam of moonlight. Just enough, however, for me to glimpse for a second or two the face of the intruder. To my utter astonishment I saw it was that of a very beautiful young

woman. Her skin was so fair it seemed to shine, her eyes wide and extremely dark, and her hair long, lustrous and raven black, hanging down loose about her slender neck and shoulders. I saw no more. Darkness closed in again, and my vision faded as all feeling ebbed gradually away, leaving only a comfortable numbness that soon subsided into dark oblivion.

When I awoke next morning my knowledge of all this was cloudy – total recall has come in gradual stages over the years – but I was aware of much of it. After some brief reflection I concluded it must all have been a series of incredible, half-sleeping, half-waking imaginings; although the fact that my window was wide open proved that part of it, at least, had been real. But in future, whenever I had my dream, I would instinctively associate the shady, anonymous figure with that strange and lovely face I had seen that night, in the silver shroud of moonlight.

II

When I was eighteen my companion and tutor, Soame, retired to somewhere in Suffolk with his widowed sister. My mother died when I was twenty-one; and my father lived on, although he was by this time almost wholly paralysed, for another two years. Then, apart from the few old servants, I was alone.

I must confess that at my father's death I felt as much a sense of relief as of sorrow. Since my earliest years I had been confined at home by my parents' constant concern for my health; and then, when I grew up, I had felt it my duty to devote myself to attending them during the illnesses of their old age. It was now, for the first time ever, that I felt really free. Not that I had any idea what to do with my freedom. For a while I considered attending a university – learning attracted me – but eventually I dismissed the idea. After all, I was wealthy beyond the need to secure a profession, and preferred the idea of private study to the tyrannies of tutor and timetable. Society held no allure for me – I was inexperienced and frankly disinterested in all the usual pursuits and pleasures of a young man of my station. I did feel a wish to travel – the Grand tour, perhaps – but here the problem was my poor constitution. Long days of riding in a coach and constant changes of diet and climate were hardly likely to suit me. And yet I felt I must do something. It was not then uncommon for the local villagers never to

venture more than a few miles from their homes in their whole lives, but for a young man of my education and fortune it was ridiculous. But the cause of my problem was plain enough. It was simply that after so many years in this remote and lonely house, I had come to view the outside world with some degree of nervousness. Isolation had become a habit with me, and one that might not be easy to break.

It was some months after my father's death, when a respectable period of mourning had elapsed, that I received a visit from one of his old friends, Mr Lansdowne, whom I had known since boyhood. He was a friendly, sturdy man of about fifty, who owned a sizeable amount of land nearby. My servant Moore ushered him into the drawing room, and he strode over, shaking my hand vigorously.

"Good day to you John, good day," he smiled. "And how are you, my dear boy? Well, I trust, in spite of your sad loss?"

"Well enough, Mr Lansdowne," I answered, my voice solemn out of respect for his long standing friendship with my father.

For the next hour or so we sat exchanging light conversation. He said that he had been in Launceston on some business, and had suddenly thought of me and decided to call; but I gained the impression finally that he had not been to Launceston at all, but had made his journey with the intention of visiting me. Before leaving he said:

"You will forgive me for mentioning it, my boy, but I think that it is altogether a bad thing for you to remain constantly cooped up on your own in this

house. I feel a duty towards you, you know, for the sake of your good father's memory. He was my best friend, and I feel his loss almost as keenly as you must yourself. But you will not lessen your grief through solitude. You will recall that at your father's funeral I mentioned that as soon as you felt sufficiently recovered you must come to my home, and stay with my family and I. I am sure you would enjoy that, would you not?"

"Yes. Yes, I am sure I would," I replied with as much conviction as I could muster.

"You should, in my opinion, mix more with people of your own age," he continued.

I nodded slowly, trying hard not to frown.

"Young people, left by themselves, become much prone to melancholy." He nodded and smiled. "And I am sure that my daughter Frances looks forward to seeing you again. You remember Frances, I am sure!"

"Indeed I do," I answered dully. I knew Frances Lansdowne from my childhood visits to their home with my father. She was a big, robust girl, about the same age as I. I believed that my parents and Mr and Mrs Lansdowne, had once nurtured hopes that Frances and I might one day marry, but I, and Frances too, were resolved that this would never be, for we never liked each other. She had been a vain and spiteful child, who had never ceased to tease and laugh at me for my frailness, and encouraged her friends to do likewise; choosing boisterous, energetic games in which I could not easily participate, and calling me "weakling", "runt" or "crybaby", in spite of the fact that she never succeeded in making me

cry, for all her efforts. However, she did succeed in making me loathe and dread those visits to her home, shun the company of other children, and feel almost glad that I lived as secluded and alone as I did; as well as feeling an overpowering self-consciousness and shyness wherever girls and young women were concerned. I had not seen her for some years, but I had no desire whatsoever to renew her acquaintance. However, her father's insistence made the offer difficult to refuse. In the end I agreed to spend Christmas with the Lansdownes.

* * *

I arrived at the Lansdowne house at midday on Christmas Eve, well wrapped to protect me from the cold, already beginning to wish myself back at my own home, and that I had made some excuse to decline the invitation. But it was too late now, so I decided simply that I must stay as short a time as courtesy permitted, and told myself that in any case it was high time I began to make some social contact in the district.

Mr and Mrs Lansdowne greeted me very cordially, though their patently rehearsed efforts to make me feel welcome were rather embarrassing. Almost at once I was thrust into the company of the fearsome Frances. Her manner towards me had changed since we were children. She no longer bothered and teased me. Now she virtually ignored me. When she did trouble to speak to me she was cold and haughty, like when she introduced me to her cousin George, who was also visiting over Christmas, and whose company

I found every bit as unpleasant as her own. This young man managed his elderly father's farm some- where in Devon, and seemed incapable of talking about anything but horses, dogs, and livestock. As soon as he saw that I had no knowledge of these things he lost all interest in me, much to my relief. Often Frances and George would sit, glancing at me across the room, whispering and laughing together; and all the misery of my childhood days spent there would come back.

There were other guests staying there, many of them warm and kindly people who, sensing my shy- ness, attempted to converse with me. But they found me poor company. They were straightforward coun- try people who spoke of practical, everyday matters of which I was wholly ignorant. It was not that I did not wish for companionship – indeed, I desired it greatly – but it seemed there was none for me here. Indeed, I felt more alone in that crowded house than ever I had in the solitude of my own home.

"There is to be a ball tonight," Mr Lansdowne informed me, finding me sitting on my own that afternoon after lunch. "Nothing at all grand or for- mal, of course. Just some of our good friends who live hereabouts. But I am sure it will be a merry affair."

"I will look forward to it," I told him, as my heart sank. The thought of a house full of chattering strangers was all I needed now to make my misery complete.

Fatigued by my morning journey, I slept for sev- eral hours into the early evening, when I was woken

by a servant who informed me that the guests were beginning to arrive. Wearily I rose and put on my evening clothes, then left my room and plodded downstairs.

At the foot of the broad staircase, Mrs Lansdowne, a rotund, florid faced woman, emerged from the pantry door and hurried towards me, beaming broadly.

"Ah! You are awake?"

"Yes," I replied, thinking that if she asked me one more silly superfluous question that day I should scream.

"Follow me," she went on. "Some of the guests are here already, and I am sure, most eager to meet you."

She led me along the hallway to some big oak double doors, flinging them open to reveal a large oblong room, in which a number of people stood talking and laughing together. Several of them looked at me curiously, but I paid them no notice. I walked slowly forward, looking all about, scarcely able to believe my eyes. On one or two previous occasions I had seen briefly inside this room; but it was only now, when I saw it all decked out with Christmas adornments, that I recognised it as the room in my dream.

All at once I was being introduced to various people on all sides – and returning their greetings most perfunctorily – while my head filled with curiosity and astonishment.

Time passed, and one or two people made efforts to speak with me, but I was unable to spare them much attention. I was far too occupied with observing

every part of the room, again and again, to satisfy myself that everything was indeed exactly as in the dream. Then suddenly there came from outside the double windows the familiar sound of childish voices, singing the Wassail song. I tottered slightly for my legs seemed to grow weak with my excitement.

"The village children," cried Mr Lansdowne gleefully. He turned to his wife. "The village children are here. My dear, tell Betsy to have cakes and fruit and a jug of cider taken out to them."

Mrs. Lansdowne nodded with a grin and hurried from the room. My eyes followed her to the door. In my dream it was always now that the dark figure entered. I did not know quite what to expect in reality; but everything that had occurred thus far corresponded so perfectly with the dream it seemed to me inevitable that something must happen; that I should see at last the face and identity of the black stranger, and that prospect thrilled me beyond all description. For I think some part of me was already convinced that it would be she – the mysterious girl whose face I had glimpsed years before on that strange summer night.

My eyes fixed on the doors while my muscles froze, my heart thumped, and my body trembled with anticipation. A minute or two passed, and then the doors swung open. I stared, growing tense with excitement. Mrs Lansdowne came back into the room alone, and I nearly cried out aloud in anger and frustration. Calming myself I continued watching.

Minutes went by. They passed into hours. The girl did not come. Nothing whatsoever occurred.

I was stunned. Devastated and overwhelmed by a misery and disappointment that was beyond anything I was able to understand.

I spent the next two days in the midst of happy Christmas revellers, trying to be pleasant, or at least passably polite, while inside I was a turmoil of inconsolable confusion and grief. Eventually I could bear it no longer. I said I was feeling unwell and thought it best that I returned home. I do not doubt they were all secretly relieved to see me go, although they expressed regrets.

* * *

Back at home I felt no better. Soon my depression grew so intense that I became ill with a violent fever, and tossed and raved in bed for several days. It was for a time feared that I would not survive, and I myself supposed as much, for my occasionally lucid spells brought on such black fits of gloom that I was left with little will to live. It was a long time since I had last had my dream, and in view of what had happened at the Lansdownes I doubted I would ever have it again. This served only to increase my misery, for I missed the dream, even though it had proved false. It was as if the one thing of mystery and excitement in my life was gone; and I felt lonelier than ever. Apparently, when the fever was on me, I raved and babbled continually about "the dark girl".

When at last I grew strong enough to leave my bed I found myself frequently affected by strange fits of

irritability and restless energy, during which I would spend hours just pacing and wandering aimlessly all about the house.

Then one day during one of these restless spells, I ventured up into the attic, where I had not been since I wandered up there as a small child. On that occasion I had at once run downstairs again, frightened by the dark. This time I took a lamp up with me. The air was most unpleasant, damp and dusty, making me cough and sneeze constantly. But it was a fascinating place, a veritable museum of my family history. There were many old toys, some of which had been mine, now crammed into trunks and corners, covered in cobwebs, which made the place seem like the deserted nursery of some long dead child. And there were also numerous ornate and exotic artifacts, many of which were no doubt obtained by my grandfather, who travelled widely as a young man, but whose souvenirs, particularly those from the East, lamps, pictures, carvings of strange-faced gods and idols, were relegated up here by my father, who had considered them gaudy.

I held up my lamp and looked about as the dim, flickering yellow light spread around. My attention was suddenly taken by the portrait of a stern faced man in a white powdered wig, that stood on the floor, propped up against the wall on the far side of the attic. I examined it to discover it was a portrait of my great-great-grandfather, Richard LePerrowne, who lived from 1696–1765. Behind this portrait were stacked two others. Naturally curious to discover what my forbears looked like I began to study them,

brushing away the dust and grime. The first was of Richard's younger brother, Henry. They were very much alike, both very good looking. As far as I could see neither of them bore any resemblance to me or to my father, or to the portrait of my grandfather that hung downstairs; we being fair while these others were dark and slightly swarthy: a tribute no doubt to our distant family origins in Brittany, and our ultimate descent from the Angevins, who were reputed to be descendants of the Devil, and whose most infamous son, King John, was said in legend to have wandered the countryside after his death in the form of a wolf.

Then I uncovered the last of the portraits, the sight of which made me gasp out in astonishment. There, staring up at me from the ancient, dirty canvas was a face that bore a striking resemblance to my own. The eyebrows seemed a shade darker – though the hair itself was covered by a wig – and the face was perhaps a little fuller, but otherwise our pale skins, dark blue eyes and rather soft features were virtually identical. I stared at the portrait for some time before I glanced down at the dull metal plaque at its foot, which read:

William LePerrowne
1675–1698

This was the father of Richard and Henry. It was absolutely remarkable. He could quite easily have passed for my father – or indeed my twin brother – yet he bore no resemblance to his own sons. Had it

not been for his likeness to me, his descendant, I might have suspected the presence of a dark hand-some young groom or footman in his service.

I took all the portraits downstairs to my bedroom, where in future they were kept. The one of my look-alike, William, I hung near to the foot of my bed. But intriguing though this portrait was, I found myself – though I could not quite define why – becoming even more fascinated by the other two. There was something about them that had a pro-found effect on me.

The question troubled me, and preyed on my mind for several days, until at last, one afternoon, with nothing better to do, I placed the portraits of Rich-ard and Henry against the wall facing me. Then, sit-ting at my desk, I took pencil and paper and began idly to sketch out a likeness, as accurately as I could, of the features common to both – high cheekbones, small nose, dark eyes and full lips. After several crude attempts I managed finally to reproduce these with passable accuracy; then sat and stared at the face I had formed, until my hand, as if by its own will, reached out and drew about it a mane of hair, which I then began to scribble over until it was virtually black. Realisation came so suddenly that I dropped my pencil and jolted upright with such force that I nearly toppled over in my chair. For several minutes I sat staring upon my sketch, half-numb with shock. For the face that I had drawn was roughly but unmistakably that of the mysterious dark girl; and the resemblance between she and the faces in the two portraits seemed suddenly so striking that I could

not understand how I had failed to recognise it before.

As I reached down to pick up the pencil, which had rolled from the desk onto the floor, my hand was trembling. I could think of only two possible explanations for this incredible occurrence, and both were profoundly disturbing.

The first was simply that my mind was unbalanced: that the apparent resemblance did not in fact exist, but was a morbid trick of my memory or imagination. Perhaps I had drawn the face of the girl not because she genuinely resembled my ancestors, but because I was obsessed with her to a degree that made me blind to reality. But the harder I gazed upon the portraits, the more objective I tried to be, the more vivid and real the likeness seemed.

The second explanation was that I was haunted – that the girl was some weird but real ghostly presence. Who she was – who she had been – I could not say. But she differed from most phantoms, that haunt houses, gardens, graveyards, or such traditional places. Her manifestations were of a far more disturbing kind. She haunted my mind. She haunted me.

III

Time passed but my fear remained. Worst of all was my helplessness. There was no one I could turn to for help or counsel, and there seemed no way I would ever find any concrete answers to the mystery that had risen about me.

Then one day, while I sat reading in the library, my gaze wandered suddenly to where several dusty old bound volumes stood, up on one of the high bookshelves. About two years earlier I had, out of curiosity, glanced through some of these. They were a random collection of family records; stacks of old letters and papers that went back for generations. Most were concerned just with everyday trivia, and I had found them to be of little interest. However, now it occurred to me that perhaps they might contain references to my ancestor, William, and his family, and I felt a sudden urge to study them.

At once I took them from their shelf, then spent several hours browsing through them. There were indeed a number of letters and notes written by or addressed to William, but these seemed to me mostly uninteresting and commonplace. I read through one letter sent by William to his mother, while he was staying in Exeter one summer, in which he described in detail the girl he married a year later when he was eighteen. He said she was tall with grey eyes and blonde hair; and I reflected that she sounded as if she bore no more resemblance to her dark sons than

William did. Next I read a letter addressed to William, dated two years later. It was a letter of condolence. It appeared that at the beginning of the year 1695 there occurred the death of William's only sister Helena – whom he had loved dearly – at the age of only twenty-one. I now vaguely remembered having been told of this long ago by my nursemaid Sally. Helena LePerrowne, a girl renowned for her beauty and virtue, had died of some unknown and sudden illness, despite all efforts to save her, just a short time before her proposed marriage to a handsome and wealthy young gentleman. It was said that one night in a fit of delirium she had run from the house into the grounds, and was finally discovered dead from exposure in the woods beyond the back lawn. Word of the tragedy was sent to the man to whom she was betrothed; and the man was said to have disappeared, never to be seen or heard of again – and he was commonly supposed to have ended his own life, or otherwise died of grief.

I thought on this as I began to read the next letter. It was sent to William, several months after Helena's death, by one of his friends: a certain Sir Humphrey Landers. This letter was evidently in reply to one already sent. And as I read it a chill spread gradually through me.

. . . I advise you, my friend, to quit your home and Cornwall for a time. It is plain to me that you have been deeply and greatly disturbed by the tragedy, as any man might be. But you must place no belief in the wild tales of the base and ignorant, nor allow

them to work on your mind. Common men are a gul-
lible and superstitious rabble. As for the nurse who
claims she could not restrain her charge! It is plain to
me that the woman was asleep when she should have
been attending to her duty. And the servant who first
went out into the night after your sister. Clearly he
was drunk. How else might a sick girl have eluded
him? I should make sure he has not stolen a key to
your wine cellar. Beware, my friend, for you may no
more trust a servant with drink than you may a fox
with a lamb! As for his drunken babble! A black form
that stole upon your dear sister and bore her away!
Indeed! Now that you are master of your house you
must, I pray, come to know the endless wiles of the
servant classes. Cheats, thieves and idlers all. They
will invent any monstrous and incredible lie to
conceal their own base worthlessness and ingratitude.

But to return to the tragedy. I fear that while you
remain there in that house the condition of your
mind is scarce like to improve. I fear, my friend – and
my physician is incidentally of the same mind – that
in view of the terrible imaginings of which you have
written, if you remain there much longer madness
may soon overtake you. Such a place to a man in
your state of grief is sure to lend itself to strange
fancies. Accept that she is gone! You and your wife
must, I insist, accompany Lady Landers and I to
Bath, or perhaps to London . . .

I sat and considered all this. It was plain from Sir
Humphrey's references to "terrible imaginings" and
"strange fancies" that, following the death of his

sister, William had had some sort of experience that left him fearing for his sanity. Now my head was filled with a series of strange and presumptuous ideas that somehow seemed entirely logical to me. I asked myself: could it be, as the letter implied, that William was troubled by dreams or visions of his dead sister? Then I asked: could the presence or the image of Helena LePerrowne exist in some form here in the house where she had lived and died? For if any spirit roamed this ancient place, it seemed to me that it must be hers, whose death was so tragic, and apparently so cloaked in mystery. Could it be her face I had seen that night? It might at least explain the resemblance between the dark girl and the portraits of William's sons. Did Helena haunt me as she had once haunted her own brother – my great-great-great-grandfather, to whom I bore so strong a likeness?

Absurd as all this might seem, it appealed perfectly to my then dark and morbid state of mind. And I felt a powerful, compelling desire to find out more about the mysterious Helena. But now it occurred to me that I had no way of discovering what she had looked like. To my knowledge there were no existing drawings or portraits of her – which was hardly surprising since she had died so young. I realised to my dismay that far from having come any closer to solving the mystery I had only succeeded in making the whole thing infinitely more tantalising.

For an hour or so I sat brooding in impotent anger. Until at last a thought took gradual shape in my mind. A ripple of shock passed through me as I realised what I was contemplating. I shook my head

quickly. It was lunatic. And yet! I remembered once reading of cases where corpses sealed in coffins had been remarkably preserved long after death, although deterioration was always rapid once they were exposed to the atmosphere. I knew very little of the process of decay, but though I supposed that the body of Helena, dead for more than one hundred and fifty years, could probably be no more than a mound of dust, it seemed not impossible that something might yet remain: that the body could still be intact and by some chance retain some vague mummified suggestion of how it had looked in life. Some strands of that jet black hair. Something.

I shook my head again. I was surprised by this dreadful notion – to venture into my old family tomb and uncover a corpse in the faint hope that something about it might satisfy an unwholesome urge of my imagination. I tried to put it from my mind. But it was no use. The idea kept returning, as if something were forcing it back into my head. And the more I thought about it the more insane it seemed; yet in spite of this I felt increasingly drawn to it. Until slowly I came to see that truly it did not shock me – or if it did that shock was all part of a great sense of excitement that was fast mounting in me. For a while longer I fought the impulse, until it became clear that my scruples reflected an aversion I did not truly feel. I was determined to do this thing, however distasteful or irreverent it might seem. I suspect the desire transcended even my wish to solve the mystery of the girl's identity. I believe it was because it went against all my Christian upbringing

had taught me that it obsessed me so. The whole idea smacked of some thrilling, forbidden adventure. And perhaps even some vague premonition of the great chain of mysteries I was beginning to uncover. Indeed, so great was my compulsion that I resolved to go to the tomb at once, as soon as I had obtained a lamp and some instrument to prise open the coffin.

The tomb stands in the grounds of my home: in a remote private cemetery in a small clearing amidst a dense wooded area at the bottom of the back lawn. It is a big imposing structure of grey stone with a high roof surmounted by small stone gargoyles, and worn steps that lead down to a great square iron door, beyond which lies the main underground vault where for several centuries, up until the time of my great-grandparents, most of the members of my family were interred.

When I arrived outside the tomb it was already late in the afternoon, and the sun was setting. But the fading light made little difference to me since the tomb was in any case deep and dark and I had my lamp. I confess I did hesitate for a moment, wondering if I might feel more comfortable returning the next morning in full daylight. But having gathered my nerves enough to go ahead with the deed, I wished it done. Besides, no doubt the approaching darkness would help speed my progress.

I had brought the key with me, but discovered that the padlock was ancient and broken. I pulled away the rusty chains then dragged open the cumbersome door as a long discordant creak escaped the hinges. A dry musty smell came from inside making

me cough as I stepped forward and held up my lamp, peering in as the pale glow faintly penetrated the gloom. Inside the vault was long and narrow. I moved slowly, passing dust covered coffins of lead on the low shelves on either side, shivering at the peculiar clammy chill that seemed to emanate from the stone walls and cling to the stale air. By counting the coffins as they stretched back into the dark, then brushing the filth from the top of several and reading their ancient name-plates, I soon found those of Henry, Richard and William LePerrowne; and then at last that which I sought: the coffin of Helena.

I had found an old iron crowbar to use as a lever. Placing the lamp on the ground by my feet, I managed to wedge the tip of the crowbar beneath the coffin lid, then stood flexing my muscles, ready to apply force. I was trembling now, but whether from nervousness, apprehension or excitement I was not sure. I pushed the lever down, trying to gauge the amount of pressure required, when the crowbar slipped loose and I stumbled backward against one of the coffins opposite, arms flailing, clutching at it to steady myself. I stepped two paces forward. With a sudden thrill I saw that I had dislodged the lid to Helena's coffin and that now it stood slightly ajar. It had come free remarkably easily, but then I told myself that after so many years that was perhaps not surprising. Gripping the crowbar I thrust it forward, knocking the lid from the coffin so that it fell down onto the shelf behind with a deafening clatter.

I stood for several moments, my body rigid, holding my breath, waiting for the distant echo to die

completely away. Then slowly I leaned forward to look inside the open coffin.

Deep inside lay a body which seemed quite whole and free from any corruption. It was she. Though it was too dark for me to gain any more than the vague impression of a white face, and masses of black hair that merged with the gloom, I knew at once simply that it was she.

Gasping in astonishment I turned, leaning down to grasp clumsily at the lamp by my feet. In my haste I nearly tripped. I lifted the lamp up above the coffin, my hand shaking violently as I stared down in the flickering light. I felt a cold trickle of sweat run over my cheek. The coffin was empty. The body was gone.

I did not know if I had imagined the lifeless form and for the moment I did not care. I was seized by blind panic and I turned and ran, beyond the power of thought as I hurtled through the darkness. Then I tripped and fell on the rough stone floor, losing my grip on the lamp which flew forward and smashed to pieces on the ground. Winded, cut and grazed, I looked up blinking into the dark. A short distance ahead I could just see the door of the tomb, slightly open, the last dull rays of daylight barely shining through. I wanted to run to it but found myself overwhelmed by such an intense sensation of dread that my head spun, my strength died away and a wave of cold nausea flooded through me. My head sank down. I felt the cold hard stone floor against my cheek. Desperately, with immense effort, I began to crawl painfully forward on my torn and bloody hands and knees towards the door, intent only on

escaping from that horrible and unnatural place. Eventually, gasping in agony, sweat pouring from me, I reached the door and, twisting my body to pull it wider open, struggled through.

Now the sun was no more than a few flecks of red on the horizon. Dark clouds were gathering overhead to threaten a dismal evening. Stiffly I climbed to my feet and lurched forward, staggering halfway up the stone steps outside the tomb before the effort overcame me and I sank down again. I gazed ahead at the shadowy, towering clumps of ancient and twisted trees. The great terror was still on me. A sense that I was not alone there, but that some unseen, inhuman presence lurked very near.

I went to scream but such was my fright that only a low rattling hiss emerged. Again I tried to raise myself up, but now my eyelids grew heavy and a sudden numbness fell over me. And there rose in me then that same burning heat I had experienced on that distant night when I had first seen the dark girl, the very thought of whom now filled me with horror. It increased rapidly, quickening my heart and pulse, swelling my veins until it felt as if my whole body might explode. Then it seemed that darkness engulfed me as there came the coolness, like a soft breeze blowing all about me, sinking slowly into my skin and filling me with that same chill of pleasure and relief as before. And yet this pleasure was more terrible and loathsome to me than any pain could have been. To feel it here, writhing on the steps of the tomb, on a bed of cold stone, dead leaves and damp earth; yet to have no strength to do other than

yield to it. It seemed obscene and horrible beyond words. After that I have no more than the vaguest memory of holding something in my arms. And blackness.

I was eventually woken late that night by a spot of rain splashing my face. I still lay on the ground outside the tomb; cold, aching and horribly tired. As I picked myself up the rain began to fall more heavily. I stumbled in the wet and the pitch dark through the trees and back to the house. I went straight to my room where I fell aching and exhausted down onto the bed. My brain swam but was sure of just one thing: that this time it had been something more than a dream. I drifted into a deep sleep.

IV

I did not wake until the afternoon of the next day, but still I felt tired and wretched. Outside it was dreary and still raining hard. I had fallen asleep in my dirty clothes, so I bathed, washed my cuts and grazes and changed before going downstairs for the early dinner I had instructed Moore to have prepared for me. Oddly I thought little on the events of the previous night. I think shock had blanked out the memory of much of it, but also my mind felt strangely dull and sluggish. I found it impossible to train my thoughts on anything for any length of time. Moore – dear old man – looked me over with some concern and asked if I was well. I had no wish to worry him. I told him I had been sleeping badly.

I found I could not eat. In spite of my hunger it was difficult to force the food down. Early that evening, after a brief and unsuccessful attempt to read a book, I felt exhausted again and went back to bed.

My memories of the days and nights that followed are even now somewhat vague and disjointed. I slept for much of the time, but was often aware of myself lying in bed surrounded by creeping shadows and soft whispers that I could not understand or identify. But gradually it seemed they were becoming clearer, that my mind bordered on strange and unfamiliar levels of consciousness and perception. And all the while my physical condition worsened. I grew pale and sallow. My cheeks sank. My mind was daily more

clouded and confused. I found it impossible to con-
centrate: the slightest effort to do so caused my head
to throb with violent pain. Very soon I went about
unthinking or unseeing, in a constant daze. Moore
became worried and offered to send for my doctor.
But without even considering I forbade it. I was
unconcerned and virtually unaware of my state of
health. I shut myself up in my room and instructed
the servants that I was not to be disturbed unless I
called them.

Alone I tossed, and twisted on my bed, my head
filled with things that I cannot describe, shapes
obscured in gloom, that I sensed rather than saw. But
I pursued them, these unseen images, towards the
horizons of my senses which seemed to shift and
expand constantly as my body grew more weak and
feverish.

Several days passed like this until my mind grew
suddenly lucid again, as if emerging from a long
sleep, one night as I lay in bed. In a single moment I
became aware how dreadfully ill I was. All the fear
and concern I should have felt for days gripped me at
once. Gasping, I clambered out of bed and stumbled
over to look at myself in the dressing mirror. What I
saw appalled me. Only my eyes, heavy, sunken and
blazing, held any remaining trace of life – like last
surviving outposts that stubbornly fight on, refusing
to surrender even though the war is lost. My body
was horribly emaciated. I was dying. I became cer-
tain of it in that instant. Exhausted by the very
effort of standing I staggered back and fell onto my
bed. Now for the first time I was recalling clearly the

bizarre events that had taken place at the tomb. I did not begin to understand what had happened – what was still happening. There was only the certainty that some unearthly force was at work. That something was attacking and slowly destroying me.

I lay a long, long while staring up at the low flame burning from the lamp by my bedside, flickering gloomy and misshapen shadows onto the wall. This final recognition of my situation should have aroused some feeling in me, but it did not. Slowly all sensation left me. My spirit seemed weak and exhausted beyond caring. Life meant nothing to me. I was ready now to submit to my fate whatever it might be. My illness had destroyed me for my powers of reason had returned too late, when the last of my strength and will were gone.

The lamplight was suddenly obscured. A shadow fell over me. Slowly I looked up through the parted bed-curtains, yet nothing was there. But then as my head dropped back onto the pillow I shivered slightly. I glanced to one side. She lay beside me on the bed, her dark eyes wide open, her face gaunt and so chillingly familiar. And yet strange. For her beauty was so stark, her skin so pallid, her face so utterly still and without any human emotion or expression that she seemed unlike the soft, alluring creature I had glimpsed here in this room those years before. Rather, she seemed like the lifeless thing I believed I had seen lying in the coffin on that awful night at the tomb. She lay quite motionless, dressed in a long white gown, her head on one side, her eyes upon me, but so blank and unmoving they did not

seem to see me. It seemed as if a corpse had been laid out alongside me. With a gasp I placed my shaking hand on the bed, pulling myself up that I might crawl away from her. But as I did so I saw one of her slender, bloodless arms begin to move, creeping over the blankets like some white serpent, until her hand came to rest gently upon my own and her fingers closed about my wrist. I grew rigid. Her touch was deathly cold and my arm grew instantly numb as her hand ran along it, gripping my shoulder as I watched with a strange fascination. She pushed me down again, and I felt like a wretched marionette for I had no power to resist her. Now that cold hand came to rest on my forehead, and in spite of my dread it felt peculiarly soothing and my body began at once to feel drowsy and relaxed.

My head was spinning slightly as I watched her rise up above me now, throwing back her head so that her long black hair fell down almost to her waist. She regarded me a few moments, her pale, impassive features like those of a marble statue; but then her lips curled slowly in a sensual smile. Her teeth were even and well formed and seemed to glimmer with her lips and her eyes in the glow of the lamp. In that moment she put me in mind of some graceful, exquisite creature of prey. Then she drew nearer to me. Now I felt that heat begin to rise up in me and I realised at once that it was her very closeness that caused this. The coldness of her body that aroused in me a great sensitivity, a preternatural awareness of the life force that, despite my dreadful condition, still burned hot in me. She came closer still, until her lips touched my

cheek and I felt her light, cold breath against my skin, while her fingers ran slowly over my chest.

Once more I made a feeble attempt to pull away from her. But then she spoke, and I ceased my struggles and simply stared at her in astonishment. As if in answer to the question I had not power or thought to voice, she whispered:

"I am Helena! You must not resist me. I have come to you. Did you not come to me John LePerrowne? I have long known you. Your loneliness. Your sickness. Your misery. Have you not wished and prayed again and again to be released? Now! You must listen hard to what I say. Tonight I take you beyond life. Together we will journey into death itself. And there I must leave you. It must be of your own will and strength that you return to me." She reached out and lightly stroked my hair. "You must lie shrouded and lost in darkness. It will seem that you are dead, but you shall be simply suspended hard and cold like a chrysalis in the completion of its metamorphosis. It is imperative that you remain undisturbed. Is it safe for you to remain here? Or will your servants intrude?"

"No," I answered at once, quite involuntarily, as if in some way commanded to speak. "I often keep strange hours. They will not come until I call them."

"I will bolt the door to be sure of it," she said, her manner at once practical, almost business-like as she rose quickly and went to the door, which all seemed strangely incongruous with the unearthly, ethereal image she presented.

When she returned and sat on the bed by my side, I

stared up at her and I felt nothing. Not fear. Barely even curiosity. Only the vague sense that ironically everything was reversed. That now she was my only reality, and that every old reality was fast fading to become the distant, intangible dream she had once been. She sank down on me, taking me in her arms and pinning me to the bed as her icy body rocked against mine, and I stretched out with a light moan as those great waves of cold flooded over and through me.

Now I could feel my heart beating, faint but fast. And gradually the pounding grew deeper, but slower, and slower, until at last each beat burst with a huge and painful throb that echoed in my hollow chest, leaving what seemed an eternity before the next. I could feel what remained of my life ebbing slowly away; being drawn from inside me. My breath caught and rattled in my throat, my limbs lost all feeling and the weight upon me increased. Through blurred eyes I saw her face above mine, and heard her soft voice whispering:

"I will call to you. When it is time you shall hear me call to you."

Her image grew more vague and distant until at last a grey mist descended over me, sweeping me away, outside my mind and beyond my senses into a vast and endless universe of black.

Life, death and eternity. For a fleeting moment before unawareness came I knew these things as they merged in me. And it was then, in that instant, that it began.

* * *

There was a sound. A voice. It came from somewhere beyond the blackness in which I was suspended. I did not hear its words, but gradually I felt myself rising towards consciousness, as if floating from a sea of murk upwards into the light. My eyes fluttered open. I was alone. I still lay on my bed in my nightshirt. Slowly I rose. I was at once aware that some immense transformation had occurred in me, and yet I could not begin to guess its nature. But although I was so confused, so unable to understand what had happened to me, my brain seemed sharper and clearer than ever before. As if all my life I had seen through a fog, and that fog was now lifted. I possessed greater awareness, although I was not yet certain of what I had become aware. There was simply the power of some great new perception, as yet sensed rather than realised.

Yet as I stood trying to grasp these things I saw slowly that my senses had grown wonderfully acute. I could hear the soft breeze rustling the grass outside and the leaves on the trees in the distance. And I could hear Moore with his stiff, slow stride walking through the room below – now stopping to cough and clear his throat – now walking on. And the heavy atmosphere and faintly musty smell that pervaded my old house – which I having always lived there had barely even noticed before – seemed suddenly overpowering. But I realised the most remarkable thing of all only as I began to glance all about the room. For the curtains were drawn and the bedside lamp had long since burned itself out. The room was in complete darkness. Yet I saw all about me quite clearly.

My skin, however, seemed to have become some-what dull and insensitive. It was cold in my room and I had always been most susceptible to the cold. But now, although I was still aware of it, it no longer seemed to affect me. For I was cold. My body was cold with death – yet I lived on.

I went over to the window and flung open the curtains. I stared out into the night, intrigued and absorbed by the subtle sounds, images, shades and motions my new senses were making available to me. Eventually I looked down. Helena stood beneath my window, gazing up at me. She wore a dark cape over her white dress, which made her less conspicuous in the night. At once she moved for-ward, scaling with remarkable speed the thick ivy that grew up the side of the house. I stood back from the window, which I now saw was unlatched. She pushed it open then scrambled quickly and noiselessly inside. She stared at me a moment, then she said:

"Go down at once and show yourself to the ser-vants. They must be beginning to worry about you by now. When you have assured them you are well come back here. I will wait for you. But be quick. There is much to do tonight. Go!"

Her tone conveyed such urgency that I made no reply, but went and dressed at once, then hurried downstairs to carry out her instructions. Moore frowned when he saw me. He was still greatly con-cerned by my odd appearance and behaviour. He asked me when I would require dinner, but I told him that I would prepare my own food later, and until

then I was not to be disturbed in my room. He frowned again, but said nothing.

I returned to my room to find her standing, staring out of the window. She spoke slowly and softly, without turning to look at me.

"No doubt there is much you wish to ask me? Many questions?"

I remained silent. There were of course countless questions I had to ask. So many that I was not sure where to begin.

"It must wait," she said. "It must wait until later." She turned to me. "How do you feel."

"I – I can't . . . I don't . . . I can't . . . " I faltered wretchedly. I was finding it very difficult to put my strange new feelings into words.

"Cold?" she said. "Cold inside?" She walked over to me and placed her hand gently on my shoulder. She was warm tonight, her skin fresh and pink; not cold and white like me. "That is to be expected. You are drained. You are exhausted. We must remedy that at once, before anything else. Ask your questions after. Come."

She went over to the window, climbed through and grasped the ivy that covered the wall outside, hurling herself downwards with effortless agility. I watched her, amazed that the flimsy green leaves seemed to support her weight so easily. I went to the window and stared down after her.

"Come!" she called softly from below, looking up at me.

Previously the very thought of attempting such a dangerous and precarious feat would have terrified

me. But now I slipped through the window without a thought, gripping the leaves, and clambered down to join her.

"Follow me," she said as my feet touched the ground. And we were away, moving swiftly around the side of the house, and across the lawn; gliding smoothly through the trees beyond. I followed her fluttering black cape, weaving through the darkness in front of me, as we made our way together into the night.

V

We made our way to one of the nearby villages, about two miles away, and covered the distance through woods and over fields in what seemed a matter of minutes. How can I describe the feelings inside me as I raced through the night, a stranger to exhaustion? Though Helena had said I was drained and weak, energy and strength were like a growing flame in me. Never had I known such exhilaration, as if nothing on earth were beyond my power. But gradually I began to feel, as Helena had predicted, a gnawing coldness in my breast and stomach, that rapidly began to spread through my limbs and cause me much discomfort. It was accompanied by an overall feeling of dehydration, as if my skin were made of dry, dusty leather.

We stood for a while in silence on the outskirts of the village, in the shadows along a dark lane that led from the local inn, through a thick clump of trees, in the direction of a few small cottages scattered into the distance. Before long a fairly large group of men emerged from the inn, and stood outside the door for a while, jabbering boisterously to each other. Then with loud farewells they split into smaller groups of twos and threes and started off into different directions. Two of them began to stroll down the lane towards us. One of these appeared to be middle-aged, and the other was a tall strapping fellow I judged to be about the same age as myself – twenty-three.

As they drew close to us I sank back into the cover of some nearby bushes; but Helena remained where she was, standing beside the path, watching them approach without apparent concern. Only when they were almost upon her did she move silently to one side, allowing them to go by, but still making no effort to conceal herself from them. One came so close to her that he almost brushed her with his shoulder. Yet it was so dark along that way, over-shadowed by trees on a night what was in any case moonless and cloudy, that they did not see her. How-ever, my own vision seemed to grow clearer by the moment. When they had passed us Helena moved up behind them, gesturing for me to do likewise. They trudged on without speaking and all was silence but for the steady crunching of their feet in the soft muddy ground. I moved forward slowly, watching in sheer wonder as Helena, after walking behind them for a while, strode up alongside them, moving fre-quently from one side to the other, sometimes cross-ing directly in front of them, sometimes moving in a complete circle about them and leaning forward as if to examine each man in turn. She moved about them with such silent speed and grace that her black hair and cape appeared to swish and weave strange patterns through the dark. And I walked, half-mesmerised by this macabre supernatural ballet which the two men had not the remotest knowledge was going on about them.

Now Helena was several paces in front of them, facing them, walking backwards, her step in time with theirs to maintain her distance from them. I

crept closer, concentrating hard on moving noiselessly, envying Helena's effortless stealth, though my own confidence was fast increasing. Then she looked between the two men at me, creeping behind, and said softly:

"Stay back now. When we leave the cover of the trees there will be light from the cottages."

Her words had a most remarkable effect. It was as if she whispered directly into my ear. The men evidently heard nothing, however, though they stood between us. Thus I learned of our ability to move and even speak undetected in the presence of men.

The two men emerged now from the shadow of the trees, and the moment they did so Helena slipped from view then appeared back at my side with such fast, catlike motions that my own senses, for all their new found sharpness, were confounded. Now we stood and watched in the cover of darkness as the two men parted.

"G'noight then, Joe," said the younger. "Sleep sound."

"Fat chance o' that, me 'an'some, wi' moi Rosie snorin' down me ear'ole all noight" said the other with a great snort of laughter; then he set off towards one of the nearer cottages. The younger walked on along the track towards a small, solitary dwelling in the distance.

Helena now moved forward, grasping my hand and pulling me with her.

"Come!" she said. "Follow me. Quickly!"

And she started off after the big figure. She moved behind him, gliding like a phantom, crouching

slightly before leaping forward with terrifying speed, her arms entwining his broad shoulders, her hands gripping about his thick, muscular neck. I heard him gasp quickly, saw him thrash about momentarily in an effort to shake free; but her grip was tenacious and the very speed and force of her attack caused his legs to give way and he sank to the ground beneath her. It was an absurd sight: a lovely woman overpowering a great, strong man so easily. Yet I must remind myself that Helena, whatever she was, was not a woman. Only in form did she appear so. I knew too well her power, the cold potency of her grasp that caused all strength to crumble and induced a lull of shock, a masking of awareness with that inexplicable chill of pleasure that overwhelmed the body in moments.

Now she drew back from the prostrate form, pointing down as she looked up at me and said:

"Quickly, now. Before he wakes."

I gazed down at the young man and my nostrils filled with the sweet, moist odour of his skin, carried on the breeze. A thrill passed through me and I swallowed with nervous excitement. I did not stop to think or question what I felt – indeed hardly a single thought had passed through my head since I had woken – I simply responded to my newly forming instincts. Drawn by some irresistible urge I crept closer, until I stared transfixed upon the young man's body and felt its incredible warmth glowing on me like a blazing fire. The coldness inside me was unendurable now and I felt a need, an immense desire for the strength and power this body possessed. At

any previous time I would certainly have envied it, yet what I felt now was something far more.

Reaching out, Helena took my arm and pulled me down until I was kneeling beside the limp figure. Then she took my head in her hands and pushed me down until my face rested against his and his skin burned into mine. I wrapped my arms about him and he sighed softly, his body moving gently. My sight grew dim. A flood of some great power was rising up about us, growing stronger until it seemed I could see it, taste it. It was an aura of living energy that flowed and swirled about us, engulfing us, making our bodies one. I clung to him tighter still, felt my cold lips resting on his hot flesh. A stream of warmth burst onto my mouth, my chin and my neck, tiny beads of heat that trickled and ran down over my chest. And that cloud of power had become as some oppressive weight that increased until I felt that our bodies might be crushed together. The sturdy frame beneath me writhed from side to side and uttered breathless gasps as I pressed my lips down firmer and the thin, hot stream flowed into my mouth. And all the while I was vaguely aware of Helena, who knelt by my side and cradled me tightly in her arms.

Then she pulled my head back, allowing me to breathe out and relax as I gargled the burning stuff in my mouth and throat. Slowly the mist cleared from my eyes. I breathed deeply, staring down at the figure beneath me. His head was on one side, lolling back, and at the base of his throat was a tiny wound, a small graze from which drops of blood slowly

welled and bubbled. Now she pushed me down again, my lips onto the blood which I began to lap. The cloud rose again and he thrashed beneath me more wildly than ever, his life energy pounding into me. A great wave of warmth rose over me, shattering the cold inside, generating strength and revitalising my withered flesh. I pulled my lips from his throat, gasping again for breath as at last I seemed to see myself and feel myself suspended over a great red abyss. And then I was spinning, and the abyss was a scarlet vortex of pleasure that drew me fast into its depths.

At once I felt Helena's small, firm hands pulling me back, trying to steady me. But I found myself struggling against her, growling from deep in my throat like some enraged animal, intent on fighting my way further into the unexplored depths of pleasure ahead.

"No! No! That is enough!" I half heard her say in my ear; and then again with greater urgency: "That is enough! Enough! You will kill him!"

With a gasp of shock I raised my head. The vortex faded and vanished, and I saw instead the once ruddy but now pale and drawn face of the young man. He was apparently in a deep trance, his breathing laboured and shallow, but as I released my grip on him his lips parted in a light moan and his eyes flickered half-open. He looked at me dreamily for a few moments, then slowly he raised up his arms towards me, like a lover imploring me not to desert his embrace. With a sigh I started to sink back down into his arms, my thoughts drifting again into nothing. Helena's cold hands took my shoulders in a

grip of steel and tore me from him as she repeated sharply:

"*You will kill him!*"

I shuddered and breathed deeply. Now I was confused, startled by what I had done, and greatly distressed by the knowledge that had Helena not stopped me I should certainly have killed him. As I fed upon him he had barely seemed to me a man. Overwhelmed by my need he had become nothing more than a thing to be used until it was dried up and worthless.

"Come! Leave him there. When he awakes he will remember nothing." Helena was walking away now, looking at me over her shoulder. I rose from my knees and followed her, feeling more life, warmth and strength inside me than ever before.

* * *

We moved on in silence for a long while, although there was so much to be said; over rolling hills and meadows until at last we walked across high, dark cliffs, staring down at the foamy sea far below, listening to the roar of the waves as they crashed against the rocks.

Helena seemed preoccupied as she stood with the great gusts of wind whipping at her long cape, hair and dress. At last she turned to me and said:

"Do you understand why I stopped you?"

I looked away and made no reply. Oddly I now felt little shock or dismay at the thought that I had in some way I did not understand partially drained a man of his very life. What I felt instead was a sense

of crushing shame and embarrassment to think that Helena had seen me as I had never before known myself: unthinking and unrestrained. Swept away by sheer physical desires that I could not control. This was so unlike me, with my reserved and fastidious nature, that it greatly alarmed and frightened me. Finally Helena continued speaking.

"Through the ages," she began softly, "men have dreamed of our power. The ultimate power. The power of eternal youth and life."

"Immortality!" I said in the faintest whisper, the word sticking and breaking in my throat so that I repeated it slightly louder. "Immortality!"

"The span of our lives has never been measured. We never age. It is believed among our kind that we cannot die naturally. That we are indeed immortal." She stared at me wide-eyed, her face unmoving. "The fountain of eternity. It flows for us in the bodies of men. To draw from humanity its strength. Its life. The raising of passions, of the body and the mind. Of all powerful emotion. The shedding of blood. These things discharge power into the atmosphere. Living energy that we may absorb into ourselves."

"Our kind?" I repeated.

She paused now, and when at last she spoke again her voice was harsher. She seemed almost angry.

"The history of man is filled with legends of unknown monsters that haunt the dark to prey on him." She frowned. "Lamia. Lilim. Incubus and succubus. The undead. Vampires. Hybrid demons and walking corpses. The names and forms attributed to us by men through the ages are numerous as they are

unflattering. And where the legends ended and reality began I cannot say. But what do we care for the superstitions of men? All hunters are anathema to their prey. We are not demons. We are not vampires. We are the Revenant – who have returned from death."

"Revenant?" I said quietly.

"So we call our own kind," she nodded. "And why else do men fear us but that we embody their wildest dreams and desires. But know this. That man is not the only creature capable of reason and restraint, whatever his arrogance may lead him to suppose."

I stood and listened to all this, believed the unbelievable with a calm and logic that was as astonishing in itself as these things I was told. Perhaps it was all too far beyond my comprehension as yet. But already my every concept of the impossible was shattered. I could do nothing but listen and accept. Now Helena drew closer to me, strands of her long hair floating on the breeze, and her voice grew soft again.

"Listen carefully, now. Tonight you would have taken life in ignorance. Now you have seen that we need not kill to exist. If you take life tomorrow you do so with the knowledge that it serves no purpose but the joy of killing. Never allow yourself to believe it can serve any purpose but that. After tonight, if you choose to take a life, I have no power to stop you. I ask only that you remember what I have said."

I stood silent awhile, staring at the soft sea spray that danced and sparkled in the night air. Then I

turned back to Helena. She was walking away, and I hurried to catch her up.

"That man!" I said. "The one tonight. If he had died . . . would he . . . ?"

"You mean," she said, glancing around at me, "would he have risen from death as you did?" I nodded. "No. Human life must be drained away slowly, over several nights, as our own life spreads through the veins to replace it. If the body is drained outright the shock is too great and the body will die." Then she smiled slowly and said: "Why? Do you wish to make others already?"

"No – no!" I said quickly, shaking my head in confusion.

"Of course," she laughed. "You must know these things. But always remember what you can give. The power of life and death. Such power is never to be granted lightly. If it is – when it is – our kind becomes as evil and corrupt as men have always believed us."

We walked on, and I was at once seized with the desire to ask why she had bestowed these awesome gifts on me. But I did not. Instead I considered how perfectly the prophecies of my dream had been realised; and how easily and instinctively I appeared to have accepted my new existence. For the time being no further explanations seemed necessary.

We returned to the house. By the time we arrived dawn was beginning to show in the distance. Now Helena explained other things to me. That it is the custom of revenants to sleep through the day. Like most creatures equipped to live by night we are

averse to sunlight. It drains our strength, dazzles our eyes and blisters our pale, sensitive skins. Prolonged exposure may eventually lead to exhaustion and delirium in a condition not unlike human sunstroke. To revitalise our strength we must in any case sleep each day our sleep of the dead; and so, naturally, we choose to rest through the brightest daylight hours.

Helena said she thought it best that I should not sleep in the house, but alongside her in the tomb. For our sleep cannot be broken and has all the appearance of death – mundane though it sounds it is for this and no supernatural reason that revenants often choose to repose in coffins, where if ever discovered a corpse will seem inconspicuous. If ever for any reason I had been disturbed by my servants while I slept a doctor would have been called to pronounce me dead. Then I would have lost my identity, my house, money, and all my possessions. Since I had no family, no one close enough to me to make the pretence too difficult, Helena said it should be safe for me to retain the facade of my human life, with all the advantages it carried.

She told me to go into the house and bring out a wooden trunk of some sort. I obeyed without question. I took an old clothes chest from my room, emptied its contents out on the bed. But before I returned to Helena in the garden I stood awhile, staring at my reflection in the mirror. Still I looked somewhat lean and drawn, but my skin no longer carried its former pallor. Now it glowed pink with the energy and blood I had taken, and a new, vital power burned visibly, almost fiercely from me.

I took the chest outside. At the tomb we opened an ancient coffin bearing the remains of one Gilles LePerrowne, who had died some two hundred years earlier. These were now just a dusty collection of bones, occasionally covered by brown, leathery strips of skin, the face a grinning skull with some trace of colourless hair still apparent. Quickly we scooped up these contents and placed them inside the chest — which I buried out in the grounds nearby the following night. Then, as if it were the most natural thing in the world I lay down inside the mouldering old box, and Helena put the lid in place, enclosing me within.

And as I lay there a sense of enormous excitement came over me. I thought back on my past life and saw how strange and unnatural it had been: solitary and withdrawn into myself, filled with dark and unwholesome obsessions that had driven me even to invade a tomb and desecrate a grave. I grew suddenly convinced, and remain so to this day, that had I gone on so I should at last have ended up raving in some asylum for the rest of my days. And all this I saw at once with perfect clarity as I lay there in a coffin inside that cold and musty tomb, yet knowing suddenly that all along the real tomb had been my old life, my old nature and perception; and that what I knew now, lying among darkness and decay, was life and freedom beyond human imagining.

The dawn chorus was loud and shrill in my ears as sleep came to me.

VI

We passed the remaining months of summer there at my house in Cornwall. I soon established a nightly routine. When I rose in the evenings I would go into the house for a time to show myself to the servants, see to any business that might require my attention, and make the pretence of eating a meal. Then when darkness fell properly I would go out.

At first Helena would accompany me on my nocturnal wanderings, but after a while I went mostly on my own, haunting the dark lanes and silent places; for Helena said it was better for me to teach myself – stressing always the need for utmost stealth and caution – that there was little she could show me that I might not learn better simply by studying and knowing my own instincts. And it is easier and safer for us to stalk alone.

And so I was left much to myself in those early days. Most nights that alluring vortex rose swirling before me, and I would linger above it, toying with death, testing myself, seeing how far I might indulge my pleasure before finally pulling back, hurling the limp gasping bodies aside; hardly yet aware that what I did was anything more than a dangerous yet exhilarating game.

Sometimes I barely saw Helena for nights on end. Often when I woke she was already gone, and frequently she never returned until sunrise. And on those occasions when she did consent to come and

walk with me she remained curiously silent most of the time, turning sometimes to smile at me softly, or give me some brief words of advice or instruction, but seemingly distant, absorbed in thoughts she did not share with me. And much as I wished to talk to her, to ask questions, to learn about her and know her, and about myself, I always felt too shy and awkward to interrupt these reveries, so that we never spoke to each other in any real depth. This distressed me. My feelings towards her were stronger than any I had ever known and I wished desperately to be close to her. Her every move, her every gesture entranced me as ever, but she was an enigma: I could not begin to guess at the workings of her mind, the thoughts that preoccupied her. I had supposed that now I was like her I should grow to understand her, but this was not so. In many ways she seemed as remote and unreal to me as always. Yet not for a moment then did I begin to distrust her secrecy. I was too intoxicated with my new life to allow anything to trouble me greatly. In those first months I lived from moment to moment, as a dreamer, never pausing long to ponder or question, swept along on a constant tide of fresh experience and discovery. Darkness unfolded its secrets to me, filled me with wonder at the endless depths, the varied shades and hues of beauty within, where before there had been nothing but blindness and gloom.

And I told myself that Helena had been a long time alone, and was unaccustomed to close companionship. That she needed to adjust to her new situation, even as I did, and that the barriers between us

would dissolve with time. For now, her very presence made me feel self conscious and naive. It left me barely capable of thought.

Yet there were times when alone I grew confused, even angry and resentful that she should have ushered me into this new existence as her companion only to seem so solitary and distant now. At times I felt the need for her reassurance. The transformation in me was utterly beyond my every power to comprehend. And then, young, ardent, long repressed and alone, suddenly released and experiencing new and powerful emotions, I would have been constantly near her, with all the cloying devotion of a lover. There was much I had yet to realise. But now, looking back, I am astonished at how little I really tried to understand.

When at last the cold winds of autumn began, Helena came to me one evening and said that soon we must move away to some city, where we would spend the winter. She explained that, strangely, we are often safer living in cities, among thousands of men, than near small, isolated and sparsely populated rural villages like those which surrounded us there.

"The more people there are about us," she said, "the more inconspicuous we can remain. But more than this. The city dweller prides himself on his sophistication and worldliness. He supposes that nothing can be beyond his own knowledge and experience, and finds reasons he can understand for everything. Country people are different. They must live by the whims of nature and have less control

over their world. They are more ready to accept that
which they cannot explain."

The news that we were to embark upon a journey
filled me with excitement. I had never before been
very far from my home, although as I have
explained, the thought of travel had long attracted
me. Now I was no longer incapacitated, mentally or
physically, it seemed I was free to do so.

We decided that we should go first to Plymouth.
Since we may travel safely only by night it is difficult
for us to make long journeys, except in small stages.
From Plymouth we might move on whenever we
wished. I made arrangements to rent a house on the
outskirts of the city. Then I ordered the construction
of two wooden boxes, like large packing cases, which
might be easily and inconspicuously transported,
and in which we might rest during the daytime.
Helena told me all the things I should do, the provi-
sions I should make, for she was inclined to travel
about for much of the time. She said she had never
thought it particularly safe to remain in any one
place for too long; though she often liked to return to
the house in Cornwall where she was born.

I arranged for a carriage to take me to Plymouth,
and told my servants that I did not know when I
should come back. I travelled alone. Helena and I
agreed that we should make the journey separately,
for I was anxious not to arouse any undue local curi-
osity at my departure – and my setting off with an
unknown woman would certainly have done that!

I soon immersed myself in city life. It was all new
and tremendously exciting, and I took to it far more

quickly and readily than I had ever supposed I might. I walked the streets by night, surrounded by bright lights and carriages and people: swarms of people of every type, class and occupation, all hurrying about, seeming hardly to notice each other. Here I could walk the streets openly, become absorbed into the crowds without the vague fear of being seen and recognised I had always felt in Cornwall. Here I felt a sense of freedom that no longer obliged me to skulk all the while in shadows. Often I would just walk the city, keenly observing all the different sorts of people for half the night; sometimes going into a tavern and pretending to drink from a mug of ale – for normal food and drink is quite indigestible to us – simply to watch and feel myself a part of the great flow of life that went on all about me. Often I went to shops and bought crates of goods that were in reality quite useless to me, just because I loved to buy things, and to see the shopkeepers with their smiling faces and gleaming eyes as they flattered me like a prince in their efforts to induce me to part with the handfuls of money I held up before them. For all these things, amidst the speed and bustle of city life, were new and thrilling experiences for me.

Helena remained as aloof and as solitary in her habits as ever, yet now such was my involvement with all about me that it seemed to concern me less. It soon became clear to me why we had come here for the winter. Back at home people stayed indoors as much as they could during the winter nights, when freezing winds blew in from the Atlantic. Opportunities to feed would have been few and

risky. In Plymouth, however, it was a very different matter. The streets were never entirely empty whatever the hour or the weather. And there were so many dark lanes, alleyways, shop fronts and doorways where we might wait and watch, unseen and unsuspected.

It was about Christmas-time, and it seemed that not a year but a life-time had passed since I was that strange, shy young man at the Lansdownes. One dark and cold evening I wandered down by the sea-front, past countless shadowy places and drifting figures. I had not walked far before two large, bearded and very drunk seamen crashed noisily out of an inn just ahead. Catching sight of me they staggered over.

"Ah!" said one, nudging the other hard in the ribs. "'ere . . . 'ere's a right gent."

They tripped up to me, looking me up and down with blatant curiosity. Then they shook my hand in turn, introducing themselves as Captain Kidd and Davy Jones, and referring to me as "Yer Majesty!" Suddenly they let out several loud whoops and began a stumbling, clumsy attempt at a hornpipe dance in a circle around me, chanting a breathy sea shanty that either I did not know or they were too inebriated to sing in a recognisable fashion. A small crowd gathered quickly about, a drunken ragged black-toothed rabble, grinning, clapping and laughing. Then at once the two sailors seemed to forget me and hurried over toward a rather grubby young woman, evidently of their acquaintance, asking with loud giggles for permission to dock alongside her for the

night. I looked at them, smiling. Then I moved quickly on.

I had gone but a short distance when I heard footsteps behind me, getting faster and nearer, until at last they walked by my side. I inclined my head to see a small red haired woman I guessed to be somewhere in her middle twenties, wearing a slightly shabby green dress. She cast me a quick sidelong glance and smiled. I said nothing but slowed my pace slightly. After several moments she spoke in a low voice.

"It's not safe 'round 'ere, y'know."

I kept my eye on her but made no reply.

"It's not safe," she went on. "Not fer a young gen-'l'man like y'self. Some of 'em 'round 'ere 'd cut yer throat soon as look at you fer 'alf a crown an' a silk 'anky. Believe me. I know 'em!"

Now I looked her up and down. She was light skinned and seemed to have a nice shape, if somewhat thin. She was really quite pretty – in fact, for a waterfront whore, very pretty.

"Still," she smiled, "there's only one reason an' 'an'some young gen'l'man like you'd come 'round 'ere. I'got a room near 'ere. Come 'ome wi' me."

We went a little further, then turned off down a small, dark winding alleyway. She walked just ahead of me to lead the way. Cold hunger was growing fierce in me, as I felt her closeness and warmth. My limbs grew tense as I reached out, my hands seeking her throat as I leaned forward. At that moment there came a faint, muffled burst of laughter and some stumbling footsteps from up ahead. At once I drew

back and stared forward into the darkness. Two figures were approaching, a man and a woman. The man was drunk and his arms were wrapped about the woman for support. Of course they had not seen us in the dark, and neither was my companion aware of them. Suddenly the couple halted and the woman leaned back against the alley wall, pulling the man onto her, both of them merging deeper into the shadows. The man swayed for a moment, as if he might fall over backwards, then regaining his balance he began to paw her clumsily with big, calloused hands as their mouths met in an awkward, fumbling kiss. My own companion meanwhile moved on towards them, still quite unaware of their presence. When she was almost upon them I went to warn her, but then, realising how odd this might seem, decided to keep silent, and watched as the girl blundered into the long legs of the man, which stuck out from the shadows as he leaned against the woman. She stumbled forward and fell with a cry, while the man grunted, and the woman pulled her lips from his and spluttered:

" 'Ere! wotch where yer bleedin' goin'!"

" 'Wotch where yer bleedin' goin' yerself. Silly sow!" screeched back my companion in a sudden, raucous fury as she scrambled to her feet. "You shouldn't stand down dark alleys if you don't want people fallin' over you. Now get out'the way!"

I squeezed past the mumbling, angry couple and we both moved on quickly to the end of the alleyway.

"Sorry about that!" the girl told me with a quick smile, regaining her composure and brushing down

her soiled dress, "but you do get some right rubbish 'round 'ere. Some of 'em 'll do it anywhere."

Now we were standing on a street corner. Overhead hung a street lamp. I knew I could not take her here. It was too open. Too dangerous.

"It's just up 'ere." She pointed along the street. I was led to a narrow, dingy doorway. Inside it was dank and unlit, and she took me up a long, creaking flight of stairs. "'Ere we are," she said, opening a door. Before we entered she leaned up close to me and smiled. "Don't say much, do you?"

"No!" I answered quietly. "Not much."

It was a garret room, gloomy and grey. Patches of damp stained the walls, and a ragged curtain that looked as if it was made from a worn blanket covered the single window. There were a few old, plain pieces of furniture – a table and chair, a wardrobe and a bed with a cabinet beside it. A candle and some matches stood on the table. She went over, struck a match and lit the candle. A dim flicker of light spread through the room which did nothing to improve the look of it. I glanced about curiously. Never before had I seen such a miserable dwelling, only read of them in the works of popular novelists, and I was astonished, not to say appalled, to learn that their descriptions were barely exaggerated.

The girl went now to her bedside cabinet and took from inside a half-full bottle of some spirit and two cups.

"Drink?" she said, looking over at me. "Go on. It'll warm you up."

"No," I answered, "thank you."

"Oh! Well, I 'ope you don't mind if I do?"

"No!"

She smiled, poured herself a cup, and drained it in one quick swallow. Then she sat on the bed.

"Come on, then," she said after a few moments. She seemed a little nervous, I thought. I had no way of knowing, but I felt she was inexperienced in her profession. A servant girl perhaps, dismissed for some reason without a reference, who could find no other employment.

I moved slowly towards the bed, my eyes fixed on her smooth white skin. Quickly she unfastened her dress so that it fell down from her shoulders. She wriggled her arms free and began to unlace her undergarment. I stopped now and stood before her, fascinated as she pulled open her bodice to reveal her pink round breasts. She looked up at me. I remained where I was and watched as she continued to pull off the rest of her clothes, her soft pale skin quivering in the cold. I had never before seen a naked woman and my curiosity was like that of a child. She lay back on the bed, her teeth chattering slightly, and eventually she said:

"What's the matter? Come on."

I sat on the bed beside her. She raised her arms, winding them about my shoulders and pulling me down onto her, then she began to unbutton my coat with quick, deft fingers, pushing it from my shoulders so that it fell down onto the floor behind me. Then she was undoing my necktie, pulling open my shirt. I felt her burning hand caress my bare chest, then recoil as she gasped in shock.

"My God!" Her voice was a small, tremulous whisper. "My God! You're cold. Your skin's cold. *So cold!*"

"Yes," I said. "But you will make me warm." And I began to run my hands over her smooth body. I felt her flesh crawl beneath my touch.

"Why? Why?" was all she kept saying. "Why're you so cold?"

"Shh!" I told her, beginning to kiss her head, her cheek and her mouth, overcome suddenly by an excitement that was mostly but not wholly born of my nagging hunger for warmth and life.

She was pulling away from me in spite of herself, wrinkling her lips in disgust at my kisses. But I grasped at her, burying my fingers in her soft flesh and experiencing a feeling quite new to me. Suddenly I wanted not just to feed from this naked, inviting body. As I felt her breath on my cheek, her heart beating against me, I wanted to take her, to hold her and enjoy the sensation of her laying beside me, the warmth and comfort of her arms about me. I pulled her closer to me and she shivered, shutting her eyes with a faint sigh as I felt that first flow of power begin to rise. I nestled my face against hers and swallowed hard, then breathed a long, trembling gasp. At once the cold pierced my breast like a steel shaft, reminding me sharply of my need. I clung to her, running my fingers up through her thick red hair, pulling her head gently to one side as my head sank down, and my lips found her throat. My head swayed slowly back and forth as the blood came, ebbing into me. She stiffened slightly then rolled back and moaned a long sensuous moan. The flood began, that

flood of every vital living force, drawn from her body into mine as water into a sponge.

Now I was draining her hard, gripping her tight, and almost at once the vortex rose swirling before me, drawing me closer towards it. Then at last I tore myself away, sitting up, throwing her down onto the bed, gasping for air. At once she reached out, encircling my neck in her arms, her eyes dull and glazed as she started pulling me to her, her body throbbing with pleasure beneath me, her firm breasts rising and falling before my eyes as she released a succession of deep sighs.

I hesitated a moment, resisting her, but then I sank back down, my lips seeking her neck. Something inside warned me, urged me to stop, but for that moment, as my hands as if of their own accord slid smoothly along her torso, over her sturdy hips and about her soft thighs, I was blind to my own entreaty as desire grew up in me stronger than ever before. For several seconds I lay there motionless, as if various parts of my being were in sudden confusion and conflict. Then I lunged forward. I did not drink from the wound I had already made, but opened my mouth wide, filling it with her sweet moist skin. I bit down hard. I felt her flesh tear.

I pressed her writhing body hard against the bed as her moans of pleasure became chokes and gasps of terror and pain, and blood burst from her in a huge crimson flood that spurted out onto my face and chest, almost scalding my skin as it sprayed over the bed and the floor. Quickly I pressed my lips between the great torn flaps of flesh and the blood gushed

into me, pouring down my throat, roaring through my veins like a burning torrent. Raw power burst and roared about me, and as the vortex rose again I hurtled down into the heart of it as sheer phenomenal pleasure engulfed me, swept me away on immense pounding waves of sensual delight that blotted out my thoughts, devastating every part of me until it seemed I was plunged and floating breathless in a great sea; spinning through vast, obscure regions of darkness. The physical sensations were gone now – instead there were a bizarre procession of mental images, like a wild, mad opium dream. Shady worlds and nebulous expanses of vague shifting forms of immense and incredible proportion that stretched beneath me and loomed above me without beginning or end. And I was soaring, hurtling through immeasurable aeons and my body had no form but was mist on the winds of endless time, drifting to some nameless destination that might never be reached.

I do not know how long it was before I finally returned to my senses to find myself lying in a pool of sticky, partly congealed blood on the bed cover, clutching in my arms a grey, withered and mutilated corpse. Startled, horrified, I threw the body from me, and it rolled slowly, clumsily to the foot of the bed, where it tottered, poised in almost a sitting position – a lolling parody of life – for a few moments, before toppling down onto the floor with a heavy thud. I rose unsteadily to my feet and found my coat on the floor by the bed. Miraculously it was hardly bloodstained at all. I slipped it on and buttoned it up,

covering the great patches of crimson that stained the front of my shirt and trousers. On the table stood a jug of water in a wash basin, so I quickly washed the blood from my hands and face. I felt bloated and torpid and my head was spinning slightly. It was as if my every capacity for pleasure and experience was filled to exhaustion, and now I was almost beyond the power to feel anything.

I made for the door, swaying slightly, and I leaned for a moment against the wall, closing my eyes and sucking deep mouthfuls of air in an attempt to clear my head. Then I slipped down the dark staircase and out into the night.

*　　*　　*

I returned to my rented home, light headed yet sluggish. I went through into the drawing room and fell down heavily into a large, soft chair, leaning back and closing my eyes. There were several hours yet to go until dawn, but my brain was numb, my body hot and swollen, and I felt ready to sleep. But I could not sleep. As the knowledge of what I had done grew clearer in my confused brain, there rose in me feelings of such horror and revulsion that my body shook, and sobs burst uncontrollably from a great, growing pain deep inside me. Tears rolled down my cheeks and my head started to spin again. Then I must have slept for I next remember opening my eyes to see Helena sitting in a chair opposite me. She reclined there, wearing a splendid gown of blue and black, looking at me. I looked away, feeling a sudden sense of panic, casting my gaze all about, feigning interest

in various things in the room to avoid meeting her eyes. But I felt her stare upon me, and sometimes glimpsed her face, rigid and expressionless as she sat curled up, silent and unmoving. My mind was still hopelessly fuddled from draining too much too fast, but I was completely aware that Helena knew, and I grew agitated and restless as the stillness and quiet became increasingly oppressive. At last I could endure it no longer.

"Yes," I said, looking up into her eyes. "I have killed."

She just looked back at me. Still she did not speak. Anger rose in me suddenly.

"Say something!" I cried, slamming my clenched fists hard onto the arms of my chair. "It was you who gave me this need, this raging thirst, this awful gnawing hunger I cannot resist or control. It is you who made me a murderer. And now you look at me as if . . . as if I am to blame. Your eyes reproach me . . . increase my pain . . . if such a thing is possible."

"I look at you as always," she replied at last. "The reproach you speak of comes not from me. If you ask yourself truly you will see where it comes from."

I jumped to my feet with a cry of anguish and rage, and began to pace restlessly up and down, shaking my head, wringing my hands.

"It is your fault!" I told her bitterly. "Your fault. If you had told me. Reminded me of the danger. If you had spoken to me – made me more aware. If you had been near me – with me. You could have stopped me!"

She gave a small sigh.

82

"John," she said, "I might be with you always, forbidding and restraining you, making your decisions, acting as your parent or pedagogue. But that is not my way. It would change nothing in you. The truth is that you want me to reproach you now, to help appease your guilt. But I have told you, yours is the freedom to act as you will. I will not and cannot control you. Do not look to me to settle your conscience."

I trembled with sheer frustration. It was futile to argue with her. I knew so little about myself – about my own nature. Now half-mad with remorse I turned on her.

"If taking life is so abhorrent to you, why did you take my life? *Why?* Why did you kill what I was?"

I felt a quick, dizzy sensation of triumph now as I knew that at last my words had touched her. She gave no outward sign of this, but I knew it. I sensed it. After a moment of quiet she looked at me and spoke in a small voice.

"It is true. I had no right. How could I? But I had been alone so long. And whenever I returned to Cornwall I felt you there – lonely and lost. Disinterested in everything your life offered. Striving in your mind for thoughts and visions beyond your reach. And I wanted you. It seemed . . . but things are not as they seem. Not as we wish them to seem . . . "

She shivered slightly and her eyes filled with terrible sorrow and doubt. And at once I knew that she shared all my feelings of guilt – that indeed she felt them even more than I, for she knew herself to be ultimately responsible. It was my first glimpse

behind the confident, impassive exterior Helena had always shown, and it frightened me to see that she, whom I had thought so strong, was as beset with fears and uncertainties as I – fears and uncertainties of a nature I was only beginning to realise. Horrified now at the pain I saw I had caused her, all my exultation turned to anguish and I ran to her, holding her to me and crying;

"No! No! Forgive me. I spoke without thinking. You killed nothing. You killed a mass of insanity and weakness that never really lived. I cannot understand what I have become. I do not know that I ever will. I know only that it is something infinitely more than I was. I feel strong now, awake and alive for the first time ever, and more content than ever I thought I could be. Content to be with you whenever you want me."

She looked at me. And still there was sorrow in her eyes. Sorrow, and something else. Something I could not gauge. I reached out, stroking her hair as I held her close. And I remembered how as a sensitive boy studying my history books I was always incensed and outraged to read of the cruelty of tyrants and monsters of the past. But now I must recognise the savage passions I had so abhorred in these men as a part of myself, and the knowledge appalled me.

"Never again!" I whispered sharply, as much to myself as to Helena. "Never, never again. I did not mean to do it. It was an accident. Just an accident. But never again."

"Hush!" said Helena softly. "Remember what I

tell you. But do not make promises you might not be able to keep."

I hung my head and made no more protestations. I was filled with conflicting emotions. Though I felt shame and shock at what I had done, it all seemed inadequate, considering my crime. It was as if something in me was fast growing cold and indifferent to human suffering and death. Yet some other part of me was much disturbed by this, and urged me to feel, to care with all my strength. But I feared I could not truthfully swear I would never take life again. It was so fast – so easy. And the memory of its overpowering pleasures were strong and fresh in my body and mind. That night desire had overwhelmed me, shattered my every control. How could I say it would never do so again?

"Do not declare war on humanity, John!" Helena's voice was suddenly agitated. "They are many, we are very few. And an eternity of hatred is a hard thing to live with."

"I bear humanity no grudges," I answered quickly. "I told you. Tonight was just an accident."

"Yes . . . but, oh, John, don't you see? Do you not realise what it can do to you? What it can make of you?"

"What do you mean?" I said. "How can I understand you? Help me to understand."

She fell silent again, frowning, staring down at the floor. She seemed relaxed, at ease in my arms. Emboldened, I clasped her closer to me. Somewhere in the distance a church bell chimed dolefully. Never before could I have visualised us so; me holding her,

reassuring her. Hitherto I had been wholly in awe of her. But now it seemed that in truth she was not so different to me, and I felt at once closer to her. As she had said, she was not my parent or my teacher. She was my partner. We were to be partners through the centuries. Perhaps even into eternity. And each was all the other had. I held her tighter still. Then suddenly with a quick supple movement she was gone from my arms, standing in the centre of the room, her face glowing in the dark, her eyes deep and thoughtful, fixed on the blank wall behind me.

"Tomorrow," she said after a long pause, and a fresh note of purpose crept into her voice, "tomorrow we make arrangements."

"Arrangements?"

"Yes," she said, her eyes never once looking at me. "To travel to London."

VII

London: then the most vast and sprawling city in the world. Every feeling of delight and attraction inspired in me by Plymouth was repeated here with even greater strength. It was indeed the perfect place for Helena and I to live – so many shady and narrow streets, like rats' nests, all teeming with life; particularly prostitutes, destitutes, criminals, and hordes of ragged homeless urchins; all exactly as Dickens described them, although to the people of today it must seem as if such things could never have truly existed outside his imagination. I confess I often felt a sense of guilt feeding from the likes of these, for most of them seemed even thinner and paler than I.

We rented a house outside the town, near the village of Highgate. I would rather have found somewhere in the town itself, for it was quiet and rather rural in Highgate, and I was still enthralled by city life. But Helena was unusually insistent that we should live there. She said she preferred a peaceful village atmosphere to the commotion of London; and that it would be easy enough for us to travel into town whenever we chose. And this is what I often did, if only to observe from dark, concealing shadows the life that abounded on the streets, which never ceased to intrigue me.

But although I preferred London proper, I had to accept that Highgate was a most pleasant place; and whenever I returned from town in the early

hours before dawn I would walk through the quiet lanes, alone with my thoughts. Often I walked along by the new cemetery outside the village. Although it became rapidly overcrowded and decaying, Highgate Cemetery was at that time only some fifteen years old, and becoming one of the very grandest and most fashionable burial places about London. Yet even then its atmosphere was strangely eerie by night.

One morning, about a month after our arrival in London, as I sauntered down a dark, quiet lane alongside the cemetery wall, my attention was suddenly taken by a glimpse of a white gown, fluttering in the wind far up ahead of me. I saw it for an instant only before it vanished, somehow swallowed up into the dark. I supposed it might be Helena and quickened my pace; but as I strode forward, staring ahead of me, I saw no further trace of it whatsoever. I wondered if Helena had seen me behind her and was hiding, playing some joke on me, although such behaviour seemed most untypical of her. And so I halted and stood stock still, looking all about me and listening for any movement. Then I heard it: quick, shallow breathing from inside a thick clump of bushes a small distance behind me. My pulse increased and my muscles tensed as I closed my eyes and listened for a moment, trying to determine as best I could the exact position of whoever was making the sound. The breath was light, too light to be a man, and I wondered again if it might be Helena. There was only one way to find out. Spinning around I darted to the bushes, spreading out my arms and sweeping aside the branches to uncover whoever was concealed in them.

As I did so something emerged from behind the bushes and swept past me. With a gasp I leapt back, throwing out my arms, then I lurched forward, reaching out and attempting to grab at it, but it eluded me and so I stood, following it with my eyes, trying to gain a clear impression of it as it dodged and weaved away from me with incredible swiftness. It seemed smaller than I, and apparently shapeless: like a vague cloud of swirling black mist gliding noiselessly over the ground. Only as it vanished from sight did a sense of shock and nervousness descend on me, so quickly had it all occurred.

I stood confused for a few moments, then to my astonishment I heard again that light, fast breathing that came from somewhere in the bushes. At once I returned to foraging amongst them. A young child, a boy about six or seven years old, lay in the grass, half-concealed by overhanging branches. He was fast asleep, and wearing a long white nightgown. He was shivering violently, his teeth chattering, and his skin was almost blue for it was a bitterly cold morning. As I lifted him in my arms his large brown eyes flickered open.

"Oh! Oh!" he groaned softly, barely awake as he looked up at me. He breathed a deep sigh, then said: "Where . . . where is . . . the boy?"

"Boy?" I repeated softly.

"The boy . . . the boy with . . . with a bright face and yellow hair."

"I saw no boy but you," I said. "You must have dreamed . . . "

"Oh, no, sir!" A look of bewilderment crossed his

sleepy face. "There was a boy. There was. I saw him. He was under my window and he called me . . . and I followed him . . . and I was cold, sir . . . so cold . . . and then . . . "

Again he grew confused and fell silent as a thrill passed through me. On his neck I saw the tiny wound, moist with blood, that would probably have gone unnoticed by anyone who had not half-expected to find it there. I was astonished. I wanted to return home at once and tell Helena of this incredible discovery. I looked at the child in my arms. He had gone back to sleep. I laid him down softly on the grass and went to walk away. But then I turned back, lifted him once more into my arms and shook him slightly. His eyes opened again.

"Where do you live?" I asked him. "Tell me where. I'll take you home."

In my excitement I had all but overlooked the fact that if I left him here in his trance-like state he would probably die of cold before he was discovered. I would have held him to me to give him warmth, but of course I had none to give. He was too lost and bewildered to tell me where he lived, and I had no time to linger for dawn was near and I wished to catch Helena before she slept to tell her my news. Finally I simply carried the child to the nearest house, knocked loudly on the door, and crept away when at last I heard someone coming to answer, leaving the boy asleep on the doorstep.

Back at the house I was pleased to discover that Helena had not yet returned. I waited for her impatiently, down in the small dark cellar where we

lay in our boxes during the day. At last I heard her come in and moved forward to meet her as she descended the cellar stairs. She greeted me with a smile then stood and heard my story without once interrupting. To my disappointment, however, she did not seem in the least affected by it.

"But of course there are revenants here," she said when I had finished. "Why else do you suppose I insisted on us coming to live here in Highgate?"

"But ... but why did you not tell me?" My response was a mixture of excitement and annoyance.

"You are always in such a hurry," she sighed. "Always so afraid of wasting time. You have yet to understand that of all things we do not lack time. I meant to tell you soon enough."

"Well! What of these revenants? Shall I see them? Meet them?"

She moved quickly to her box and opened the lid.

"Can all your questions not wait until tomorrow?" she said carelessly. "Day has come and I want to rest."

"But when?" I persisted. "When shall I see them? Tell me when."

She hesitated, regarding me steadily for a moment, then she said:

"Tomorrow, if you wish it."

"Tomorrow! Yes, tomorrow!" I agreed eagerly as I watched her climb into her box and pull down the lid.

* * *

When we rose the next day it was already quite dark for the sun set early and fast on those bleak winter

afternoons. I tried at first to question Helena about the revenants, but she did not say much, only that I would see them myself soon enough.

At last we set out and she led me along the familiar lanes near the cemetery, then along quiet, deserted pathways, until at last we came to a large, isolated and dilapidated old house. A big rusty iron gate hung half-open on only one hinge, and inside the garden was so wild and overgrown that for the most part only the upper parts of the house were easily visible. We entered and made our way throught the dense bushes and trees, avoiding the leafless, claw-like branches that reached all about, becoming entangled with other branches as each tree and bush appeared to struggle against its neighbours for survival and supremacy. With difficulty we made our way around the side of the house.

At the back we came across two identical grey stone statues, old and weather-beaten; benign faced maidens who stood with their hands clasped in prayer and their empty eyes cast reverentially upward. Only their heads, shoulders and hands could be seen above the thick undergrowth that enveloped them, as they stood like forgotten sentries at some stone steps that rose out of the scrub behind them, and led up to the back entrance to the house.

We were following a narrow, irregular pathway, when I became suddenly aware that we were not alone: that others were moving nearby; dark shadowy figures that crept silently behind the thickets, observing us. Figures like the one I had disturbed in the bushes the night before: vague, indistinct

and apparently inhuman in shape. I was beginning to wonder somewhat nervously what manner of creatures these could be, when one of the figures loomed up before us like a cloud of black smoke. I stepped back with a start but Helena calmly stood her ground, until at last a lean white face apparently materialised out of the blackness, seeming to float in mid-air before us. Now more faces appeared, one by one, all around us, and at last I realised how the effect was achieved. These revenants – for such I now saw they were, four of them in all – were clad in black, hooded robes that entirely concealed their bodies and swirled all about them as they moved, blending with the dark to make them seem insubstantial and ghostly. Now they had all pulled back their hoods to expose their faces. I looked forward, fixing my eyes on the face in front.

It was the face of a woman of indeterminable age, gaunt but beautiful. The eyes were deep set and stone grey and very wide. Almost too wide for the narrow cheek bones. The nose was sharp, the mouth firm yet sensual; and the thick, dark brown hair was swept back in long waves from the high forehead. Her grave expression was then suddenly lightened by a smile.

"My dearest Helena," she said in hoarse but charming voice, tinged with a faint trace of some foreign accent. "But how wonderful it is that you should come to visit us here. It has been so long. So very long." And her smile broadened as she raised her arms so that the long black sleeves of her robe hung

down almost imperceptibly in the dark. "Gather around, my loves, gather around," she called softly, and the other white faces at once began to draw closer. "A friend," she went on. "It is a friend from long ago, come to visit us."

As the others gathered about I glanced around, studying each of them in turn. Two were young women of exquisite beauty. One a striking blonde with great blue eyes, and the other was darker even than Helena. Their loveliness seemed flawless, and I gazed from one to the other spellbound. Their companion was a youth, who looked to be no more than thirteen or fourteen, and he too possessed remarkable beauty: as fair as the blonde girl, with the same huge violet eyes – "the boy with a bright face and yellow hair" – in fact they might easily have been brother and sister. The youth walked towards me, studying me intently, his mouth fixed in a grin, his white teeth gleaming. He nodded to me, so that his great mane of hair fell down onto his face, and his expression told me that he recognised me from the previous night. His eyes unsettled me. They were deep and clever. There was nothing young or childlike about them. It was some time before it occurred to me that he was probably a very great deal older than myself.

"Here then is my family," said the first revenant, gesturing about her, "or at least part of it." And she went to the two females, standing between them, clasping them lovingly about their tiny waists, kissing their marble-like cheeks in turn: soft, lingering kisses. A faint smile of satisfaction showed on her face as she looked first at Helena, and then at me.

"Observe them," she said. "Admire them. Is it not the greatest of gifts to seek out such beauty? Such perfection. To discover it. And then to immortalise it."

The two girls began to laugh: soft, harmonious laughter. And the woman-revenant walked over to me, but her eyes were on Helena.

"But who is your companion, Helena? Will you not introduce us?"

"Of course. His name is John."

"John," she said, grasping my hand tightly, holding it to her breast as she bowed her handsome head gracefully. "You are most welcome here. I am Hermione." She looked up at Helena and the others. "Now! Let us go inside the house."

She led us along a winding pathway through the trees and shrubs, around onto the stone steps up to the house.

"You must forgive us our furtive welcome," she said, turning at the door to Helena and I. "But the others saw you first and informed me of your presence. It was only when I came out and recognised you, Helena, that it was safe for us to show ourselves. You understand that we must be careful to avoid the attention and intrusion of curious locals."

We entered the house. It seemed just as derelict inside as out. Cobwebs and thick layers of dust covered everything. Furnishings were sparse. All paint and paper had long since peeled from the walls. There were no carpets, just bare floorboards. However, we were led by Hermione down a narrow, rickety flight of stairs and through a door, then several

paces along a dingy passageway, until we came to another doorway covered by a drawn curtain. Reaching out, Hermione pulled the curtain open. Before us lay the cellar, which was square and very large, and to my astonishment as lavishly arrayed as a palace. Fine rugs, paintings and tapestries adorned the floor and walls. There were many beautifully preserved pieces of ancient furniture and strange and exotic ornaments. The whole place carried an opulence with a silent, timeless air of mystery that made it seem not unlike some esoteric temple of the orient. In the centre were a group of large, luxurious satin covered couches, like Roman banqueting couches, on which we all reclined.

I had no idea what to expect now, but nevertheless what happened was a surprise. We all simply sat there in silence. Something in me wanted to speak out, to ask questions, to discover more about these beautiful, fascinating creatures; but somehow the words would not come. I had always experienced a similar awkwardness when trying to ask Helena questions. With my powerful senses and feelings, which I could not yet properly understand or control, it was difficult trying to express anything adequately in words. Even now it is far from easy. But as I sat there with these others I felt that my thoughts were in some way shared, and in the silence my mind was suddenly filled with the most strange and abstruse ideas and images. I cannot really define or describe them, but for brief, fleeting moments it seemed my concepts of communication were changed: that speech and physical contact were

almost unnecessary. That in some ways we might be closer without them. It was as I tried to make some sense of this that Hermione clapped her hands and called out to her "family":

"Some entertainment, my loves. Some entertainment for the pleasure of our guests."

The two beautiful girls rose at once and crossed the cellar to a large, ornate bookcase. They took out several leather bound books and in turns proceeded to read out some of the most imaginative and disturbing literature ever produced by man: pieces by Dante, Milton, Coleridge, Byron and Poe; and a then lesser known writer whose works nevertheless seemed to me even more dark and disquieting that all the others: William Blake. But the dark girl began by quoting a traditional invocation to the ancient and dreadful deity Hecate: in legend the mother of lamias, queen of darkness, goddess of dark magic, death, and the shedding of blood, "who wanders amidst tombs in the night and thirsts for the blood and fear of mortal men". Yet this was spoken without seriousness or reverence, not as any kind of prayer but only as another reading.

All the while I simply sat and listened, absorbed wholly by the physical splendour of the readers, and their soft, dramatic, whispering voices that flowed past me, carrying me away to strange nether worlds of fantasy and imagery, reciting powerful passages from the "Inferno", "Paradise Lost", "The Ancient Mariner", "The Giaour", and others.

"The minds of men," remarked Hermione at some point in the midst of these readings with a low laugh.

"The darkest force of the earth. So much beauty. Such nameless dread. Such total confusion interspersed with shafts of such terrible clarity. Imaginings so dark as to be beyond the knowledge of any revenant. No black power can rival the thoughts of man. And why? Because man must live always in the path of advancing Death. We cannot know, cannot recall what it is to be pursued and hunted by Death. To feel our bodies infected by Him. To fear the dark unknown He brings. To sense His coming, brought nearer, ever nearer, with every heart-beat of life."

While the blonde girl read from Blake's "The Marriage of Heaven and Hell", another revenant entered silently. A dark haired man, very tall, and he too seemed young and handsome. He waited, standing in the shadows until the reading was finished, then he went at once to Helena, his long legs carrying him across the wide cellar in a few quick strides. He took both her hands in his and kissed them again and again, staring hard into her eyes for several moments, then he released her and turned to look at me.

"This is John!" Helena spoke to him for the first time.

He came over and sat on the couch beside me, staring at me, his eyes dark and piercing.

"Greetings to you, John," he said, leaning close to me, and his voice carried an accent similar to Hermione's – German, I thought, but I could not be sure. He continued: "I am Maximillian, and I hope we shall come to know each other well." And as he said this he turned to give Helena a wide grin. Then he

gestured to the fair haired youth, who sprawled languidly on the next couch.

"Music, Karl," he said. "Play for us. Sing for us."

The boy smiled, rose slowly, gracefully, and went over to where a lyre stood in a glass case nearby. He took up the instrument, then came to stand before us.

I cannot properly describe how he played. It was harsh, discordant and tuneless. Yet its melody was the most terrifyingly beautiful I believed I had ever heard. It conveyed stark desolation, a strangeness that seemed hardly real, yet profoundly unnerving. But for all this it utterly engrossed me, stirring in me a great and weird depth of feeling. And when he sang! His high pitched, echoing and totally inhuman voice rose and fell in irregular *crescendos*, chanting uneven verses slightly out of time with the music, which made the whole effect even more unsettling.

The verses related the story of a man, a magician of great knowledge and power who lived many centuries ago, and who learned the deepest secrets of life and death through commerce with unearthly forces. But at last this man fell into the hands of his enemies, who condemned and murdered him for his consorting with forbidden arts, then took his body and hung it on a gibbet. Yet by divination and discourse with spirits of prophecy, the magician had learned his fate; and thus it was that his followers came by dead of night, bearing his body away to a nearby tomb, where all lay prepared in accordance with their master's commands.

Now the followers assembled about the corpse,

laying it upon a sepulchre to perform the dread rite of necromancy, calling the spirit of their master from death, back into his mortal shell, that he might speak to them. Slowly, as the invocations were said, so the corpse was seen to stir amidst a sudden rushing of wind. Its eyes were opened, and the voice of the magician was raised from unmoving lips. The corpse let out a groan, then cried:

"*I thirst*! I feel that which was my body. It is wasted and dry. Give me blood to quench this thirst. Blood to strengthen the ritual of calling. Blood that I may find strength to speak."

It was known to all the followers that the power and energy discharged into the air by the shedding of blood would revitalize the manifestation of their master's spirit, and it was agreed between them that they should each give of their own bodies the offering required. So as their incantations rose, the first of them stepped from the protection of his magical circle and cut with sacrificial knife into the palm of his hand, pressing the flow of blood into the mouth of the corpse. Each follower did the same, until the voice of the magician rose up clearly.

The voice commended the followers for their faithfulness, then related how the magician had found his spirit consigned to the underworld to encounter Death, ruler of all earthly things, in the form of a vast and terrible monster with ravenous jaws. Now Death took him in its horrible maw and bore him away into the depths of a giant abyss; past towering ranges of black mountains belching smoke and fire, through Cyclopean structures of timeless stone, until

the magician was abandoned in what he knew to be Death's deepest realm. Even within the Stygian gloom he could glimpse strangely as a vision within his mind swarms of hellish spirits filled with endless malignity; insubstantial creatures which crouched and gibbered upon thrones of skulls above a great river of blood, from which the hands of the damned reached out in hopeless anguish.

The spirits cried out now, gloating in monstrous anticipation, as they took the magician and hurled him before a shadowy presence. This was the same familiar spirit whom the magician had, in his mortal life, summoned often into bondage upon the earth, to serve his hunger for knowledge and power. Now their roles were reversed, for the magician found himself held in subjugation before the dark spirit; and as once the spirit had been compelled to grant the magician knowledge of the lands of the dead, so now was the magician commanded to answer the spirit's questions upon the world of the living.

Now the corpse of the magician fell silent.

"Master," the foremost among his followers said, "what knowledge did the spirit seek?"

"I grow weak," the corpse said. "I must go back into darkness. But return you tomorrow at midnight and repeat the ritual. Summon me again, and give further offerings of your blood, that in exchange I might speak more of these things."

So the next night they returned as their master bade them. The corpse was once again imbued with life, with the voice of the magician, who demanded offering of their blood; and the shrivelled and

decaying body stirred, and this time raised its hands to hold their wrists and drink from each one, feebly pressing their wounds to its dry lips. Once more, the magician began to speak with revived strength.

"The dark spirit sought knowledge of human life," said the corpse. "Of what it is to breathe, and touch and feel. To know sorrow and joy and love. For the angels of Hell are charged to confine and bring suffering upon damned souls. This they are charged to do by God."

"What is the manner of suffering in Hell?" asked the magician's apprentice.

"Memories of flesh!" the voice within the corpse cried. "Phantom pains of sorrow and regret, which are the absence of happiness and hope. Agonies which persist while the flesh is gone. For in Hell there is only pain, but those spirits which are Hell's wardens are granted one privilege: to feel nothing. Eternally nothing. They are immune to all pain, but devoid of all feelings. And they despise human souls for their memories of flesh."

So their discourse continued into the night, delving into many dark mysteries, the magician's spirit serving as a conduit into Hell itself, until at last it bade them once more to return again the following night.

The followers were now aware that their strength was becoming drained, yet such was the temptation of the knowledge the magician's spirit imparted that they could not refuse him.

The third night they carried out the ritual again, and this time the corpse sat upright upon its slab,

embracing each of the followers in turn as it clung to their bodies and drank deeply of their blood. Until at last the followers themselves seemed each as wasted and pale as the corpse had been, and matters between them were reversed, for the body of the magician was restored to new life, its wounds healed, while it glowed with vigour and strength.

Then the revenant stood up before them and spoke, while its voice seemed strangely powerful and resonant, for it possessed at once a strong echo which was unlike the voice of the magician himself, but seemed like two voices that spoke as one.

"Now," it said, "we shall know eternal life and eternal flesh. We shall belong to neither death nor life, and shall carry the retributions of Hell into the world of men. You too, our disciples, may elude Death evermore, if you will give us always offerings of blood."

The followers lay now in exhaustion, and said that they had no more blood to give, or they would surely die.

"In death there will be life!" the revenant replied. "Go into the world of men! Find offering there – eternal blood sacrifice in our honour – that our pact may be sealed."

Thus was born the first of revenants – the Master-Revenant – and his children.

This story alarmed me deeply, with its dark and sinister allusions, for it seemed to me that every wild legend was based upon some initial truth. But then Maximillian leaned close to me, smiling, and said:

"An amusing tale. You see. Even we have our myths and fables. Even we."

I nodded, but felt the need to question him further, when the boy Karl struck at his lyre again, and sang out louder than before.

"Wanderers in the realms of time,
Travellers in infinity,
Souls which may forever thrive,
And fear not man, nor God, nor Death.

"We are as Olympians
That feed on nectar,
Warm sweet draught of death,
Dark wine of immortality.

"O Tyrant Death! That everywhere
Asserts His harsh despotic sway,
We know Him well, His chosen few,
And yet He knows us not.

"He knows us not for we alone
May live beyond His cold embrace,
Yet time and time we take Him
As a lover in our arms.

"Death our slave,
We alone have conquered Thee,
Have brought Thee to subjection,
May touch Thee with impunity.

"We are the masters,
Haunters of the night,
Rulers of the tomb,
We are the Lords of Death."

More verses followed. I cannot remember them, only the effect they had on me as the singing and playing became more frantic and intense, more harsh upon my ear and soul. I was infected by a growing sense of upheaval and conflict inside: part of me was distressed by this bizarre cacophany, yet part of me greatly excited: yet through my confusion I saw no reason why I should feel anything in particular. I glanced once over at Helena, who looked back at me, apparently unmoved by the performance. And all the while I felt the dark eyes of Maximillian upon me, though for some reason I could not bring myself to look back at him. And when the final piping *cadenza* of "We are the Lords of Death" came, I felt a sense of relief, but then also of renewed discomfort.

"Now!" said Maximillian at last, looking all about him as he stood, his smile gradually broadening as his eyes came to rest on Helena. "All is ready."

Everyone rose, and the two girls came to me, smiling and laughing, placing their hands on my shoulders, guiding me up the cellar stairs, following Maximillian and Hermione.

"What now? Where are we going?" I asked one of them. Her smile widened and her pupils dilated, but she said nothing.

We continued climbing to the upper reaches of the house, and stopped at last outside an attic door.

Maximillian turned and gazed at me intently for a moment, then he moved forward, pushing the door slightly ajar and glancing through. He turned back again.

"Go!" he said softly. "You may begin." His manner was solemn. He possessed none of the sudden excitement that seemed to have infected his companions.

The revenants stepped forward as one, their eyes upon the door. Maximillian pushed it wider open, then stood aside. I followed the others curiously, straining to see past them into the room. Inside were a human couple, sitting on chairs by an empty table; a young man and woman wearing poor, ragged clothes, with thin, haggard faces. Couples like this, hungry and penniless, were to be found all over London then, and could easily be enticed with promises of food, shelter or employment.

Slowly the revenants filed one by one into the room, and stood in a row before the wretched couple, staring upon them, silent and still. At last Maximillian followed them, leaving me alone on the threshold. For it was only now I realised that Helena was gone. But for the moment I was too intent on seeing what was happening inside the room to try and find out where she might be.

The human couple were visibly startled to find themselves confronted by these pale, beautiful strangers. The man looked up at Maximillian with some relief, for it was evidently he who had brought them there. At last he said in a stammering voice:

"Might we . . . I mean . . . might you be so kind, sir,

as to tell us some of the duties we should be called on to perform, sir, in the position you have in mind for us?"

The revenants remained silently staring. Now the woman grew frightened and whimpered slightly. The man at once reached out and gripped her hand, his eyes bewildered and fearful as he looked up at the row of white, expressionless faces.

"Is . . . is anything the matter, sir?" he stammered, swallowing hard. Still there was no reply.

By this time both had realised that something was wrong. The man stood up, and helped the woman to her feet.

"I think . . . I think we must go, sir. I think there has been a mistake . . . "

"Possibly!" agreed Maximillian, moving to him, placing a hand on his shoulder, his face full of mock concern. "It is possible that you have made a mistake. Oh, yes. Yes. I should say that is very possible. I have made none. I said I needed you. And so I do. As for your duties," he grinned, "you will see them soon enough." And he laughed, an ugly, exaggerated laugh.

Now the woman burst into frightened sobs and the man grew angry.

"Stand aside," he told Maximillian, his eyes wide, his fists clenching. "You've got no call to treat us like this. We don't want the job now. We want to go."

"Oh! You want to go. You don't want the job anymore. Well, I must admit that most people would not regard it as the ideal position." Maximillian smiled and nodded gently. Then he reached out and

grasped the woman's bodice, ripping it quickly to expose one of her small white breasts. She screamed and tried to force his hand away as the man bellowed in fury and lunged, fists flailing, at Maximillian, who eluded him effortlessly, then with a contemptuous grin grasped him about the neck and threw him heavily to the floor. The woman screamed again and Hermione moved behind her, grabbing her and hurling her down beside her husband. Now both Maximillian and Hermione stepped back, allowing the terror stricken couple to struggle to their feet, making no more moves towards them, as if inviting them to run and escape. Desperately the man looked all about him. Behind him, on the far side of the small attic room, was another door. Grasping his half senseless wife he pulled her to the door and threw it open.

At once the room was flooded with the sickening stench of decaying flesh. Beyond the door was another small room, and there, slumped on the floor inside lay the withered, naked corpse of a man dead for several days. The throat had been brutally slashed and was caked with black dried blood. The eyes were wide open, frozen in a dreadful expression of final pain and anguish, and the face was swollen and black while the mouth hung open, filled with blood. Behind lay two other corpses in a similar state of mutilation.

The human couple stumbled back, clinging to each other for support, gagging at the foul smell, then collapsed together onto the floor to the accompaniment of echoing ripples of cold laughter, filling the

chamber. And I heard Maximillian speak in a low hissing whisper.

"Now they see their heritage. Know their fear. Their despair. Their hopelessness. The horror of death. Feel it. Taste it."

Now the revenants closed in, running their hands over the faces and bodies of their helpless victims. And in the midst of it all the man clutched at the woman and began to cry: great rolling sobs, calling on God to help and save him, which only delighted his oppressors all the more, raising them to what seemed a kind of delirious ecstasy.

Maximillian's voice boomed out now all about the room.

"*You fool!*" he cried, his tone on the verge of gleeful laughter. "There is no God! There is no help! *There is only death!* Show them, my loves. Show them their birthright. Show them their destiny."

All this time I had stood, knowing what must happen, yet rooted to the spot by some macabre and numbing sense of fascination. Now at last feeling flooded back and at once I turned away with a cry. At once Maximillian was standing beside me.

"Join them if you will!" he said blandly with a graceful gesture towards the hideous proceedings. I gazed up at him speechless. He arched his dark eyebrows. "It is the only way. The only way we may understand men. Understand death. Understand ourselves."

I shut my eyes. I could not speak. To kill the innocent was bad enought, but to precede it with this evil and brutal terrorising – this was monstrous

beyond belief. Maximillian drew closer to me and said:

"Do not be shocked. Can you not see? This is the reality of our lives. This is the ultimate beauty. Try to understand." He wrinkled his lips in a slight expression of contempt. "Through those creatures" – he pointed casually to the struggling victims – "we may know death. We may feel again the moments of death and of rebirth. We may know the fear, the desperate but – ah! – so useless struggle for life. And then the final sublime experience of death itself. The death we bring. Our minds, our souls, become joined in death to our victims. Through them we may journey beyond life itself, pressing farther and deeper into the unknown realms with every life we take. Oh! But you cannot know, cannot begin to imagine the power, the vision, the excitement – *to experience death when you cannot die!*"

Behind all my dread and disgust I understood him totally. I remembered how, in that instant I had become what I was, and again when I had taken the life of the young prostitute, I had known Death; glimpsed for the briefest moment the vast, fabulous regions that were but the beginnings of His Empire. I saw now that I had barely yet begun to realise the true experience of taking life.

Slowly I glanced back inside the room. The boy-revenant and the fair girl were crouched over the prostrate body of the woman, while Hermione held the fainting man from behind and the dark girl clung to his chest. Their lips were red and their bodies quivered as they glutted themselves; their gaunt,

beautiful features transformed, made gross and vile with their pleasure. But their eyes were blank – cold and ruthless – devoid of emotion like the eyes of mindless ravaging sharks. And it was a terrible, tragic sight, to watch the pink, glowing bodies of the humans turn gradually withered and white, as their life flowed away to bloat and colour the wan, bestial faces of the revenants who had before seemed to me almost god-like. But the worst, the most obscene thing of all! The poor victims, dazed and overcome beyond any further power to struggle: for all their terror and distress their bodies were excited. They were physically aroused. I turned away, burning with a horror, anger and indignation I cannot describe.

"Come along!" Maximillian was leading me away now, pulling me by the arm, taking me downstairs again. He led me to a small door and, taking a key, unlocked it and pushed it open. He pointed inside. It was a cupboard, dark and cold, and sitting inside, hunched in a corner, for there was no room to stand, was an infant, a tiny fair haired boy who looked up at us, his eyes red and dull with fear and misery. He began to cry and plead to be released, but Maximillian paid him no more notice than the attendants in a slaughter house might give a bleating animal. He simply turned to me and said with a mischievous smile:

"I save the best for myself." And then he said: "Take the child with me. Let us know death together."

A cry escaped my lips. I could take no more. I knew only that I had to get away from that place. I ran, through the hall to the back door, and I heard

111

Maximillian coming after me, calling to me in that strange whisper that echoed in my head and would not cease, even when I covered my ears with my hands in desperation.

"Wait!" he called. "Stop. Listen to me."

I threw open the door and ran into the garden, blundering into the bushes, battling my way through branches that reached out, scratching my face and clawing at my clothes. Maximillian's hands grabbed my arms, pulling me back. We struggled for a moment but his grip was unbreakable, so I turned to face him. His black eyes stared into mine, and I could not help thinking for a moment that there seemed much sadness there.

"Why do you run? Is it really because what you have seen appals you? You should have seen yourself in there, John. You should see yourself now. Your eyes gleam. Your limbs tremble. You are excited. Excited nearly beyond your control."

I wanted to shout at him, to tell him he was mad, but the muscles in my throat tightened, the words would not come, and I just groaned.

"It is true," he went on. "You cannot deceive me. You cannot even deceive yourself."

I turned from him. I hated him. He pulled me back to face him.

"Do you not understand? Do you truly not understand? Can you not see why Helena brought you here? Your reaction. Your fear. Your revulsion. They are as she intends."

I stared at him stupidly. I was almost beyond any state of reason.

"You are yet very young," he sighed. "You do not begin to understand the endless life that is yours. You are still frightened by what you must do to live. And Helena must keep it so, or she knows she will lose you." He studied me closely and smiled, as if at some grim secret joke. "There is much you should learn about Helena," he said. "Much indeed." He shook his head and his face grew grim again. "But I will tell you this much. She denies all that is natural in herself, but can no longer bear her deprivation, or the anguish it brings, alone. And so she will burden you with a conscience that is redundant and useless to you. She will bind you to her in an eternity of torment."

"No!" At last I found my voice. "She allows me to choose . . . "

"Choose!" He cut me off with a loud laugh. "Indeed! But I see she has you firmly in her power. You do not feel her fetters about you."

"No!" I cried again in fury.

"Listen to me. I have lived longer than you. Longer than Helena." He drew a deep breath. "It was I who initiated Helena. She is my daughter. You are my son."

A shudder passed through me. He saw the horror in my eyes and laughed again, but this time it was a cold, hurt laugh.

"I was betrothed to her. I installed myself into the graces of her family. I find such games amusing. And then I took her for myself from under their eyes. I wanted her for her beauty. For all her remarkable qualities. But at last her qualities proved too

remarkable for her own good. In truth she knows, as you know, that the greatest compulsion, the ultimate satisfaction and excitement, is to kill. For men as well as for our own kind. But men must have doubts, must invent trite standards and laws which are unnatural, to compensate their mortality: fostered by their fear of death and the vengeance of God. We are different. For us desire is the only law. Desire and nature – they are one. How could they be separate? And to suppress desire is to give it unendurable strength. This is true in the space of a human life-time – in the space of a year – even days. Then how much stronger, how much more unendurable do these desires became in immortality? Can you imagine the torture? And the sheer destructive force when the hidden passions of centuries can no longer be contained and break free. All the vast power of Nature herself. Do not allow such evil to build up in yourself, my friend. For in the end it will crush and trample your poor scruples underfoot without mercy or restraint, and breed horrors beside which the things you have seen this night will seem insignificant. The poet Blake expressed it clearly in his 'Proverbs of Hell', which we heard tonight.

'Sooner murder an infant in its cradle than nurse unacted desires'."

"Blake was in many ways a man of great penetration. More, I think, than he himself could always have known. Some believed his works to have been inspired by the Devil. Think of it! A man unafraid of his own imagination. He might have made an admirable revenant." He nodded slowly then went on: "All

life must feed upon life. And if beast and bird and crops in the field grow on the earth to glut the appetites of men, then what should be the purpose of men but to satisfy the needs of we who are more than men?"

Tears were welling in my eyes now; tears of hopelessness and misery. I could not bring myself to listen to any more of this. But I could not break free from his terrible grip.

"I must go now!" I said at last, my tone low and trembling.

"Go!" he said. "But remember there will be nothing for you. Not the way you have chosen. Your existence will become a timeless torment. A curse that cannot be ended. A Hell of your own making. Will you breed your own children? Time will come when you wish to. Or you will find beauty and love and watch it fade into death and decay, leaving you to face the centuries alone. It is only our power to preserve these things, that they will exist with us forever, that makes our lives a blessing, not a torture. But you will lose your children. Or you will exist with them in strife and hatred when you try to bind them with your own outworn and misguided conceptions – the miserable remnants of your lost humanity."

At last he let me go and I stood for a moment looking at him. A tear ran down my cheek and I felt like a foolish humiliated child. Then I turned and went, wading through the bracken. Maximillian's whisper continued to ring in my ears, even after I had left him far behind.

"Go and learn," he said. "We must each find our own path through infinity. But when you have learned, as you surely must, return to me. I will teach you."

VIII

I ran blindly until at last Maximillian's ghostly whispers faded into silence. But the memory of his dismal, frightening words remained, echoing relentlessly in the mind. Suddenly I stopped and stood still, staring ahead. Although I could not see her I knew at once that Helena was there, watching and waiting for me. Anger flared in me now. Anger and hurt as I saw how she had used my trust and dependence to lure me unsuspecting into that terrible encounter. I was in a frenzy of confusion and fear. I did not know what to think or believe. I remembered all that Maximillian had said or implied about Helena and began to wonder if it might be true. Whatever else he might be, I could not believe Maximillian a fool. And what reason had he to lie to me? I shook my head, my thoughts vague and spinning, then, half-mad with fury and grief I shouted into the dark:

"Keep away! Keep away from me! Leave me alone!"

I hurried on through the cold night without any sense of direction or purpose; like Jan Tregeagle, pursued by devils in old Sally's tales, my own devils of doubt, fear and misery hard on my heels.

My head hanging, my eyes cast down, I felt rather than saw people passing all about me as I drifted on towards town. At last it began to snow, and it grew heavier as a bitter wind rose and swirled the flakes

about me, until at last it seemed like a spinning white fog. I walked on barely able to see anything around me, beginning to know some of the blindness and helplessness men feel in darkness: feelings I had all but forgotten in recent months. At once I turned up my collar and pulled my coat tight about me, though in truth the cold meant nothing to me. Passers-by loomed out of the clouds of white, then faded back into them, and a feeling of utter hopelessness engulfed me as at last began those first dreadful pangs of hunger.

Then I heard footsteps behind me and stepped to one side, to see the vague figure of a man walk past. My need to feed was growing strong and I followed, stalking him instinctively. He went very slowly and carefully. I could easily have caught him, and the falling snow yielded perfect cover in which to take him, but for some reason I held back.

I moved after him, keeping him just in sight until at last he stopped outside a doorway, produced a key and leaned down, searching for the lock in the gloom. I crept up silently behind, ready to pounce before he opened the door, but again at the last moment I hesitated. He pushed the door open, stepping inside as a flood of light and warmth came out. Then he turned and saw me. He looked at me, smiling, trying to make me out through the screen of drifting snowflakes, with no apparent surprise at my being there. He was young with dark, straight hair and a pleasant, bright face. I stood rigid, staring back, more startled than he.

"You look lost," he said then in a friendly tone. I made no reply. "Are you lost?" he persisted.

"Yes," I mumbled at last. "Yes. I am lost."

"I'm not surprised," he grinned. "I'm lucky to have found my own way home. Where are you trying to get to?"

"Nowhere," I answered at last. "It doesn't matter."

"Well," he said, "that's about the only place you will get for the time being." He hesitated a moment, and seemed about to close the door, but then he said: "You're welcome to come inside for a while. Until the snow stops. This is no night to be wandering about lost on the streets."

I nodded and thanked him, stepping through the door and following him inside. I could not really explain it, but at once I felt a powerful sense of attraction to this bright, cosy dwelling – I, who was by now well accustomed to the cold and dark.

He took me along a narrow passageway to his rooms, which were small and basically furnished but filled with books, on bookshelves all about the walls and in several piles in the corners. I guessed he must be a student of some sort. He lit a lamp, then started a fire, after ushering me into a chair. Then he removed his hat and coat and sat opposite me. For a few moments we sat in silence, and I stared at the floor, my mind still vacant and numb. Then he began to talk. I cannot remember the things he talked about, for I was too absorbed in myself, and just sat and allowed him to run on uninterrupted, hardly listening to what he said. And yet his voice, his smile, his very presence brought me comfort and reassurance. He seemed warm, straightforward and friendly.

And his manner brought home to me the thought that never in the past had I truly known friendship – equal friendship with someone my own age. And I stared at him as he sat finding trivial things to talk about. But what he said seemed barely important. It was so long since I had had any kind of conversation with anyone. It was so different from Helena's aloofness and distance. Suddenly he laughed, and I, not even knowing why, laughed with him. And as I did so I felt inside a vague, wistful stirring of half-known and half-forgotten things. Of things I had never known, and of things I had, but that I hardly remembered since in human life they had always seemed so plain and commonplace. Things a whole existence away, denied me now forever.

And this ordinary young man seemed to me at once like the inhabitant of a strange and wonderful land that I had never known or seen, his life a marvellous and intriguing adventure beyond my every experience. I longed to ask him questions. To ask him to describe the simplest things. What it was to walk in a fragrant garden while birds sang and the sun burned down bringing everything to bloom. What it was to know companionship, careless laughter, contentment and belonging. To know the intimate, loving touch of a woman. And the knowledge of death, which binds men close. I longed to throw my arm about him, to sweep him out into the city streets and walk with him as he explained these things to me. To move in the world of men and to feel through him once more a part of it. But how could I? It was too late. It was hopeless.

And I sat and smiled pleasantly at him as an over-powering rage rose inside me and I shuddered with grief, and a voice in my head seemed to roar: "What have you done? Forsaken a life whose pleasures and rewards you in your blindness never began to see. And to have forsaken it for what? An existence that is endless darkness and death. Eternal destruction and misery."

And I thought with contempt of Maximillian and Hermione and their foul brood, who called themselves gods when they were maggots who crawled and fed in stench and gore. And then I thought of Helena. Helena, who had deceived me and robbed me of life and hope. And it was all I could do to prevent myself falling on the floor, pounding my fists and screaming in a fit of sheer desolation. Instead I told myself:

"The Devil take them all. I am finished with them. Finished with her. I will not live with her in darkness and despair. I will find some other way. I want never to see her again."

"But really, you must forgive me," said the young man suddenly. "I've been talking far too much. A bad habit of mine, I'm afraid. I apologise if I've been tedious."

"Tedious!" I said. If only I could have begun to tell him. "No. Not tedious. Not to me."

"But tell me something about yourself," he went on.

"Me? No. No. There is really nothing to tell."

"I can't believe that," he said, raising an eyebrow slightly.

I gazed at him hard and smiled. It had just occurred to me that the hunger which first drove me to follow him had, in the course of our conversation, been forgotten. He said at last:

"Why do you stare at me so?"

I lowered my eyes, at once embarrassed.

"I am sorry," I said. "It is just that . . . that you remind me of someone. Someone I knew once. Someone who is no more. Only you are better than he was."

He smiled quickly, then jumped to his feet and said:

"But I've been a poor host. Here you've been, wandering lost in the cold, and I've not even offered you any refreshment. I won't be long."

Before I could say a word he disappeared into an adjoining room. Once alone I grew restless, and rose to pace about the floor. I stopped then by the bookshelves and began to scan their contents. There were volumes of poetry and literature, ancient and modern, as well as works on religion, philosophy, science and history. At last I reached out and removed a heavy book, that seemed to draw me to it in spite of myself, on the subject of demonology. I began to thumb through it quickly, more through nervous agitation than any real interest. There were many ancient, crude pictures, representing all manner of things dark and disturbing. One showed the figure of Death, clad in black robes, His face a grinning skull as He moved through the world, leaving His indiscriminate victims all about: the prostrate corpses of kings and beggars, saints and sinners, the old and the

young alike. He reached out His skeletal hand to touch one amidst a crowd of travellers who laughed and revelled together, and only the one He touched saw Him and fell, his face twisted with terror.

Another, amidst an account of the hierarchy of devils, showed grotesque, gloating fiends torturing, mutilating and devouring writhing, screaming masses of the naked damned in the fires of Hell.

Next I saw the representation of a woman seized by demonic possession, her body twisted as she tore at her clothes and dug her nails deep into her breasts, her face horribly distorted, her eyes bulging and her tongue lolling. I slammed the book shut so that clouds of dust rose swirling from its yellowing pages. Then I asked myself: did such things truly exist – demon and elemental creatures, without material form, circling in the atmosphere like predatory birds, seeking some entry into the physical world? Was it possible for such entities to inhabit and possess a body at the moment of death? To keep it from decay and animate it that it might appear to be human, a cold husk immune to ageing, to all living infection or disease. To death itself. But worst and cruellest of all that the human soul should remain, trapped in its earthly shell, as unnatural an intruder there as the evil itself, and must watch on, tortured and power-less, while that evil drives it to create relentless destruction and terror.

I returned the book to its shelf and began to pace up and down once again. I was thinking of all I had seen that night; of what Maximillian had told me of desire and its suppression, and remembered how,

helpless in the grip of a raging passion, I had com-
mitted murder. A renewed and overpowering sense of
dread and disquiet fell over me. I thought on that
terrible story the boy-revenant had related in his
song: of the first revenant, and his bargain with
infernal forces. Could there be some truth behind it?
Could I, in my human misery and weakness, and my
longing to escape it, have made myself in some way
vulnerable to the powers of darkness? Some submis-
sion, some unspoken spiritual pact with these powers
that doomed me forever to their arbitrary domin-
ation and control.

These things were like archaic superstitions, but
all the more ominous and frightening for that. At
once I felt the need to run, as I had been running
since I left the house of Maximillian: running from
something, a part of myself, unknown and unnamed.
I made for the door, when my young host re-entered,
carrying two cups. He saw my hand reaching for the
door, and setting down the cups came over to me and
placed one hand on my outstretched arm.

"What is it?" he said. "What distresses you so?"

"Distresses me?" I repeated slowly. "Distresses
me? Why do you think me distressed?"

"It isn't difficult to see," he answered gently.

I looked up at him, confused. For the moment he
disturbed me, stopped me from thinking, from rec-
ognising thoughts that were for now just noises in my
head: angry, growling and indistinct. I stared all
about the room, then back at him, into his eyes.
They seemed filled with real concern.

"Will it help," he said, "to talk about it?"

He had seen my need even before I had. I wanted to tell him. I needed to talk, to be freed at last from my terrible burden of loneliness. To break away all the barriers and confide in him totally. But how could I? It was impossible. He would think me mad. Or worse. If he believed me, he would shrink from me in loathing and terror. There was only one way I might feel again his alluring human life. And that was to end it. To pull him to me and absorb myself in him for a few brief moments. We might share nothing but his death. A bitter sorrow came over me as all this grew clear to underlying, half-known senses. I turned from him, pulling open the door. But he darted forward, grasping my wrists, and I did not resist him as he pulled me back to face him.

"It won't help," he said. "Solitude. It will only make it worse. It won't do you any good to wander about the streets on your own."

It was at this moment that my hunger returned, harsh and biting. So great and unexpected was it that I gasped and doubled over slightly.

"What is it?" he said. "What's wrong with you? Are you ill?"

He took both my arms to support me. I looked up at him, felt his concern, his closeness, his warmth. I straightened up slowly. All thought and worry dissolved from my mind, and instead was only a blind need. Involuntarily my lips parted and I drew them back, grinning at him as I edged forward, grabbing his hands, pulling him to me as my breaths came in great, trembling gulps, and the muscles in my throat grew rigid and tense. He stood and watched me, as if

transfixed for the moment by my gaze. Then his eyes grew wider and his face contorted with stark fear. We struggled, and he stumbled back, pulling me with him, unable to break my grip. We wrestled for a few moments, but for all my hunger there was still a strange reluctance in me. Then as I spun him about I looked up and saw for an instant my own reflection in a small mirror that hung on the opposite wall. I barely recognised myself. Every trace of humanity was gone from my face, hidden beneath a dreadful, pallid mask of hunger and madness, gaunt and skull-like, my eyes sunken and glaring in the dull light. So startled was I by this that I ceased to fight, and he pulled free, toppling back against the wall. Then he cried out with all his strength. This shocked me, brought me back to my senses.

"*Stop it*!" I hissed in alarm. "*Be quiet*! You'll bring everyone in the street!" A foolish thing to say, indeed, since this was plainly his intention, and a reasonable one at that.

He cried out again, louder still, and I turned and ran, along the passageway and out the front door. By now the snow had almost stopped, but it lay heavy all about, and I stumbled through it down a narrow, empty street nearby. I went on down this back-street, down towards the river past dark dirty slums, where the bricks and pavements stank of squalor and urine, even though covered with snow, growing more noisome and oppressive with every step I took. And still my head swam and I ran, not looking where I went, until at last I blundered into a pile of wooden boxes outside a dirty shack, knocking them down

and slipping over, crashing into the soft snow. I went to rise, leaning up, but my mental turmoil overcame me, draining my strength, and I sank back down again.

Then from somewhere nearby came a faint whisper that in the still and quiet I heard clearly.

"'Ere," it said, 'wot's 'e doin' 'round 'ere?"

Another whisper responded.

"Look at 'im. Drunk out of 'is 'ead."

"Rich, an' all, by the look of 'im," said a third.

There was a low chuckle.

"Looks like it's our lucky night."

Then there were footsteps approaching, crunching in the snow. Slowly I climbed to my feet. Three ragged men stood before me. I stared at them dully, and they back at me.

"Garn," said one at last to him companions. "Get 'im. 'E's too dead drunk to make any trouble."

I prepared to run. I often drifted through such wretched poverty stricken areas as this, where it was poorly lit, densely populated, and easy for me to feed; and it was not uncommon to find myself followed by one or more of the scores of sinister figures that lurked behind every dark corner, lured by my good clothes and the promise they gave of a full purse. Of course these cut-throats never represented any threat to me. I could lose them without effort in the night lanes – although to lose them was usually the last of my intentions. Now one of the men, the biggest, came at me. I watched him closely, making ready to evade him and escape. But I did not. I stood and watched him advance. I would run no more. I was

tired of running. My attacker drew close. He was huge, towering above me, and broad: a great brute of a man, with a leering mouth, thick arms and a bull neck. His small eyes glistened malevolently as he raised his massive fist, ready to bring it crashing down onto me. I watched the fist descend, and to my eyes the movement seemed so cumbersome and slow I nearly laughed up into his idiot face before reaching out to intercept it. I caught his wrist and held his arm, suspended above me, heard him gasp and felt his shudder at the coldness and strength of my grip. Slowly I tightened my hold, twisting his arm, and watched enthralled as the expression upon his coarse features turned from arrogance to panic and fear. I felt his limbs stiffen and his strength crumble before me. Then his legs gave way and he sank wailing like a child to his knees, grimacing in pain and shock. A tremor went through me as I looked at him, writhing abject and helpless. I was going to kill him. I wanted to kill him. The raging hunger was in me, and now I would not resist it. I wanted to kill! To immerse myself in death, to swallow up all my fear and confusion in sensual oblivion. For my every sense was alive and ready, and power pounded in me. The power of the night, to be suppressed and denied no longer. Power to be released.

My eyes blazed and his were dull, mesmerised with fright. I bared my teeth in a great snarl of excitement and rage. My hand slammed into his face, hurling him back, rolling him over and over across the ground. The air was saturated with the scent of blood, filling my senses, wiping away what remained

of my reason so that I stood growling and grinning like some maddened animal.

Another of the men drew a knife now and charged at me in panic. I faced him, waiting until he was upon me, then moved forward and pulled him to me with such speed that his knife swiped the air behind me. I pushed my face close to his and felt his strength fail as I looked into his eyes, gloating and savouring the moment of terror I inspired before tearing his throat, tasting the fount of blood that poured out, then hurling his body to the ground.

The last of them cried out and turned to scramble away blindly. He made no more than a few steps before I was on him, gripping his shoulders, pulling him down. He went to scream, but only gurgled as I pulled him to me and pinned him down, as his warmth and life flowed through me.

We lay there until I felt once more the rigid, final shudders of death against me, beyond the great spasms of pleasure and swirling visions that accompanied them. Then I threw his limp body aside and rose unsteadily. The big man, the one I had struck down first, was on his feet again: stumbling, half-conscious, his smashed face a mask of dripping blood. I reached him before he saw me and grasped him about the neck, my hunger for death even yet unsated. In an instant I ripped his throat, and he dropped to the ground with a crash.

I leaned down, grabbing his head, twisting it to face me, staring into the wide, lifeless eyes.

"Lucky," I said, blood welling from my mouth, running down my chin, "is not the word I would

have used!" Then I sank down to my knees, my head spinning wildly.

I knelt for several moments, breathing hard and deep as my savage fit passed rapidly into drowsy bewilderment, as if emerging from a trance. The madness, the awful lust that had plagued and pursued me since I had witnessed the horrors at Maximillian's house, was gone.

Suddenly there were footsteps running all about. I looked up to see a crowd of men with lamps standing nearby.

"There he is," cried one of them. "There's the madman. There's the murderer."

The young man whose home I had run from must have alerted his neighbours. And of course it would have been easy to follow my tracks in the fresh snow. I watched them, blinking, dazed, as they moved in a single mass towards me. Then there were gasps, screams of disgust and outrage as they saw the bodies of my attackers. Then they looked at me in total horror as I rose to my feet. And indeed I must have been a fearful sight, gorged and smothered in blood.

A cry of "Murder" echoed all about me, and at once four big men moved out of the crowd and stood before me. Others moved up behind them, their eyes glaring with menace as together, warily, they began to advance on me.

I stood and watched them stupidly. My head still spun, my vision still blurred. Bloated, half-numb with shock, I had no strength left to fight them, no presence of mind even to escape. I could only look down at the victims of my rage and reflect that they

were right to fear and despise me so. I had destroyed not for my protection, but from sheer intoxication with my own power – I, the weakling, the invalid. I had been as a mad dog.

Strong hands suddenly grasped me from behind, and the men in front rushed me. They were blind and mad with hate, but I, knowing how totally I deserved it, merely submitted to them. They grabbed at me and struck me, and I was lifted from my feet as they swarmed all about me; howling, punching and clawing, tearing at my clothes and hair. I knew that they meant to kill me. What I did not know was whether they could.

Then at once they were gone, letting me fall heavily to the ground. I looked up in weary surprise. The small crowd stood, their faces frozen, their eyes wide and gaping as they stared beyond me, as if they had all quite forgotten me. Slowly I turned my head. My body jolted with shock. From out of the shadows behind had emerged a terrible form. Its eyes blazed and its features were livid with horrible fury. It advanced swiftly, its teeth bared, its arms outstretched, hands clenched like talons ready to grab and tear at anything in reach. It was several moments before I realised it was Helena.

She stood above me, snarling and spitting like a harpy, or some awful demonic image from a medieval tapestry, glaring upon the petrified crowd. And then all her fury was gone, and in an instant she was transformed from raging fiend into cold, arrogant beauty. She spoke, her tone soft but all the more deadly for that as it cut through the night air.

"The first of you to move," she said, "will die. As they died." And she swept out her arm in a gesture towards the mutilated bodies.

She reached down, taking my arm, pulling me to my feet. As I rose I felt a trickle of blood fall from a cut on my lip. But I felt no pain or injury. Apart from a few scratches I was unhurt. Now Helena pushed me forward, past the staring crowd that stumbled back to let us pass. And so we moved unmolested through that jungle of stupefied eyes that looked on me as the eyes of that young man had: that saw Helena and I for what we were – unnatural and inhuman – and could not bear what they saw. It was now at last that I understood why Helena had made me what I was: the utter loneliness and misery that must have driven her to it. And I remembered what Maximillian had told me: that we might find human love or companionship only to watch it shrivel and die. It was only now that I saw beneath those words and understood them totally. Together we moved swiftly away into the dark lanes.

* * *

We walked for some time without speaking, down by the river. At last Helena said:

"There is nothing for us there. With them. Only hatred. Only pain. We are death to them. And they cannot endure the knowledge of us."

She stared hard at me and her voice trembled slightly, as if from some dreadful secret memory.

I said nothing. A dark cloud of fear had been released that night from some corner of my mind,

and consciously I refused to stifle it. It might have been possible to do so, and that in itself was the most frightening thing of all.

"These are hard lessons." Helena said, "but they must be learnt for they cannot be taught."

But I shut her voice out, drawing back into myself. At last the veneer of fantasy I had always imposed upon my life was beginning to crumble. All along I had been the captive of my own hopeless naivety. It had been too easy for me to see my new existence as something magical: a wondrous thing never to be questioned. Helena, beautiful and wise; Helena, the faery princess. She had made it easy. Her enchantment was always there to dispel all doubts and fears. Now I rejected it. Or at least I began to question it. Behind the glittering facade of endless life and immortal beauty rose the grim dark shadows of bestiality and horror. They seethed in my brain to show me the nightmare realities of hypocrisy and delusion.

I glanced around at Helena, seeing now the real depths of her fear. And there came the crushing sense that all her strength and nobility were false and doomed to failure. That truly they were nothing more than stubbornness and conceit, ultimately pathetic and inadequate for the life which was ours. She spoke of learning. What was there to learn? Only to see ourselves as we truly were. And that was enough to leave us desolate for eternity. No. Such knowledge could not be borne. The only escape was in self-deception. The world of fantasy from which I was only now emerging. The fantasy by which

Maximillian could convince himself that evil was good. And worse. That evil was divine. The fantasy by which Helena told herself that we were something other than monstrous.

"How did you find me?" I asked her at last.

"Find you! Do you really suppose I could lose you? Or you me? I know your thoughts. I know your fears. But more than this. I have known your life, your death. We are one. And you are as close to me as I to you, if you would only see it. But you will not. You are distant. You are remote from me."

"I . . . *from you*? I blurted out in astonishment. She paused a moment as my mind struggled to understand. Then she went on.

"You hold back. You cling to what was. You would wrap your life in a cocoon of things you know and recognise. You cannot. You cannot judge this new life through old perceptions. You must see that. You must know the change in you and let it guide you." Then she said carefully. "I should never have made you like myself. I know that now." She shook her head. "Truly I always knew it. It was wrong. It was weakness."

"No. Not weakness. I think it must have taken courage," I said, for her distress seemed at once so great I felt I must say something.

"No!" she cried, and flinched as if she had been struck. "It was weakness! Such . . . such weakness. I pray . . . " for a moment her voice fell to a nearly inaudible whisper . . . "I only pray you will never know what weakness it was. But you must understand, I did it because you willed it. Because your

will drew me to you. And if you had not willed it you would never have survived. Never have fought your way back from death."

"Then we are both weak," I said.

"But now it is done. It is irrevocable. And you must come to me that we may find strength together. We *need* that strength. Do you understand? Without it we are lost. We are without hope."

"But what of humanity?" I said, for this seemed very important to me. "Do you really care nothing for men?"

"Care for them. Why should I? How can I?"

"Then why . . . "

"Why do I not kill them? Why can I not abandon myself to destruction like Maximillian and Hermione? Oh John, if you think I am immune, that I do not know their desires, your desires, burning inside me, you are wrong. But I left them many years ago because I could not accept what they believe. We, with our minds and powers and senses which may exist for age upon age. We who may gather the wisdom of centuries. Is all this to be squandered in an eternity of mindless and vicious sensuality? No. It must not be. Maximillian is mad. Our kind are much prone to madness. Remember that always, in all that you do. We became without form or purpose through the centuries and the desolation and horror we spread are but the reflection of these things in ourselves. Death becomes our only purpose in a war against life. An escape that leads ultimately to nothing but evil for its own sake. But to follow such a

135

course is the final admission of defeat. The defeat of our minds by our own life and our own power."

"But is it possible? There are times . . . " I faltered " . . . times when I do not know myself. Times when power is like a separate entity inside me that I cannot control. Is the evil in us our own, or does it claim some other source? Some external source? Are we possessed? And how can we fight these impulses when they are the key to our very survivial? When they lie at the root of our being. Do they toy with us? Do we deceive ourselves in supposing we can overcome them? What else is there for us?"

"We must protect ourselves," she said, "against this madness. Against the stagnation which is evil. After so many years there is little I can tell you. But I will not accept that there is no choice. We must fight. We must search ourselves for awareness, for purpose. We must find our own way. There are times of hope . . . times of frustration and confusion. But I have found that some answer lies just in the searching."

I nodded and said no more. Her words impressed me, edged me towards a clarity of thought. I was at once aware that something in me was fading, yet in its wake something else, powerful and new, followed. I was as some newborn creature struggling from its egg, fighting through the wall of blindness that is the only world it has ever known; suddenly aware of a vast imminent new world just beyond. I feared this new world. It was dark and strange beyond my wildest conceptions. It threatened things I could no longer ignore or dismiss. But I had nowhere to go but forward into it. There were no alternatives. All I had

ever wanted or valued before became unimportant – feelings discovered then lost, all sacrificed to truth. What I needed instead was understanding – a knowledge of myself – and one in whom to find and share that understanding. A love to transcend all earthly needs, that might span the centuries in its discovery and growth. And I could not speak or even turn to look at Helena, for these were distractions that seemed an impediment to realisation. I knew simply that her thoughts were close to mine, and there was at once reassurance in that knowledge.

"What keeps us from truth," she went on slowly, "from understanding, are the needs and desires which cloud our minds. Beyond these, I am convinced, lies the destiny I seek. My wish has long been for another to join me in my search. I chose you, in whom life was so weak. Now you have the power to understand. Now the choice is truly yours. Now we may search together . . . if you will stay with me."

And again, through every feeling of confusion and dread, through every doubt, her beauty dazzled me, her enchantment touched me. There was a sudden impulse to reach out and clasp her hand, to tell her I would love her always and never doubt her again. But I resisted and at once it died. I knew simply that it was meaningless now. I just gazed out on the lapping waters of the river, at the squat gloomy buildings on the other side, covered with glistening snow; and at the moon, lighting the long thin clouds that streaked the sky: silver claws that raked the dark. And I said simply:

"Let the search begin."

IX

Decades passed. I can find little to say of them, for in truth they were uneventful, though the memory of them seems alive with events. Of gradual awakening, of growing strength and control. And of love, that was my support and security; a love that could only increase as I followed Helena into a timeless twilight world, where everyday life passed beneath us; leaving all I had ever known far behind, all my former links with human life lost without trace or regret. I grew to prefer solitude and quiet to the breathless noise and pace of cities. And when circumstances did force us into cities and towns, it came to seem as I walked the crowded streets almost that I was in strange foreign places, surrounded by babbling, incomprehensible alien people.

And so the nineteenth century passed into the twentieth; the Great War with Germany came and went, with very little effect on the lives of Helena and I – except for one occasion when I was stalking a woman who turned to see me at the last moment, and promptly produced a white feather which she thrust into my open hand, leaving me so astonished that I simply stood and watched her walk away.

It was our custom to pass the summer months in some remote part of the countryside, and it was soon after the Great War that we found ourselves in Derbyshire. We both felt a strong attraction for that bleak, hilly county. To begin I rented a small house in

the town of Matlock, and from there we journeyed several miles out into more rural parts. It was always difficult to find any accommodation deep in the countryside that was suitable for our needs – and even when it was to be found we inevitably aroused a good deal of unwelcome local curiosity – and so we did now what we were often forced to do. We found a graveyard near to a village, broke the decaying lock on one of the long deserted vaults and vacated two of the coffins therein.

One night soon after our arrival I wandered down a narrow lane that led past the graveyard and on down to the village, when there was a distant clattering behind me, and I turned to see a small horse-drawn carriage approaching rapidly. I stepped aside as it rattled past, and watched it pull to a halt outside some closed gates just up ahead. The coachman jumped down and opened the carriage doors, and a young man climbed out, pulling his overcoat about him, for it was raining slightly, as he opened the gates and went inside them. The coachman followed, carrying some luggage. I moved forward, and as I passed the open gates I glanced inside. The young man stood by the doors of a house, where he was being greeted by an old man. I stopped, staring, for behind the old man, framed in the light at the threshold of the open door, stood a very beautiful young woman. She looked to be no more than eighteen, not tall, but with a slender and graceful form. She had long fair hair and wide eyes, and her skin was so pink and fresh that it seemed to glow in the gloom. Her looks had a youthfulness, a sweetness that made her seem perfectly angelic.

I leaned slightly forward, staring harder. Then I turned my head away. I felt for her an immediate, overpowering attraction, and it unsettled me. Made me aware of all the old passions that still lurked in me. For the desire, the madness, had never left me. Most of the time I learned to suppress it, but occasionally it rose in me with such strength it infested my every thought, allowed me no peace and filled me with restlessness as I wandered the night, loading my mind with seductive images of human beauty; obsessing me with wild, sensual fantasies of death. And when in this state I hardly dared look on my victims while I fed, taking them from behind, pulling away while my hunger was barely yet satisfied, fearing the lightning grip of that deadly climax.

But though I dreaded the feelings the girl roused in me, I could not long keep my eyes from her. I drank in her beauty and it warmed me like blood.

When he had finished greeting the young man, the old man turned to the girl and said:

"Elizabeth. Come along and welcome your brother home."

"Yes, Father," the girl answered in a low, soft voice, and stepped forward. The young man embraced her quickly, and I watched as the fever rose in me. I wanted her. Desired her more than I had desired anyone before. I gazed after them as they turned back into the house. I closed my eyes. I resented my feelings. I had fought so long to overcome them. And I knew too well how dangerous they could be: to the girl, and to me. Cursing angrily I turned and hurried away.

I wandered in agitation for hours, not even seeking for a victim, though I was hungry, intent on first overcoming my disturbed emotions. At last I returned to the graveyard shortly before dawn. I walked slowly, weaving a path amongst the old, decaying gravestones, surrounded by overgrown grass and shrubs, when at once a strange sound came from somewhere nearby, a low stifled groan. I stiffened, then crouched behind a bush. Then I straightened up slowly, looking all about me. A woman, all dressed in dishevelled black clothes, knelt on the ground beside a newly filled grave. Scattered all about were brightly coloured wreaths and fresh bunches of flowers. Plainly the funeral had taken place the day before, but the woman had returned alone, half demented with grief. I moved closer. Her eyes were swollen and red, her face grey and lined. At first glance she had seemed ageing and worn with care. Now I saw she was really quite young. She knelt, looking down blankly at the soft soil with a sorrow that seemed to grip and crush her crouching, trembling form in a giant invisible palm.

She sobbed weakly, bringing up her small hand to cover her face. Then the hand dropped and she raised her head, staring at the dull grey sky from which the rain still drizzled miserably. Her face contorted with sudden bitterness, as if demanding some reason or redress from Heaven itself. And then she simply curled up like some small, frightened animal, burying her face in her hands as her sobs grew wild and uncontrolled. I stood, reflecting that I did not understand it, this human horror of death. It seemed any

part of me that might once have understood it was no more. And so it is, I suppose, for all my kind. To take a life seems a small thing because all men must die, now or later. It is just a matter of time. And time has so little meaning to us. But nevertheless I felt sudden compassion for this woman, as I had felt for no human being in many years. It hurt me, to see such grief. I wanted to ease it. To end it.

Her sobs ceased abruptly and she gave a tiny cry as I swooped down on her, pulling her to me, her cheek against mine, my lips on her throat. And no sooner was I locked to her, it seemed, that her life was gone, surrendered in a moment. And through the mounting pleasure I pulled away and whispered breathless in her ear:

"Do not fear. It is death. Only death."

And the clouds gathered as at last the rain began to fall heavily. I left her lying on the grave of the one she had so mourned, her rigid hands clutching the damp earth, her lifeless face a mask of tranquility. And as I walked away I felt no guilt at her death, for I had not killed her. She had simply sought death, and found it through me. Yet I was disturbed.

When I returned to the vault Helena was waiting for me, and I felt that she knew — indeed our thoughts and senses were by now so close I could not have hidden it from her. But she made no mention of it. There were no questions or reproaches, nor even any warning of the dangers of leaving a dead woman so close to our resting place. She seemed worried. She stared at me for several moments, then she said:

"What is wrong?"

"Nothing," I told her. "Nothing. It will pass."

"I feel it too," she said with a frown. "It extends to me. Disturbs me. I don't like it."

"It will pass," I said again. But I felt it, this strange unease. Indeed I had felt it all that night.

"Something about this place," she said finally. "A sense of . . . " She shook her head. "Let us go from here."

"If you wish," I told her. "But not yet. Not for a day or two."

She nodded, but stood, still frowning, as I went to rest.

The next evening when I rose my restlessness seemed only to have increased. I roamed the country lanes for a while, though in the back of my mind I knew all along where I should finally go. It was growing late when at last I stood at the back of the house I had passed the day before. It was she, the fair girl. She was the reason for my unwillingness to leave at once, as Helena had wished. I wanted her, and I was tired, so tired of nagging, unanswered passions. After a time some curtains in an upstairs window were drawn back and I saw the girl there, her slender figure displayed beneath a thin nightgown as she unfastened the latch and pushed the window open, for the night was close. It seemed almost an invitation.

I watched her as she stood and stared out into the dark. Her face seemed sullen, her eyes sad. In some ways I think she reminded me of myself when I was young. The house she lived in was a grey, rambling, old-fashioned place, without brightness or joy. The

countryside about was bleak and lonely. The whole scene seemed to belong to a bygone age, so distant from the lively, modern world that had sprung up since the end of the war. She was too young and much too beautiful to be locked away from the world in such a place, and no doubt she knew it.

At last she stepped back out of sight and the light in her room was extinguished. It was agony to know that she lay so close. My limbs shook and my veins throbbed, but even now there was a part of me unwilling to submit to these impulses. But at last in anger I set aside these nagging doubts and moved swiftly across the back lawn, scaling the wall of the house, crawling onto the canopy over the ground floor window, grasping the ledge above and hoisting myself up to peer into her window. She lay in bed, sleeping soundly. I pushed open the unlatched window and, swinging my legs, vaulted silently into the room and moved to her bedside. I stared down at her. She seemed even more lovely in repose, and my hand trembled as I rested it on the pillow by her head, gently twisting a lock of her fine silky hair between my fingers. She rocked slightly and sighed as I leaned over her, placing my arms about her, brushing my mouth across her cheek and throat so that she stirred, about to wake as I grasped her to me and felt her soft skin open between my lips.

Pleasure overwhelmed me as she lapsed back into sleep, until at last I pulled away, lying gasping on the bed beside her. Her breath came in great sobs as she reached out and clung to me, but I pushed her arms back and whispered softly:

"Enough, now. Enough. Sleep, now. Go to sleep."

She lay back and her frantic breaths grew regular again. I rolled over and drew my face up close to hers. For some time I lay there, just gazing at her, feeling an unfamiliar sense of perfect physical contentment. My hunger was satisfield, my desires at least under my control, and I was warm and comfortable, lying here on a bed beside this lovely, sleeping girl. Before long a drowsiness settled on me, but it was so peaceful and pleasing that I did not fight it – simply enjoyed it. And then I must have dozed, for I next opened my eyes to see the room brightened by the first light of approaching dawn. I felt a momentary sense of confusion and panic, sitting upright with a jolt. Then I looked down at the girl. Her eyes were half-open, looking back at me. For a moment she stared, drowsy and uncomprehending. But then she recoiled, thrashing her arms in shock, gasping in fright. And she screamed, loud and shrill. Alarmed, dismayed, cursing myself for my carelessness, I slipped at once from the bed, back into the shadows, out of the dull beams of light from the open window. The girl continued screaming as I stood rigid, pressed against the wall. And then from outside the room I heard the sound of hurried footsteps, and the urgent voice of the girl's father calling her name. The doorknob rattled as he gripped it outside, and in that instant I moved across the room, past the terrified girl, and leaped through the window, hurtling down to land noiselessly on the grass. Without looking back I ran, for there was no darkness now to conceal me, sprinting fast as I could across the lawn, into the cover of the bushes and trees beyond it.

Still dazed and shaken, I made my way back through the half-light to the crypt.

* * *

Darkness. I was alone in a darkness so immense and impenetrable that even my nocturnal senses could perceive nothing through it. My body was without feeling, heart or pulse. I was lying deep in my death-sleep, yet I seemed to possess an awareness I had never known before in this state – as if some part of my mind hovered urgently close to consciousness. It was an awful, frightening feeling: live thoughts in a dead body. I felt horribly vulnerable. It was not like a bad dream, from which men may escape by waking. I could not stir. I could not wake. I was trapped.

Then there came a ringing in my ears, and with it a horrible sense of foreboding. And at once I heard voices; distant mumbling voices, but I could not make out what they were saying. It reminded me vividly of my old childhood dream. What significance this dream could have to me now I did not know. I knew only that it filled me inexplicably with a dread far greater than ever it had in my human life. And I listened hard to those mumbling voices, disturbing though they were, for they were all my bemused mind had to cling to. And they grew louder and clearer, but still I could not understand what they said, until at last they faded back into a mighty buzzing inside my head.

Now a wave of shock swept through me. From the darkness in my mind there appeared a strange apparition: a grim sinister figure that stood in the distance

observing me. And gradually it was drawing closer. Its features were indistinct. I could distinguish nothing about it. I just lay there afraid, aware again of my appalling helplessness. I wished only to wake and be free of these nightmare imaginings. But I could do nothing except stare and concentrate on the ghoulish figure, and at once I heard sharp footsteps as it advanced: a steady clack, clack, clack. And even when at last it stood over me I could not see its face. But then as I looked at it fearfully there started to grow about it countless tiny threads of brilliant silvery light which dazzled and sent a flood of nausea shooting through me. And for a fleeting moment the face of the vision grew clear – a twisted face with bright harsh eyes that looked down, burning with malevolence, gloating in a horrible hateful triumph. And then it seemed that a great cry split the air, and in the same instant the figure was gone, swallowed back into the sea of darkness in my brain from which it had come. Then there was just a single voice that came from somewhere nearby, booming out so loud and clear that it rang all about me.

"We've found it. We've found it. Thank God!" There were a few moments of silence, then the voice went on, hoarse with emotion. "What you see before you is the spawn of darkness. Sheer evil in human form. Satan's power manifest on earth."

"But . . . " a second voice broke in . . . "It's fresh. It can't have been dead more than a day. It isn't possible. Nothing has been buried in here for more than fifty years."

"No," said the first. "It's not dead. Not truly dead."

147

"Not dead! *Not dead!*"

"No. Watch when I cut the skin."

"Fresh blood!" The second voice was a whisper of awe. "In God's name how did it get here?"

"Father," said the first. "What I must do now will seem like madness. Like sacrilege and desecration. But you must trust me. I know what must be done."

"What?" demanded the second. "Do what? What are you talking about? How did you know where to find this corpse?"

"I didn't. It was just a guess. I couldn't think of anywhere else to start looking but here in the vaults. You saw that the lock has been broken. And see. This coffin has been forced open recently."

"But of course. Someone must have put this body here. I don't understand any of this . . . "

A sense of numbness fell over me. I understood only too well. And through my head pounded again and again the single hopeless thought:

"This is no dream. It is real. I am discovered and I will be destroyed. And I am powerless. I cannot even open my eyes."

The first voice droned on in a low breathless tone.

"Since I was a child I have known that the Devil is active in the world. You taught me as much. It was for this that I entered the service of Christ. And since I became a priest I have learned of many things. Terrible things. I have known them as reality. I have seen good pious men and women attacked by the forces of sin – raving, shouting blasphemies against God, obscenities against men and against the church. Human beings possessed, shrieking with the

voices of devils. Men made less than beasts. I have seen that Satan is a reality. I have seen what his power can do."

I lay, these words bursting through my head, frantic with fear, fighting hopelessly for life and feeling somewhere in my body.

"And this morning . . . " the voice went on . . . "when I went to visit Mother's grave, and I found that woman dead. When I saw her . . . the signs were there. But I would not . . . could not believe that such a thing could happen. That such a thing could be true. But last night! My own sister . . . in our own home . . . that mark on *her skin*! And now this! How can I doubt it any longer? Thank God we've uncovered this evil in time. It is God's providence. It is God's will we've found it. It is our chance to fight with evil. With Satan himself. And I know what must be done."

The second voice spoke again, crying out in bewilderment, and then alarm, until at last both voices were raised almost to hysteria, and I could not follow what they said. But then silence fell. A silence so long and terrible it seemed to scream at me. Until at last a great cry rose up:

"*I know what must be done!*"

At once there was a cry of outrage and horror, but it was instantly drowned out by another cry, a terrible scream that burst all about me and inside me, as searing pain tore through every part of me. Then the pain was gone and I was spinning through darkness, spinning into death. But this was death as I had never known it. Death without distance. Not the

death of another; no fleeting human demise I might experience from my pedestal of immunity. This was mad, frightening and uncontrollable. All about me it seemed were masses of fleeting phantom forms, while a voice throbbed suddenly in my brain. It was my voice, and it said softly:

"Do not fear. It is death. Only death."

Now I was sinking down into eternal blackness, and my thoughts and senses were fading. I fought desperately, clinging to them, clinging to life, refusing to let go, knowing with certainty that if I did I should lose them forever.

I started with a cry, gasping for air, struggling frantically to rise up out of the stifling heat and darkness that entombed me; thrashing my arms, hammering my fists against something solid just above. There was a mighty crash, a painful blow to my head, and I fell back down. I was weak with fright, exhausted, and my breaths were groans as I lay, trying to control and collect myself. Finally with incredible, almost disbelieving relief, I realised that I was lying awake and unharmed in my coffin. Light headed, laughing, near hysterical I pushed open the lid and clambered out, tottering on unsteady legs to the back of the vault, stumbling against the wall for support, unable to find my co-ordination.

"It *was* a dream," I murmured to reassure myself, shuddering at the memory of how vivid, how hideously menacing it had all seemed. "All a dream, nothing more, brought on by what happened last night."

I staggered to the door of the vault, leaning

against it, sucking in gulps of fresh air as my head cleared; looking out into the night, which to my surprise was quite far advanced.

But now, though I told myself all was well, there crept over me that strange and powerful sense of disquiet that had been growing in me over the past two nights. As my strength returned I stood and pondered this. And when at last the thought came I simply froze and stood, my mind rigid, refusing at first to let it all grow clear. Then I was back inside the crypt, kneeling on the ground, grasping the lid of Helena's coffin and tearing it open.

I stared down, and it seemed for the moment more than even my life could withstand and survive. Inside the coffin swam with blood, and she lay, her white dress stained all red. Into her breast was driven a metal spike, and her head was hacked from her body, and had rolled into the corner of the coffin, her mouth twisted, the eyes slightly open. Then there was just a wild cry that thundered and reverberated through the stone vault: my head roared, my vision swam, my strength and reason dissolved, hurling me down so I floundered on the cold, rough floor. I cannot say how long I lay there, half-senseless, as there passed before me memories of the life we had so long shared; of a bond so great that I had even known her death – that should have been my death – felt it as I lay unseen in another dark corner of the vault. And still it seemed that it was my death as in my thoughts I saw the terrible image of her lying mutilated and dead, and tried hopelessly to imagine life without her. Centuries of life without her.

And then I was on my feet and there welled inside me a wail so loud and long it seemed it must end or break my body in two. I was throwing myself about, mad with a violence my mind could not support, smashing out at anything in reach, grabbing the ancient coffins, flinging them to the ground so that they split open and their mouldering contents spilled all around. And when at last not a box remained undisturbed, save the one in which she lay, I stood staring all about at the yellow, leathery bones and skulls that littered the floor. And I truly believed that they laughed at me, those leering skulls. That the dead mocked me and whispered:

"She is ours now. Yours no longer. Now she belongs to us."

The fury rose again out of my despair and I grabbed up each of the skulls, one by one, hurling them down so they shattered into fragments at my feet.

Then I turned and went to stand over Helena. Already her body had begun to decay. And as I looked down silent tears came, falling, discolouring patches of the dark, fast congealing blood. I closed the lid on the box and staggered to the door of the vault, almost falling outside. The sky was light. It was a bright, cloudless morning and the sun was half-risen over the distant, soaring hills. Its searing beams fell full on me and I shrank back, seeking the shade. But then I stopped. And I stepped forward and stood, staring out on the hostile, unfamiliar world of day, assailed by its harsh, scorching light and heat. I remained there until the sun climbed high above the

horizon, filling the sky, and my eyes, with blinding white. My breath burned inside me and my body ached as if pricked all over with needles of fire. Yet I stood and endured all this in some terrible, deranged act of defiance against this world from which I was outcast. And I thought of the fair girl, of her father, and of her brother who had done this thing. And at last I shouted into the light, my voice croaking through blistering lips:

"Man! Priest! You think you saw evil lying passive and helpless in there. You are wrong. I will show you evil, beyond your every imagining. I will show you."

And at last I spun about, back inside the vault, pulling the door shut behind me, falling down into one of the coffins I had thrown onto the floor as unconsciousness engulfed me.

X

The next evening I rose and walked the several miles back to my rented house at Matlock. I sat there in the dark the rest of the night. My thoughts were blurred. The world seemed confused and remote, in fragments about me. Strange images flooded through my head and I sat concentrating on them until they grew clearer; talking to them, laughing at them, my thoughts distracted from the true horror of my situation. It was only my plans, which formed and grew gradually within my mind, that kept some twisted sense of reality alive in me.

My recollections of the days which followed are few and vague. I remained there in the town the whole time, pacing the rooms of the house, or else drifting the lonely night streets as dull shock gave way gradually to feelings of fury and hatred. And vengeance. But it was only these obsessions, and my delirium, which kept me from thoughts of Helena, and of the future; kept me from a total fear and grief that might otherwise have finally destroyed my mind.

Once, as I roamed the night, I was importuned by a woman in the shadows behind me; ageing, half-drunk and shivering with cold in her flimsy, garish clothes. Barely thinking I turned and took her there in the open street, caring nothing that I might be seen. And as I felt the pull of death, the fury within found release and I drank deep, seeking oblivion. Yet

at the last what I saw, beyond the rising wave of power and relief, was Helena, her bloodied countenance and bulging eyes fixed in a lifeless glare of fury and rebuke. I tore myself free, hurled the woman barely alive into the gutter and strode on.

Slowly now it came to me that I must act. I had arrangements to make there in Matlock. And as I carried them through I turned the details of my plan over and over in my mind, allowing myself no other thoughts, pushing myself on.

When all was complete I returned to the village, to the home of the girl, Elizabeth, and her hated family. I concealed myself outside their house, watching, catching occasional glimpses of them through the windows. And when I saw the brother, the priest, I shook with blind rage, maddened with the urge to rush forward and kill him. But I held back, suppressing my hate, holding and nurturing it inside, grinning as if I had seen some subtle trap and cleverly avoided it, looking at him and whispering with a low laugh.

"Oh no! Not yet. Not like this. It will be when I choose. When everything is as I want it to be."

Several days later, soon after dark, I went back to the house. I entered silently through the back door, while the family were at dinner, and I slipped down into the cellar, concealing myself, and there I waited for several hours until the house above grew finally quiet and still. Then I climbed the stairs softly and entered the girl's bedroom. She lay sleeping, as before, and I took her, drained her, but not too much. She was my instrument. I needed her and she must

not die. But life was strong in her, and even as I drained her there was some part of her that resisted me at first, making my head spin and the pleasure even greater. Then at last I lay with my arms about her, and whispered gently into her ear:

"Now hear me. Hear only my voice. Your limbs grow numb and heavy. No feeling. No strength. Only my voice. Do you understand?"

She stirred, gave a short sigh, a feeble nod. I had come to realise what a simple matter it is for my kind to extend our will over our human victims, as Helena had controlled my mind in the beginning. When strength and life are drawn away the human mind is hurled blind and helpless into confusion amidst a rush of strange sensations that create a trance more powerful than any mesmerist may induce. And when a voice penetrates that state the lost mind must grasp at it, the only link with its conscious state, to know and be guided only by that voice.

"Lie still and sleep," I told her, my hand resting gently on her brow. "You are quite safe. You will not move until I tell you."

Now I stood above her, looking down as her face shimmered, damp with perspiration, her beauty if anything increased by her sudden pallor and disarray. On her bedside table stood an old oil lamp. I lit it, turned it down low. Not much light, but enough. The time had come.

I crossed the room to the far corner, where stood a large heavy wardrobe. I placed both hands against it and shoved it hard. It toppled with a great crash and the floor shook as its panels splintered. I sank into

the shadows, pressed up against the wall beside the door, and stood waiting, listening for the clamour, the footsteps, the voices calling in alarm. Then the door was thrown open. It was the old man, and he rushed in looking all about. I stepped forward. He turned, gazed at me in astonishment in the dim, flickering light. He looked older than when I had seem him before. His experience in the vault had clearly left its mark on him. Before he could move or utter a sound I struck out, hitting him in the chest, hurling him back against the wall where he cracked his head and slumped senseless to the floor. At once came the scuffling of more footsteps outside, and I stepped behind the half open door, watching as the young man entered, bleary eyed, dressed only in a nightgown. I threw the door back, slamming it shut. He spun about and I advanced, positioning myself between him and the door, my eyes meeting his. He stared for a moment, his mouth hanging open, searching for words, but I silenced him with a gesture.

"You must forgive me," I said in a whisper, "calling so late. But I have a matter to discuss with you. An important matter. And really it cannot wait."

His face stiffened, his eyes blazed with mixed outrage and bewilderment. But it was not until I sprang at him, grabbing his arms so tight he gasped in pain, that a look of fear came over him. I pulled him to me, brought his face up close to mine.

"Now," I said, my expression rigid, my eyes wide. "Observe." And I pulled him around so that he saw his father lying unconscious on the floor. Instinctively

he made to go to him, but I held him fast and gestured quickly to the girl on the bed. "Yes," I said, "your parent, and your sister. No. You shall not go to them. First you will hear me."

At once he stopped struggling. No doubt his first thought was that I was a madman escaped from some institution, and that it might be dangerous to anger me further. I regarded him grimly, then I said:

"Once I had someone. A parent, a sister, a companion. A love. But no more. She . . . "

At once he interrupted me with a cry, a hoarse strangled choke. He was staring at his sister. He had just seen the fresh puncture in her bare neck, the dark drop of blood that trickled down her pale skin and stained her pillow. And he looked back at me, his eyes bulging in sheer horror as all grew clear to him. I remembered his words that night in the vault: how the mere knowledge that such as I could exist, the sight of Helena lying in repose, had been almost more than he could bear. Now, faced with the living presence, all his senses were overwhelmed and petrified. And this infuriated me more than I would have thought possible. All my control and restraint, that had until then been so necessary for the construction and execution of my plan, and the preserving of my sanity, was at once hurled aside as I gave way to the full power of my misery and rage. With a growl I threw him down onto the floor.

"But of course!" I spat the words at him, "I forgot. I cannot love. For love is good and I am only evil. 'The spawn of darkness'."

I loomed over him, the lamplight throwing my

shadow huge and grotesque on the opposite wall. His eyes swam, his body shook violently as his lips fell open and he gasped:

"God . . . God help me!"

"And why should God help you? What is it makes your kind so arrogant? To believe you alone are entitled to the love of God? That only you are capable of feeling and good. And how covetous you are of this pretended goodness, hoarding it to yourselves like misers, allowing none other a single drop."

I sneered, at once exhilarated. It was the fear, blind panic that blazed from him as a living thing, intoxicating me, exciting me to a frenzy. I wanted more of that fear. I wanted to tear from him every ounce of hope, strength and sanity, as he had torn these things from me. To make him lost and abject as I was. I grinned, leaning close to him, saying in my gentlest voice:

"And what if I told you, with all my unearthly knowledge, from my discourse with death, what if I told you, priest, that there is no God. That God is the invention of man, an illusion of light in a world that is only darkness. And I, who can see through the darkness, who knows all this, free from man's delusions: I, who may live forever with this knowledge. *I am the closest thing to God!*"

Wild demonic laughter burst and rang suddenly throughout the room. I started. It was several moments before I realised that it came from me. And then I stopped. I froze. I drew back. I noticed something. Around his neck on a thin chain, fallen from the front of his nightshirt, hung a silver

crucifix. Its effect on me was instantaneous. As I looked on it I felt a rush of shock and shame at what I was doing. I realised the blasphemy I had just spoken – denying the existence of God when truly I knew no more of God now than I had in human life – raging and laughing, deranged with hatred. It made me see myself! And I remembered uneasily the distant Christian teachings of my childhood as again I felt the old dread – the fear of what I was, of what I had become. And for that moment all my strength and will were gone, lost in doubt and confusion.

The priest seemed to sense my agitation, and also the reason for it. His trembling hand reached up at once, fumbling for the crucifix, gripping it awkwardly, pulling the chain from his neck; then with superhuman effort he staggered to his feet and lurched towards me, holding the cross before his face. He advanced unsteadily and his voice broke so thick and strained it was nearly incoherent.

"O God protect your servant and give him strength!" He glared at me suddenly, his eyes blazing, the cross too, reflecting the flame from the lamp behind me. His voice grew louder. "I banish you with all your evil and perfidy. Get from this place in the name of Almighty God, and the power of our Saviour Jesus Christ."

He held the cross before my eyes. The light glinting on it seemed at once bright, dazzling, and I stepped back blinking. I felt the power, the force of all his vehemence somehow projected at me through the symbol of his faith. It hurt me. I could not bear to look at it. I stepped back again, and my head fell

so that I stared at the floor. Emboldened he moved closer, and began to mumble one of the psalms, an invocation against evil.

"'He that dwells under the shelter of the Most High, who abides under the shadow of the Almighty.

Will say to the Lord, 'my refuge and stronghold: my God, in Him I trust.'

For He shall deliver you from the snare of the hunter: and from the deadly pestilence.

He will cover you with His wings, His faithfulness your shield and buckler . . .'"

Anger flared in me again. And in an instant, before I knew what I did, I stepped forward, reaching out, grasping the crucifix, snatching it from him, holding it up and gazing on it in triumph. Then, smiling, I looked around at him. Had I suddenly been transformed into the Devil himself, amidst a burst of fire and brimstone, his look of sheer horror and disbelief could not have been more.

"Well said," I told him with a nod. "But you see," I waved the crucifix at him, "baubles, words, they mean nothing. As you can see, we understand each other perfectly, God and I. And now to business. You have robbed me. Robbed me of all I had. Now I want compensation. That surely is not unfair? I seek only for justice. A life for a life." And I moved to the girl on the bed, pointing down at her, my eyes meeting his. "Her life," I said. "I could have killed her when I first came here. But I spared her. And let me tell you why. It was because of she – the one you killed.

Because of all the things she told me and taught me. But now she is dead and all my compassion and restraint are dead with her. And it is your fault. You are to blame." I pointed again at the girl. "Let her death rest on your conscience."

At once I fell onto my knees, wrapping my arms about the girl, raising her up, resting my lips on her throat and running my tongue over the bloodstains there. With a scream of desperation he was on me, pulling me from her with immense strength, pounding me with his fists. I staggered back off-balance, momentarily startled by the force of his attack. Then with a snarl of fury I lashed out, knocking him down, turning back to the girl. But at once he was up and struggling with me again. I grasped his arms, pulling him to me, ready in my rage to strike him dead. But then I threw him back and he slammed into the wall, falling to the floor gasping for breath.

"No!" I told him. "Oh no. To kill you would be too easy. And what a poor revenge it would be. No! *She* must die!" I moved back to her side. "But do not fear." I gave him my most pleasant smile. "You of all men must see that she dies 'In sure and certain hope of the resurrection to eternal life'."

He stared up blankly for a moment, then his face twisted with an agony beyond description, grew paler even than the face of his bloodless sister, as the significance of my words grew clear. And in that moment of his utter hopelessness, I pitied him. My heart beat in my throat. My voice lost its harshness, broke and trembled. And I called out, almost pleading:

"Don't you see? Can't you understand? I have no choice. You have cut me adrift, alone in the wilderness of eternity. How else may I find companionship? How else may I find love? What else can I do?"

I do not know what I hoped to achieve by this outburst. Needless to say I achieved nothing. He just stared back at me with revulsion and terror beyond reason. And I told myself: "Be strong. You cannot afford weakness now." I regarded him coldly.

"But why do I remonstrate with you? What purpose can it serve? You robbed me with death. I shall rob you with life. You call me evil. But to me you are evil. Do you understand that? You, with your arrogance and blindness and hatred. You, fearful helpless creatures who creep through life like mice never daring to venture out from your dark secure corners of ignorance. On your hopeless journey into disease and deformity and death. But this girl . . . " I laid my hand on her head . . . "I will save her from these taints and evils of man. I will preserve her youth and sweetness and she will live with me forever. And now," I told him, producing again his crucifix, "she shall have this."

And I put the chain about her neck, placing the cross delicately on her breast. The idea had come to me that instant. "There," I said, standing back, looking down on her, and then back at her brother, smiling at him. "Perfect. Now who will know? Who will ever suspect?"

And then quickly I fell on her, drained her some more. I rose, taking her up in my arms. And as I

carried her away I glanced quickly back. The young priest looked up at me from the floor, but his eyes were blank and unseeing. His eyes were mad.

Suddenly I stumbled and tripped forward, almost dropping the sleeping girl. The old man had regained his senses and had crawled over to me, clinging frantically to my leg, trying to pull me down. I spun about, kicking out, throwing him back, and he lay gasping and sobbing. In his eyes I saw death. I saw it and knew he would die, and that I had killed him as surely as if I had taken him in my arms and drained him dry. I stopped for a moment by the door, looking quickly from father to son. And all I saw staring back at me was madness and death. I had anticipated with pleasure this moment of final victory. But it was bitter. It brought no satisfaction. Still carrying the girl I turned and fled.

I took her from the house, along the lane outside towards the graveyard, to a dark secluded place where a motor car stood. Now I whispered gently into her ear:

"Walk now, Elizabeth. I will put you on your feet. Lean against me for support. Just a short way."

I swung her down, threw my arm about her. There was a suitcase concealed in the bushes nearby, containing one of Helena's cloaks, which I threw about the girl's shoulders. Then I pulled her along with me, whistling for the driver's attention. He jumped from the car, a broad grin on his face, winking at me. I had found him in Matlock. Told him that I and a young lady planned to run away together.

"Unfortunately," I had sighed, leaning close to him, whispering confidentially, "her family disapprove of me."

Then, smiling, he had pressed me to tell him more, and when I had he'd roared with laughter, slapping his knees, crying:

"Well, well! A priest's sister, is it? Running off with a priest's sister in the middle of the night. Very nice too, I'm sure, you young devil."

Then I handed him money, enough to make his eyes bulge, telling him there would be more when the job was done.

Now he helped us both into the car, patting me on the back, muttering and chuckling excitedly. Then the engine roared and we were away, blazing through the night.

He drove us back to Matlock, left us in the town centre. I paid him off, then, pulling the still stupefied girl to me, swept her off into the shady backstreets, away to my rented home, where everything lay prepared.

*　*　*

In the cellar of my house I had placed a bed, and I lay Elizabeth upon it. I knew that I must drink from her again, but with great tenderness and care that the strain upon her should not be too great since she must be kept alive, but sufficiently weak that my power over her mind might be maintained. Over the next days and nights I must keep her as a prisoner, locked in this place as I gradually drained her life away, and while I slept her days would be spent

alone. I resolved that I must try to keep her insensible of her physical circumstances. I must protect her if possible from the fear and knowledge of her condition. I would not wish her human self to die in solitude and terror, as mine had died. She must not become the weak and miserable creature I had been in death. I would make her fearless. I would make her strong. Of this I was determined.

I would administer a sleeping draught at dawn, that she might sleep through the days. And through the nights I would feed her and attend to her comforts, and I would speak to her always to reassure her of the life and strength that would be hers. I would make her rebirth a glorious one.

Now I raised her in my arms, brushing back the soft dank hair from her neck, and drank, pulling back almost at once to speak gently.

"Hear me, Elizabeth. I know that you are weak and ill. But you must not fear. I have brought you here to make you well. Just a short while and you will be well again, and stronger than ever before. You must trust me, and sleep now, for this will make you well. Sleep until I waken you."

And she clung to my words, sinking ever deeper within herself, remaining in a state of near oblivion as the nights passed and her body seemed ever more pale and wasted. At times she appeared to grow restive, for some part of her was no doubt aware of her body's gathering decline, and yet she remained deep within my power as I spoke to her ceaselessly throughout the night, reassuring her, carrying her upstairs, sitting her opposite me at the

table, caring for her needs, arranging her, controlling her, my companion already, and telling her of my thoughts, and of her life, and what it would soon become.

On the final night, when she lay upon the brink of death, I sat in silence for hours, staring at her, savouring the last of her burning beauty; the beauty which had caused such tragedy, and had obsessed me from the moment I first saw her. After tonight that beauty would be no more. Or rather, it would be different. It would be no longer human.

I took her, and the flow began, the flow that would in moments become a torrent.

"Now comes death," I mumbled through the stream of blood. "Do not fear. Be courageous. Be strong. Cling to life. It will not desert you."

I drained fast. Her body trembled in my arms, her life slipped away almost at once, carrying me on its tide of overpowering pleasure. At last I let her drop down, panting for breath as I rose from the bed. Now I must wait.

For the remaining hour or so of darkness I sat by a window upstairs, looking out into the empty street. In my thoughts I saw them still – her father and brother. Saw their staring monstrous eyes however hard I tried to push them from my mind. Until at last I rose and shouted out into the deathly stillness:

"I had to do it. It was just. I must not think on it."

The next night I woke early, feeling strained and nervous. I went at once to Elizabeth. Her body was cold and white. I paced the cellar. Hours passed but

she showed no signs of life. I was growing frantic. Had I misjudged? Had I drawn away her life too quickly? I did not know. I had no way of knowing.

It was late, well past midnight, and I was half-wild with alarm when at last it happened. A tiny movement about the muscles of the face, a momentary twitching of the extremities; and all so slight that no human eye might have discerned them. But to me they were as clear as they were joyful. I leaned down, taking her hands, pressing my ear to her body, detecting slow, faint but unmistakable heartbeats. More than an hour passed before she moved again, but this time it was like a convulsion that affected every muscle. Then finally her eyes opened. And slowly she sat up, looking all about her. She looked at me, but seemed not to see me. Her mouth fell open and she mumbled something incoherently. I moved forward, drawing my face close to hers.

"Elizabeth!" I whispered.

She made no response. I reached out, brushing her hair from her face. She was dreadfully white and utterly lost; confused and unable to realise the transformation in her, the burst of new feeling and senses. She was weak. She needed strength.

I took her hand, led her gently up the cellar stairs and out into the streets. We walked for a time and I whispered to her constantly, telling her I would soon cure her hunger. But still she would not acknowledge me, just allowed herself to be led, staring dully ahead.

At last a car drove past and pulled to a halt just in front. A man climbed out and walked to a door inside

a deep porch. Leaving Elizabeth I moved forward and took him, letting him sink to the ground at my feet. Then I brought Elizabeth to him. She knelt slowly beside him, gazing hard at him for several moments before she let me push her down. She clutched at him and drained him frantically. If I had not pulled her back for breath at last she might have choked. But she fought me, struggling to take him again as her skin burned against mine and colour poured rapidly back into her. I held her fast until finally she grew calm again, and did not resist as I dragged her to her feet and led her away. Then she turned to look at me, her lips covered with flecks of blood that sparkled under the beam of a nearby light. It was as if she saw me truly for the first time. As if the vital warmth she had absorbed restored at once her reason. Wide-eyed she stared down at her red-stained hands. And at last she murmured:

"My father . . . my father . . . and . . . my brother!" She looked at me again as she repeated it over and over. Then she pulled free from me and said: "You . . . you did it. To them . . . to me . . . it was you. *It was you!*"

I stared back at her, horrified. For at once came the realisation. I had underestimated all her strength and will. She knew everything. I had told her to sleep but she must have fought me, even in her weakened state, struggling through her trance, striving for awareness in half-consciousness. And while she lay incapable of motion, and I destroyed her family in fury and vengeance, some part of her had known it all, absorbed it, and even now was remembering. And

I turned from her as a single awful thought came to me.

"She knows everything – she knows it *exactly as I knew Helena's death!*"

Now she strode up to me, quite fearless, her beauty at once made twisted and ugly through emotion. And in her outraged expression I saw her brother's face; a sudden and intensely powerful resemblance. I could hardly look at her. But I must. Her terrible gaze held me to the spot.

Until now my plan had seemed so flawless, my revenge so perfect. Obsessed, maddened, I had never stopped to consider beyond its completion. But now it was all too clear. It was hopeless. After what I had done, how could she, knowing all, do anything but hate as I had hated? How could she do other than hate me forever?

Her lips quivered and her body shook. She made a few inarticulate gasps of anger, and I prepared myself for her rage and loathing. But what she said, screeching through the black empty streets, left me more aghast and horror stricken than anything I could have believed possible.

"My father – my brother. They will come after us. They may find us. They are dangerous. *You should have killed them!*"

Together we walked back to the house, and as we went she talked without cease, as if she needed to convince herself finally that all this was real and no dream. Unfortunately, I needed no such assurance.

"If you only knew," she babbled, "how long I've dreamed of the day I might escape from my father and that stinking bloody mausoleum of a house. The time I've been walled up there like a prisoner having to listen to him and my halfwit brother drivelling on about Christ and salvation. How many times I've prayed to get free from them. Oh! *Why didn't you kill them?*"

She threw back her head suddenly, laughing hysterically. Then her eyes grew wide, her voice fell to a whisper. "That man. The one back there. The one you gave me. God! God! I could have killed him. I felt his life. I had it in my arms and felt it . . . felt it just fading away. Oh! It was . . . it was like nothing I've ever felt before. That power. Power beyond reason. The excitement. He was nothing. His life was nothing. I could have snuffed him out. It would have been so easy . . . but you stopped me."

She turned to me, at first bewildered, then she frowned, her cheeks flushed with anger and blood. But at once she grinned again and prattled on as if she were drunk. "When I was at school . . . there were men. Just village boys. With grubby clothes and rough hands and manners like pigs. But we used

to creep out and meet them secretly when we could. It was exciting. Well, it was exciting then. But it was nothing. Children's games. All nothing, I see that now. Nothing compared with this!" And she began to laugh again, stretching out her arms as if to embrace the night.

I walked on, staring blankly into the darkness ahead as I told myself again and again:

"She is mad. She is totally insane. And God help me. I have given her power. I have made her madness eternal."

The days which followed served only to confirm my worst fears. She learned to control and use her powers with a speed that was alarming, as might be expected in a nature that knew repression but no restraint. Night after night she went out, to return flushed and full, her skin feverish, her eyes glazed and voice slurred. Then she would come to me and sit beside me, drawing me into a loathsome intimacy where she related in whispers the details of her newest excesses: of the many diverse ways she had discovered to find pleasure in death, as if seeking my encouragement and approbation.

"It fascinates me," she would say, her lips brushing lightly against my ear and cheek. "It fascinates me when they die. I like to watch them die. Sometimes I can't decide whether I most want to feel them die or just sit back and watch. Sometimes I kill just to watch. Just to see death. I like that when they're young and strong. And beautiful. I like to watch them die when they're beautiful. I like that best of all."

And I would sit, silent and expressionless, endur-

ing all this. I deserved it. It was perfect justice. It had all been my fault, everything from the very beginning. And though I had terrorized and destroyed rather than admit this to myself, it was too horribly true to be denied any longer. Helena's death, and every calamity that had followed it – the guilt was mine. The direct result of my blind, wilful passion for this abominable girl. I had failed Helena utterly. I had failed myself. Then I used revenge – a revenge Helena herself would never have wished – as an excuse to take what I had wanted all along. And when I looked at Elizabeth, saw her grinning and giggling, drunk with power, I told myself:

"Well! You had her life. And now you have her. And she is everything you deserve!"

Sometimes when I went out in the evenings she would come and walk with me awhile before she went off on her own. And as she strolled beside me she drew attention from all around. Men would walk nearby, staring and smiling; as enthralled by her beauty as I had once been. And she would look coyly back at them, her great blue eyes so appealing. Who could resist her? She was perfection. I had created the perfect instrument of death.

I questioned myself much during this time. How could I try to repair the wrong I had done? How could I begin to teach her moderation and control, as Helena had taught me? Once I even considered taking her to Maximillian, to repeat for her my lesson with him. But I dismissed the idea in alarm. She might soon have found things to teach him! But how could I presume to teach her anything? After the evil

I had done how could I even try? She would assuredly laugh in my face. And who could blame her? There also existed in my mind the nagging fear that I might even be responsible for her disposition. That the fury and madness that had possessed me when I made her like myself had in some way infected and deranged her.

Soon we moved down to London. I hoped my state of mind might improve far away from the scenes of my crimes. But of course it did not. Plagued by guilt and loneliness there were even times when I came to fear the extreme dark; for it sometimes seemed as I sat alone I saw shapes there in the gloom; horrible visions, shifting nightmare forms and vague malignant images of damnation. I sometimes saw myself and felt myself a soul in Hell, amidst a thousand wailing others, tormented by black leering devils far above us. And though I loathed and feared those devils, my only wish became finally to crawl to them and join their numbers; to escape my pain, to turn and torment the multitude of wretches I had left behind – to be oppressor rather than oppressed. I was going mad. Occasionally the knowledge struck me like a thunderbolt. But madness terrified me. And I would fight to shake off these morbid notions, push my way back to reality. Only to find that sanity frightened me no less. There even came times when I half-wished for total insanity, and the release it promised.

One night as I sat in the property I had rented near Richmond, Elizabeth returned home rather earlier than usual. She seemed in high spirits. She

came and stood before me, her face beaming, and said:

"He is dead. My father. I managed to find out." And she smiled as if the news should bring us both joy.

For months I had endured her ways in silence, giving no indication of the pain and revulsion they brought me; regarding it all, I suppose, as some kind of just punishment. But now, at this final outrage, all my control left me. I rose, thrusting out my arms, shoving her aside.

"Get out of my way," I cried, stamping to the door, throwing it open. "You would have killed him in time. If he had known you, if he had really known you, he would have died of grief and shame." I glared at her, my face twisted with anger. And she just looked back at me astonished. "How much more of you do you think I can endure? I don't want to speak with you. I don't even want to look at you. You disgust me. I cannot bear to be near you."

I turned and left, slamming the door behind me.

Throwing on my coat I went out and wandered the streets for a time until my anger cooled. I finally returned home a couple of hours before dawn. Elizabeth was still in the room where I had left her, sitting in the chair I had vacated. She looked up when I entered but said nothing, her features cold, impassive. I sat on the opposite side of the room, facing her.

"Elizabeth," I said at last. "We must talk. There are things I must explain to you."

She did not answer. And I went on to explain my

life to her, telling her of Helena, of all the things she had taught me, and of the understanding we had sought together.

"I know what it is," I assured her quietly, "to watch like gods humanity swirling beneath us. To know we may take at will whoever and whatever we choose. The power is exciting. But do you not see? This power, it does not make us masters of humanity. It makes us slaves. While we indulge it we are not even masters of ourselves."

But even as I spoke I knew my words were empty. They carried no conviction. I had so little conviction left in anything. And Elizabeth just sat and stared at me as if the things I said were incomprehensible or insane. At last she rose and left the room without a word. Any regard she felt for me died that night. And the knowledge of this brought me some sense of relief.

* * *

The next night I went out, and came back late. As I climbed the stairs I saw a shaft of light shining from inside one of the bedrooms, the door of which hung slightly open. I crept to it softly, glancing inside. Elizabeth sat on the bed, wearing only a thin white slip, unfastened almost to her waist. A young man was with her. He was naked, his clothes in a heap on the floor. He stood above her, lithe and muscular with handsome, sensual features, his body trembling with passion. Then he reached out, running his hands over her hair, her shoulders, then down onto her half-exposed breasts. She sat, rigid and unyielding, her

face blank and her eyes cold and expressionless as a statue. Her practice, as she had once confided to me, was to find two separate victims. From the first she would drain just enough to dispel the cold and pallor of her skin. Then, more often than not, she would indulge her vile tastes and watch the unfortunate man or woman bleed to death. Then she would go and find another and, still tinged and disguised with human warmth and colour, practise these bizarre and deadly games.

"That way," she had told me with a smile, "they never know. Never. Until it is too late."

Now he pushed his hands back onto her shoulders, pulling off her slip. And he sank down to his knees before her, kissing her neck and her breasts with intense ardour, beginning his love display to this exquisite creature who truly could be enjoyed by no man; who was cold and sexless as a stone and whose only desire was death. I looked on grimly, knowing what must come next, waiting dully for the final moment. But Elizabeth appeared intent on prolonging the game. She leaned up suddenly, throwing her arms about his neck, pulling him to her. And he rose up, poised above her, his body rippling, throbbing with excitement. She slid her hands along his back, stroking his lean smooth flanks, her body at last responding to him but her eyes hard and blank as before. The room was alive now, charged with invisible yet tangible power. And he jerked forward, thrusting at her, but at the last she rolled aside, depriving him of that pleasure she could not attain – that was dead in her. Cursing, he toppled clumsily

down beside her. Then he sprang up again, his face hard with anger. Elizabeth lay quite still on the crumpled sheets and regarded him silently.

"Whore!" he said through clenched teeth. He seemed drunk. "Damn cold bitch!" And he lashed out slapping her hard across her face. She just lay there and smiled at him slightly. He swore and struck her again.

Alarmed I went to move to her defence. But then I held back. A foolish impulse. It was hardly she who needed protection.

Now she raised her head, her face red from the blows. And she looked at him and laughed.

"You'll have to do better," she said in a whisper. "You'll have to work harder, before I reward you."

And he laughed too, grabbing her roughly, more passionately even than before. Elizabeth gasped suddenly and her eyes at once grew wide and crazed. And in this moment they seemed overcome, each blind to all but their separate desires. And the intensity of their desire, the power it created, and my own confused feelings at once unnerved and frightened me. For the instant I felt some sense of secret jealousy. Not, I must explain, the jealousy of a husband for his wife's lover. I could no more have envied that man in her arms than I could a beast led to slaughter. And besides, any physical desire I had felt for Elizabeth died naturally when her body became like mine, cold and barren of the human energies that gave me life and warmth. No. This vague jealousy was for Elizabeth – for her power to find release and pleasure without the tortuous burden of conscience. I almost

sobbed with shame, despising this bitter truth; but all this was fleeting, swallowed up at once by a stronger, more definite emotion. Remorse. A remorse so great it crushed my soul beneath it. Remorse for making Elizabeth what she was – for all the things that had led to it – and for this young man, sentenced by my actions to die; and for all the countless others that must follow him through ages to come.

In despair I closed my eyes. But the demons of my imagination allowed me no escape. For it seemed I saw them still, far, far away, beyond the darkness in my head, as if they lay at the end of a long black tunnel. And as they writhed in each other's arms I shuddered, for it appeared that a macabre transformation was taking place. That their skin was beginning to wither from their bodies, their hair to drop out, their eyes to bulge then fall from the sockets, until at last they were no more than two twitching masses of muscle, tissue and pumping organs. And then these things in their turn shrivelled away, blackening and dissolving into nothing until at last only white bones remained; two skeletons locked together in a fearsome embrace, still intent on spending their deathly passions. And it was as their awful lipless mouths met in the grinning parody of a kiss that there jolted through my brain the fear that again I tottered near the brink of some awesome madness. My eyes opened. I saw them both, whole once more, sprawled on the bed. Elizabeth lay staring up at the ceiling. The young man was still in her arms but now his body looked rigid, his skin white and wasted.

"It's all right," she called out suddenly, "you can come in now."

She had known I was there all along. I should have guessed it. This whole grim scene had been planned in spite and revenge; a wilful act of defiance against my pleas for restraint. I entered the room slowly, anger swelling in me. The scent of blood was strong and heady. It unsettled me. Elizabeth raised her head now, looking at me and laughing faintly. I should have preferred not to have risen to her taunts, but I was much too incensed to hold back.

"How dare you!" I told her, glaring at her. "How dare you bring this depravity here!"

"I had nowhere else to go," she shrugged. "I found him in a very exclusive nightclub up West. Though you would never think so to go by his manners. Positively frightful, to strike a lady. But anyway. I wanted him. And I get tired of killing in dark alleyways, it's all so clumsy and hurried. We couldn't go to his place, you see. He lives with his family. He thought they would be shocked." She giggled. "I think he was right, don't you? But if the rest of his family look nearly as good as he does, perhaps I'll pay them a visit one evening."

She turned to the young man now, staring hard at his still, handsome profile, ploughing her fingers through his thick black hair. Now she smiled, stretching out lazily, taking obvious relish from my distress. Next she took the young man's expensive looking cigarette case from the bedside table, lit a cigarette and blew a cloud of smoke towards me.

"You sorry old relic!" she said at last. "You belong

in a museum. Or locked away in an attic somewhere, like the family idiot of whom everyone is ashamed. Didn't you know, darling? This is the twentieth century. Morality is so old fashioned. Really, no one who is anyone bothers with morals any more."

She reached out, caressing the soft growth of dark hair that covered the bare white chest beside her with infinite tenderness. I was about to say something when the man stirred with a weak groan. Elizabeth stubbed out her cigarette then nestled close to him and whispered:

"Open your eyes. Open them. Look at me now. Hear what I say."

His eyes opened slowly. He tried to speak but he had no strength.

"Quiet. Be quiet!" she told him gently. "Save your energy. You only die once so why hurry?" He looked back at her dully. "But then," she went on, "I could let you live. I could even make you immortal." Her eyes met mine for a single moment. "Oh yes, I could do that." She turned back to him. "How would you like it? To keep those looks forever? It is my decision. Now! Will you live? Or will you die?" She paused, as if carefully weighing the matter. "But no," she said at last with a shake of her head. "I can't let you live. Really I can't do it. My friend here" – she turned to me with a ghastly grin – "he wouldn't like it. Oh, no. He wouldn't approve at all. But remember, it is his fault that you are going to die. Not my fault. It is all his fault."

How much the unfortunate victim understood of

any of this I cannot say. But Elizabeth kept up her awful charade until the final moment. "Ah," she said. "Just one last thing." And she lashed out, striking him hard in the face, giving a contented smile before she fell on him, and his faint groans of mixed pain and pleasure grew more intense, then faded away as violent convulsions shook her, and she rolled back gasping, throwing his body aside.

I stood by, devastated again as I thought of everything Elizabeth had been to me in those few months since the first time I saw her. To begin, an object of desire, then an instrument of revenge, but now, finally a reflection of my own dark nature; a living reminder of my evil, that was no longer contained in me but unleashed and embodied in her, forever beyond my control. The worst of my fears was realised. All along I had used her, manipulated her to my purpose. Now she made it clear that I would never do so again. And with total despair I knew that everything I had struggled to find with Helena was gone; discarded and lost forever.

Now Elizabeth sat upright, staring at me insolently, a single drop of blood rolling down her lip onto her chin. Suddenly I was acutely aware of her nakedness. I stepped forward, snatching up a sheet from the bed and throwing it at her.

"Cover yourself," I told her through set teeth, looking away. For a moment she just gasped in sheer disbelief, then she fell back screeching with laughter. I shook my head, feeling utterly foolish, knowing how ridiculous I was. And then I saw that about her neck she still wore the crucifix I had taken from her

182

brother and put there. It horrified me. It seemed the ultimate profanity.

"That!" I roared, pointing to it. "Take it off. Take it off now."

"This?" she fingered it, held it up towards me. "Well, make up your mind. One minute you want me to put something on, the next to take more off."

"Take *that* off!"

"No. Why should I? I like it."

She jumped from the bed and stood before me, still holding out the cross, still laughing. Cursing in fury I turned and stormed to the door. But then she called after me, her voice at once loud and harsh. Startled I turned back. She stood, her eyes blazing at me, her laughter all gone.

"I never knew," she said in a cold flat tone. "Until yesterday I never knew how much you hated me. You shouldn't. You have no right to hate me. If I've disappointed you it can't be more than you've disappointed me. You abducted me. You were strong and ruthless and you didn't care about anything but me. You brought me pleasure and power. More than I ever knew could be. You were everything I dreamed of and much more. But what do I find now? You are as weak and timid and contemptible as those you took me from. You deny your own desires and hold back from your prey as if you are afraid of them. And you ask me to do the same. You give me power and need, then tell me it is wrong to satisfy them. It is lunacy. I didn't ask you to make me what I am. But you ask me to be other than you've made me. And you ask too much."

Now she went to where her clothes lay, picked up her short frilly dress and slipped into it. Then she stepped into her shoes and went over to the mirror where she began to brush her tangled hair.

"When I've tidied myself," she called to me, "you'll have to help me get rid of the empties."

"Help you! You are insane. Why should I help you?"

She shrugged, went back to the bed and sat beside the corpse.

"Well, we can't leave him here. How disgusting." She reached down, patting the cadaver's head, smiling up at me. "Although I'm sure you will get tired of him before I do. But we must dispose of him carefully. We cannot allow a body to be discovered close to the house. It might cause us trouble. You will have to help me."

Furiously I saw that I must agree. The body must be bound and weighted, then thrown into the river nearby. It would then be advisable for us to leave this place at once.

"I will help you," I relented, "if you promise me never to do such a thing again."

"Another sermon?" she said in her most malicious tone. "You are becoming as bad as my brother. Next you'll be giving Sunday school lessons. But can't it wait? At least let's get rid of the body first. Or would you sooner stand here and argue about it all night?"

Together we wrapped the body in some sheets. At the back of the house stretched a small heath, and beyond this passed the Thames. Having gathered several heavy stones by the riverside and made sure

184

the way was clear, I threw the corpse across my shoulders and we set out, stumbling through the mud and over the lumpy ground. As we approached the river the bushes all about grew tangled and dense. Our progress became difficult as my burden snagged on the branches, and I slid and struggled to find my footing in the damp earth.

At last we emerged into a small clearing, making towards the river bank ahead. Then together we froze. Elizabeth's eyes caught mine. She nodded towards the thicket a short distance along the bank. Someone was hiding there, watching us, shifting uneasily. Glancing over I could make out his shape, well concealed though he was. And now I could hear his faint, fast breath; feel his body warmth carried on the breeze. I could not think what he was doing there – probably a housebreaker who came to reconnoitre the local dwellings. But a half-moon shone down on us. It was light enough for him to see us quite clearly. I became aware then that the bedclothes wrapped about the body I carried had caught on the bushes and come loose, and one limp, bare arm had dropped and swung in full view.

"Catch him!" Elizabeth hissed at me. "He doesn't know we've seen him. Catch him quickly. He must be silenced."

We moved away into cover behind a nearby clump of trees. Then I dropped my burden and went silently off through the dark. Our intruder had started to run as soon as he had lost sight of us. I heard him blundering through the undergrowth

ahead, his breath coming in short, frightened gasps. I moved alongside him until at last he emerged from cover. He saw me the moment I closed on him, springing forward, my fingers tightening about his throat as he went to cry out. Then I held him fast as he fought and struggled. The next moment Elizabeth was at my side.

"Do it," she said. "Quickly."

His struggles grew ever more frantic as I pulled him around, my muscles clenching as I stared into his twisted face and wide terrified eyes. A very young man, little more than a boy, really.

"Finish it!" Elizabeth urged, and she reached up, pulling back his head, exposing his throat. I pulled him closer. He was barely conscious now, but as I drew nearer his face grew gaunt, pale and stricken with the fear of death. I hesitated. Then I drew back. Again there flashed before my eyes the image of Helena lying mutilated and dead. I remembered that awful night in the vault when I had known death. Not the shadow, nor the illusion of death, but death itself. And I had feared it; its force, its dark endless unknown. It shocked me to realise suddenly that I still feared it. That truly I feared the thought of death as much as this luckless youth. As much as any normal creature.

I bit down into the soft flesh. As the blood came I was aware that Elizabeth stood observing me, and I hated the feeling of this. As I felt the struggles of the boy grow still, and his strength dissolve into my arms, I pulled back and let him drop senseless at my feet.

"What are you doing?" Elizabeth whispered sharply. "What is wrong with you? *Kill him*."

"It is not necessary to kill him," I told her firmly. "He will remember nothing."

"We cannot be certain of that!" she said. "We are outside our own house, and we haven't time to get away tonight. The risk is too great. He must be killed."

"No!" I replied in fury. What she said was true enough, but still I could not bring myself to do this, to murder in this cold and calculated way.

"*Coward*!" she spat, waving her fists at me. "You must do it. I can't. I have just drained the other one. I cannot drink any more."

In spite of everything I began to laugh. I was simply incredulous.

"What are you suggesting?" I said. "Are you reducing this conflict between us to merely a matter of wasting blood?"

I turned away. And in an instant she darted forward, kneeling beside the unconscious youth, digging her fingernails into the small wounds I had left, tearing clumsily at the flesh so that I winced at the ghastly sound as she exposed the artery, like a piece of cord, then severed it. A great jet of blood spurted out, drenching her.

"There!" she said, looking at me with contempt, a dreadful sight, her clothes, face and hair all soaked with crimson.

I looked down at the body, blood still bubbling from the awful gaping wound. Then I sprang at her, every vestige of restraint gone, grabbing her throat

and shaking her like a doll. Her legs buckled and her eyes swam as I tightened my grip. She beat at me, clawed at my hands and tried to prize open my fingers, but I would not free her. Then her body grew limp and she breathed no more, and my rage was fading into despair as I loosened my hold and flung her down, staring in disbelief at her twisted lifeless form. I staggered back, barely able to comprehend what I had done. I was more monstrous even than she.

But then her body trembled and sprang back into life, gasping and choking with shock. She glared up at me, then she smiled and all her arrogance returned.

"Go on, then," she said. "Kill me, if you really know how to do it. Destroy a life that you created. Hah! You haven't the courage."

I strode off, back to the house, and she whispered taunts after me.

"It is fortunate you couldn't kill me. Then you would have been forced to dispose of the bodies yourself. And mine as well. I know how such things distress you. But don't worry. *I am here to do your dirty work!*"

For the rest of the night I locked myself away in an upstairs room. I heard Elizabeth return shortly before dawn. I never learned what she did with the corpses.

When at last she slept I emerged and went about the house, gathering my personal things. I knew the decision was weak and wrong, but I had to leave.

The next evening when I rose I departed at once.

XII

Evil: for so long it had lay brooding close beneath the surface of my existence, a creeping amorphous thing. Now it had festered to find lasting form. Elizabeth had blasted my world like a thunderbolt, shattering its fragile structure, then taunting me as she stood amidst the ruins. Unleashed from the confinement of her human life, like a wild beast from a cage, perhaps twisted by an unnatural upbringing, she possessed no feelings of inner conflict or loss; none of the things I now realised had allowed me to see in evil a terrible depth, a vastness that amounted to a sort of monstrous grandeur. Spiteful and remorseless, it was her smallness of vision, her sheer brutal simplicity that I found hardest to understand.

But what had first drawn me to her? This question plagued me most as I ran from her. Was it just a calamitous mischance? Or did it run deeper? Like going to like. Evil seeking out evil with infallible instinct.

I made my way back to my house in Cornwall, where I had not been for some years. A long time before I had set up a trust to preserve it, although by now, for all I knew, it might simply have been forgotten by the authorities altogether. I had also sold various properties and possessions over the years, making investments with the proceeds to protect my finances. But as time passed I came to find them increasingly complicated and tiresome, these delvings into human matters.

The old house and grounds had stood derelict for so long now they looked reminiscent of the palace of the Sleeping Beauty during its dormant century. But this in no way distressed me. In fact I preferred it so. I had little love for the modern world that was forming about me, with its frivolous, foolish new generations. It seemed this house was the only place that remained unchanged, and to which I truly belonged.

Often I spent hours wandering in the gloom, deep in my thoughts, sometimes walking in the local churchyards and occasionally finding stone memorials to those who had been my human contemporaries. In some ways I was more miserable alone even than I had been with Elizabeth. At least while I had concerned myself with her I had been kept in part from the dismal, lonely reflections that assailed me now.

Over the years, with Helena's aid and example, I had come to convince myself that my kind existed naturally. Freaks, aberrations of nature, certainly, but belonging to the natural world. Yet lately I had begun to question this. Every old doubt, long banished, rose up to take new shape. That death ruled the world was a simple truth. But it seemed I stood immune. How could I pretend to be part of nature when I defied her most potent law? And yet if I was supernatural! Infested by formless evil, doomed to wander the earth as a parasite, a mockery of everything natural and good, feeding on destruction. Was I any of the things men had ever called me? Incubus. Vampire. Revenant. The name barely mattered. It did not change what I was.

"The spawn of darkness!" I would speak the words in a low whisper, a fearful whisper that echoed through and through the house. Looking back it appeared that all I had ever done had come to evil — as if that were my inevitable destiny, and all else far beyond my reach. Again a host of devils seemed to form and gather and leer at me through the darkness. Perhaps, they said softly, I was but the child of the time and society into which I was born: that used its power to ravage the world, taking all it wanted, serving its own ruthless ends yet seeing always what it chose to see. Keeping intact its ludicrous delusions of morality and correctness.

I was afraid.

Several weeks after my return to Cornwall I sat one night in my old study, brooding over these and other things in silence, when I became aware of a light, familiar step outside. The door to my study swung open but I did not turn about, just sat staring down at my hands, clasped together on the desk.

"How dare you!" Her voice was filled with anger. "How dare you leave me. What right had you to go away and leave me alone?"

"None," I replied, still staring down. "It was wrong."

"Did you think you'd lose me? Did you think I couldn't guess where you'd come? That I never took the chance to search through your papers and things, to find out about you; who you were and where you came from?"

"No, Elizabeth. I knew you would find me."

And as I said this I knew it was true. I looked up at

191

her. And when she saw that I would not argue the matter she turned sharply and sat in a chair, facing away from me.

From that moment there was forged an unspoken truce between us. For all the things that divided us, there was still more that bound us together. Apart from each other we were utterly alone. And despite the fact that my life with her was the perfect mockery and dark reflection of all that my life with Helena had been, there remained nevertheless a bond between us that was nearly as strong as that which I shared with Helena. I was responsible for her. And most certainly now I would never create another to be my companion. Without Elizabeth I would be forever alone. Had I deserted her, I would force her to create her own companion. And so the disease would spread. I imagined a tribe of revenants with Elizabeth its teacher and I its father. It was too terrible to contemplate. But while she sometimes taunted me with threats of creating another, she never did so. I doubt that her nature would easily have endured a dependant. I think that truly I suited her as a companion, and that she found some perverse satisfaction in our opposing natures, and the conflict between us.

Yet it would be wrong to suggest that our companionship did not serve my own inward needs. The need to do penance. The need to suffer as I knew I deserved, and to seek within that suffering a distraction from the knowledge that my life would continue forever, which remained always terrible and unimaginable to me.

So years dissolved into the past, bringing no change to Elizabeth or I, except for the gradual evolution of a weary half-tolerance for one another. She remained as ruthless as ever, spreading death as she chose, while I lived from day to day and bore the guilt for it all.

The second war with Germany came and passed, and in the decades that followed it the world changed more totally and rapidly than I might ever have thought possible. And I hated it, more and more. Remote from it, yet trapped in it, it held nothing for me, meant nothing to me, this new world with its swelling population, its frantic pace, glaring lights, blasting noises; its roaring, stenching machines, foul air, hard grey streets and towering buildings. Its growing irreverence and careless sensuality. And all with me was hopeless and static. The purpose, the growth of understanding I had sought with Helena was gone. Alone I was not strong enough to keep sight of it. I was lost and drifting, seeing nothing ahead but the desolation and madness I feared. And I no longer pretended to understand anything.

Now I sought more and more the sanctuary of my remote Cornish home. Often I went there alone while Elizabeth lingered awhile in some town or other, for she was always as fascinated by humanity as I had once been, and soon grew restless and tired of the quiet lonely places I now preferred.

On one such occasion I returned home, taking a train to Bodmin, then arranging for a car to drive me to the outskirts of a village near my house. I walked the last couple of miles in the very early hours of

morning. I would travel in trains and cars no more than was really necessary, and a walk though quiet countryside afterwards was pleasant.

Walking through the fields and woods I approached the house from the back, past the small cemetery and tomb, across the overgrown garden, along a cracked, narrow stone pathway that stretched between the high grass on the lawn. The night was dark and stormy as I stood awhile, gazing up at the tall Gothic towers and spires, dark and eerie against the heavy sky, but familiar and comforting for all that. And it was as I looked on the house from a distance that at once I thought I saw movement in the shadows near one of the back doors. I stiffened and stared hard. For an instant it seemed that a vague figure moved swiftly, then stopped momentarily, as if suddenly aware of my presence, before vanishing completely. At once I rushed forward, fast as I could, to the spot where I believed the figure had been. But I saw nothing more there.

At once I felt an urge to go and search inside the house; to make sure my sanctuary was not invaded or disrupted. I produced the key, turning it with trembling fingers in the rusty lock, and entered quickly. I wandered all about the ground floor, then down into the cellar where my father's high racks of vintage port and brandy still stood, coated with inches of dust. All appeared as it should be. As I had left it. Curiously, though the property was badly dilapidated, it had never suffered any human invasion, not even from adventurous local children. No doubt it had acquired a reputation for being haunted.

Now I climbed the wide staircase to the upper floor, walking across the landing, staring from a window down into the back garden, rubbing thick dirt from the glass.

The wind whipped at the grass and trees and the night seemed alive. From all over the house came sounds: rattlings, creakings, scufflings. These things were not unusual. But that night was unlike any other. A sense of inexplicable strangeness hung all about. It was not just what I thought I had seen in the garden. In fact for the moment I pushed that to the back of my mind, dismissed it as another of those shades my imagination was at times inclined to conjure. But something unsettled me.

I walked down the long corridor, to the door of my old bedroom. I pushed it open and it swung back with a discordant creak. Inside everything was familiar, but yet strange. It was years since I had ventured into this room. And nothing there had been touched for virtually a century. Bed, desk, chairs, books; everything was as it had been when I was a young man; except that now it was all damp and crumbling, covered like the rest of the house in dust and mould and cobwebs. A hidden remnant from more than a hundred years ago, stagnant and forgotten. But it brought such memories, of my human life, of Helena, of my dreams of passion and power – the prelude to immortality. And as I sat caught up in these recollections I became gradually aware of something – a faint but unpleasant odour that clung to the air of the chamber. It was not just the cloying mustiness that filled the house. It was sharper than

that. More pungent. It was the smell of something starting to decay.

All at once I became aware that there was some other presence with me in the room. My hand reached out slowly, grasping the curtain drawn across the other side of the bed. I hesitated. I was frightened. Something was beyond that curtain, something I feared instinctively. Something I knew would be beyond my every comprehension. I did not want to see it or know it. But it must be faced. Whatever it was it lurked in my home. In my room, behind that worn curtain. And it must be confronted.

In an instant I tugged at the rotting cloth and it tore between my fingers as I ripped it aside.

A thousand visions of Hell could never have found anything more dreadful than the figure I saw stooping over me. Its eyes bulged at me, sunken in bluish sockets, its yellow skin dry and scaly, stenching of death. Its shrivelled lips and chin were smeared with black dried blood, and tufts of hair were gone from its head exposing flaking patches of scalp. A vile resurrected corpse that rotted as it stood.

All this was frightful enough, but my real terror came as I stared deep into the face of this heap of animated corruption. For beneath it all, the horror and disfigurement, the face I saw was easily recognised. *It was my own.* A terrible distorted image of myself. What I had always dreaded most – to see myself as I feared I truly was: the hellish remnant of what was once human. A twisted parody of man and of God; tainted with blood and guilt.

I sprang to my feet, stumbling across the room,

196

crying out and covering up my eyes like some terrified child, inwardly praying to God or the Devil or to any divine power that might hear me and deliver me from the sight of this abomination. My own sobs rang in my ears as I half-swooned against the wall, choking and gasping. Then, gathering some strength and control from somewhere inside me, I looked up again. It was gone. I stared into the gloom, trembling, my heart pounding. Then I saw it again, emerging from behind the curtain drawn about the foot of the bed. It leaned towards me now, gibbering, dribbling, stretching out its shrivelled, shaking hands as if to grasp at me. I cowered back as it approached me, a look of astonishment on its obscene face to mirror my own. Then they fell open, those distorted lips, wrinkled in a deranged grin and omitted a few slurred sounds; the voice hoarse and quite unintelligible, as if dredged from some great murk of inner turmoil. I watched transfixed as it tottered forward. But then I saw and I knew. On the wall behind it I saw that old portrait I had found and hung there all those years before; the discovery of which had been the start of it all. The portrait from which my own features seemed to stare imperiously out at the world. The portrait of my own ancestor, of Helena's brother: William LePerrowne.

XIII

For long moments we both stood and stared at each other in silence. It must be William. It could be none other. And the knowledge of this rendered me incapable of any other thought. I simply watched him there, nodding and sighing at me, until I heard movement behind me and spun about. Another figure was there, hurling itself upon me, another revenant, gripping my shoulders with frantic strength, clinging to me as it thrust me back hard against the wall. In an instant I struck out, a terrible rage starting to grow in the midst of my confusion, knocking my assailant to the floor; but only for an instant, then he was back upon his feet, crouching down ready to spring at me. A brown haired man, young in appearance, in plain black clothes and overcoat. I raised my hand to stay his attack. Although my body was ready to fight, some part of my mind seemed scarcely present there within the room. After several moments the stranger drew back and spoke.

"He . . . we . . ." he pointed over to William ". . . have been waiting here. We came to find Helena. Someone called Helena."

His voice carried a gentle accent of some sort, but I was in no mind to identify it. At the mention of Helena, William showed some signs of excitement, mumbling, shaking his hands and swinging his head back and forth; but then it all died as rapidly as it

had begun, his face contorting miserably, as if he were about to burst into tears or throw a fit. Then he fell silent, staring dejectedly down at the floor.

"Too late!" I mumbled blankly after a pause, the words at first sticking in my throat. "It is too late. She is dead. Helena is dead."

William looked up, seeming to frown and glare at me momentarily, as if he were quite sane and I was a lunatic who failed to understand any of this. Under other circumstances the expression might even have seemed comical. But then he grinned again and turned away, muttering incoherently to himself.

His companion still stared at me, studying my face. And when I looked back at him he shook his head and said bewildered:

"Dead! Dead, did you say?"

"Yes. Dead. Do you understand? The number of interpretations you may apply to the word are limited, even in our unfortunate condition." I spoke with a sudden vehemence. The memory of Helena was at once more acutely painful than it had been for many years.

He looked at me a moment longer, then went over to William, taking him firmly by the shoulders, staring into his poor mad face and speaking to him sharply.

"No. Listen to me. She's dead. Can you understand? It's over. Helena is dead." He turned back to me, shaking his head. "I don't know if he understands. Or ever will. Not now. His mind has gone. There is nothing left."

But I barely heard him. I was no longer able to contain that rush of gathering rage.

"*Why did you come here?*" I cried, turning on the mad, gaping creature, seizing him by his collar, pulling and shaking him. "Why? Why did you have to come back?" And I hurled him flinching and whining from me, turned and fled the room, hardly yet knowing why I did so.

By the time I had hurtled down the stairs and crashed through the door of my study, I understood. And I sat at my desk, clamping my hands over my face, crying out aloud:

"It was him. All the time. Oh, you must have loved him. Your precious brother. Loved him so much you couldn't bear to lose him. Not to humanity. Not to death. So you infected him with the disease, with the evil. Took him in your arms. Worked away your forbidden lust upon him. But you did lose him. He left you. Then when you found me, his very double, you plotted and schemed from the start to hold me, giving me all your fear and guilt, moulding me into what you wanted. Blinding me and binding me to the tortured thing you were. Maximillian knew. My God! He warned me. He was always right. Idiot! How have I never understood? It was never me you wanted. It was William. It was always him."

And in a moment came the memory of something Helena had once said to me, on that bleak winter night in London, long, long ago; after she had taken me to Maximillian.

"I should never have made you like myself!" she had said. "It was weakness. *I pray you will never know what weakness it was!*" Subtle, insidious words.

I sat absorbed in total misery. It was not only hurt pride. Not only rejection and broken illusion, though that was painful enough. It went far deeper. For the memory of Helena, of the love and understanding I believed we shared, had long been my only strength. My last hope that there could be any goodness or redemption in my existence. But now this too was swept away, and nothing remained but desolation.

"We are all the same!" I whispered. I was thinking of my own unnatural line. Of the repellent hypocrite Maximillian, who could convince himself that any atrocity might be justified with perverted sophistry. Of Helena, struggling hopelessly for purpose and reason in the face of chaos. Of myself, with my ridiculous pretensions to human morality. And of Elizabeth, who cared for nothing but her own desires. Each of us from a different century and age, representing the ways and thoughts of a different time. Yet each of us finding our own inevitable path to evil. It all seemed like one of those grim Greek tragedies my tutor Soame made me read as a boy. Cursed by a tainted line, pursued throughout centuries by a black and relentless fate; by vengeful furies that gave no quarter.

I do not know how long I sat before there came a faint scratching at the door. Wearily I looked up. The other revenant, William's companion, stood there.

"I must speak with you," he said.

"Enter!" I told him abruptly, indicating a chair. "Sit. Speak."

He sat, staring at me, then all about the room in agitation. He looked at me again. He seemed lost for words. Plainly he feared and distrusted me, though that was hardly surprising. I stared back, raising an eyebrow.

"I want you to help me!" he blurted suddenly. "I don't . . . I can't understand any of this. And the more I see and hear, the less damn' sense any of it makes. Ever since he made me like I am . . ."

"How long ago did it happen?" I interrupted.

"A few months. At my home in Ireland. He was mad then but he's got much worse since. He was obsessed with getting back here and finding Helena. But he couldn't have made it alone. He needed me."

I nodded. I began to appreciate all his fear and confusion. When I had become a revenant I had known similar feelings. But I had had Helena to guide me. To have been ushered into this existence by that mad, shambling thing upstairs – and for no better reason than to help him get back home – must have been terrifying indeed.

"I had no choice but to follow him and do as he wanted, until I could begin to understand. I had to come here with him, to try and find some other like me." He scowled with disgust. "He can't do anything for himself any more. I even have to help him feed."

"But his condition," I said. "What happened to him? Do you know? What made him the way he is?"

"I don't know!" he shook his head, staring downward. "He didn't speak of it. Never. He was raving

202

mad from the start. He told me almost nothing." He paused for a moment. "He told me . . . he told me that we do not grow old. And we do not die." His eyes grew wide as he looked up at me suddenly.

"Did he?" I replied.

"But . . ." he spread his hands in a gesture of bewilderment ". . . it seems that he is dying. Something in him lives on, but I've watched as his body withers and dies. And I've thought: is this it? The immortality he speaks of. Living decay? And now you tell me that Helena is dead."

"Yes," I said with a quick harsh laugh. I believe that something within me found a cruel pleasure in his distress. "Ah, yes. Death. The supreme terror of this modern time. The Antichrist of your age. With their medicines and machines the men of today cling to a few extra years of life. Fewer babies die in the cradle, fewer women in childbirth. And so they try to forget death. To regard it as a distant unreal thing. In my time death lurked about us, young and old, in a thousand forms, and we could not ignore it. Even in the nursery we were urged to reconcile ourselves to it, prepare ourselves for it." Then I said: "No, the Great Beast of my age was sensuality. Dark disruptive passions. And frivolity. Those things which have become the delights of today. And it is a strange thing, but to me, who has lived in both times, these alternate fears and obsessions – passion and death – they are the same. They are one."

He looked entirely confounded, and I dismissed all I had said with a wave of my hand. These were my private reflections, voiced only in bitterness, and

doubtless he would think them trivial. I was simply struck suddenly by the sheer irony.

"As far as I know," I went on, "our lives cannot be measured in human terms. Perhaps we really are immortal. Certainly we may exist for centuries, and we are not susceptible to natural ageing. Helena died violently. By dismemberment. The brutal destruction of a vascular system powerful beyond belief." I rolled the words out flatly, my voice conveying nothing. "But what is happening to William is unlike anything I have ever seen or heard of. It is as you say, as if something has brought death upon him, but because of what he is life will not finally desert him." I frowned. Once again anger was seeping uncontrollably into my words. "Death is not so terrible. It is like anything else. It seems much sweeter when you know you cannot have it. We exist in a void between life and death. This creates a void inside ourselves. And within this void lurks a devil who drives us to his will, into endless misery and corruption. The longer it lasts the more terrible it becomes. So! If you come to me seeking hope or comfort I must disappoint you. I can give you nothing."

My bitterness rose again, but now I lacked any will to restrain it. I stood, walking swiftly to the shuttered windows, peering through a crack into the grey wilderness outside. From the corner of my eye I saw him sitting, regarding me solemnly. Then his eyes blazed suddenly with all the power of his lost humanity.

"But what of God?" he said faintly. "*What are we to God?*"

I began to laugh now, as I turned to gaze at him fiercely.

"I have existed for more than one hundred and fifty years," I said, "and I have known less of God with each passing day. I know nothing of God. Yet in spite of this, I feel that I know God better than He knows me. We do not concern each other much any more, the Almighty and I."

He did not answer, but simply stared at me, his poor face white and aghast.

"What did you think?" I told him. "That we are angels placed upon the earth to spread joy? Well! Have you learned now what you needed to know?" I laughed again. "Do not worry. You cannot offend me. You look upon me and see everything you must fear. You see what is worse than disease or death, what is more dismal even than the condition that William is in. In me you see what you may become. And if you look to God, being what you are, then I am surely what you will become. Beyond this I am hardly fit to advise you. Find your own answers. They can be no worse than mine."

He looked back at me, but still said nothing.

"It will not help us to talk any more tonight. No doubt you have noticed that I am not in a bright mood." I glanced again through the crack in the shutters. Outside thick morning mist was forming over the high grass. "It is dawn," I said. "Leave me now. Go and attend to William. Then rest. We can talk some more later, if that is what you wish."

He rose and departed at once.

* * *

Over the following nights, William's companion – whose name was Niall – and I circled each other like wary felines, speaking together of little but William's condition, which seemed to deteriorate visibly as we attended him: his form growing ever more shrunken, his eyes more lost to reason. William remained an enigma.

Soon afterwards Elizabeth arrived. When she knew the situation she drew the same conclusions as I, and threw back her head with a burst of laughter.

"Aha!" she cried. "So the pure and wonderful Helena turns out to be a fraud after all. Incest of all things. That's something I never tried. Should I be jealous?"

"My dear," I told her with a shake of my head, "it isn't any use. You cannot antagonise me any more. I should have thought you would have realised it. I am beyond caring." And this seemed the truth. What I felt now was just an immense weariness. A vague wish simply to lay down and sleep peacefully throughout eternity. A futile wish, indeed.

Nevertheless there was one thing that astonished and almost amused me. That was Elizabeth's reaction to the presence of William. She – whom I had thought beyond a sense of physical disgust for anything – regarded him with intense revulsion. When she looked upon him she actually appeared to shudder. And she could not bear to remain in the same room as him for even the briefest time.

But I, on the contrary, found myself increasingly fascinated by him. I could not exactly explain it, but rapidly I lost all the initial horror I had felt for him. I found it remarkable to sit and observe, hour after hour, this supposedly eternal being decaying, stenching, dissolving like any human corpse before my eyes. And this macabre fascination soon grew to become intense. I wanted to know why. I wished to understand how it could happen, and what could have caused it. I tried again and again to speak to William, to make him understand me. But it was no use. His mind was as dead as his body. Only the supernatural life force remained.

So the question of William came to haunt me more and more. An idea had formed somewhere in my mind, yet it was so awful that I hardly dared realise it. But it returned to me constantly, this shadow of a thought. I felt drawn to it in the way I had been drawn against myself to the notion of invading my family tomb and opening the coffin of Helena all those years before.

One night I sat alone with William in the master bedroom, where he stayed most of the time, just gazing into the gloom. I looked at him and wondered how much longer he could endure. How long would it be before his body utterly disintegrated? How might even his life continue in such a form? Occasionally Niall would feed him – an unpleasant duty which Niall seemed to accept as his – by returning from feeding himself, then letting William suckle drops of fresh blood from a vein in his arm. But this brought no improvement to William's condition. And as I

considered this, and listened to him breathing hard and painfully, there came a strong sense of urgency. If my attempt was to be made, I felt it must be done at once.

At last I rose, moving to him, taking his shoulders and pushing him down onto the bed. His eyes looked up at me, but did not seem to see me as I leaned down towards him, clasping him to me, ignoring with difficulty his fetid skin and breath, his dreadful proximity, his burning cold. And I lay beside him, flinching with disgust, forcing myself to draw forward, placing my lips on his neck and gnawing slowly at the dry, rank flesh, until at last I tasted the polluted fluid in his veins, clotting and vile. I had no idea of the effect this lifeless blood might have on me. It might make me ill. It might even poison me. There was no flood of power, none of those hot waves of strength and relief that came from human bodies; only the icy blood, oozing onto my tongue and down my throat, making my stomach shudder and heave, and then a sense of darkness spreading before me, a bleak winter land that pulled me rapidly towards its lifeless wastes. Every instinct urged me to draw back, to spit and vomit out the filthy blood, but I resisted, drained him harder still until it felt that my whole body was consumed by cold, like the cold that was hunger, but worse; more sickening, more painful, as his body shook then grew limp beside me. Then, gasping and choking, my head pounding as if to split, I felt myself thrown back, as if by a great force, rolling from the bed, crashing down onto the floor. I lay there a few moments, groaning and clutching at the

pain that writhed in my stomach. Then I rose and staggered forward, sitting on the bed beside the twisted, motionless form there. He remained still as I studied him closely. His eyes were half-open and glazed. A thrill passed through me. In his weak state it seemed I had succeeded in throwing him into that trance-like condition into which my human victims always fell. I bent over him, looking for a moment at the brown blood that fast congealed about his small neck wound.

Whether this attempt could meet with any success I had no idea. I had once read that hypnotists could use their art to unlock and draw out anxieties, fears and memories buried deep in the subconscious minds of their subjects. Whether this process could be employed with madmen I did not know. It seemed doubtful, but then, we were not men. Our minds were powerful and preterhuman as our bodies. William's mind had endured through centuries. His conscious thoughts were lost. But his unconscious. If anything remained there, behind the tangle of insanity, could it be reached? Now that I had induced this trance, opening the depths of his mind to me, I believed it might be possible.

I spoke to him softly.

"Hear me, William. William LePerrowne. Hear me and answer me." There was no response. I went on, my voice becoming stronger. "Understand me. Reach out to me. You will cast back into your mind. You will find form and memory there. Obliterate the present. Remember long ago. Remember Helena. And the time when your human life ended. Send your

thoughts back to when the change occurred in you. Hear me. And obey me. Now answer."

He lay without moving. The faintest breath was all that stirred in him. I repeated my instructions several times, each time more insistent, and was about to do so again, when at last he gave a long sigh, and frowned as he tossed his head from side to side. I grew rigid, at once lost for words, then I gathered my senses and restated all I had already said.

"If you hear," I urged, "if you understand, answer me. Speak."

"I am sick!"

I jolted back, startled as the voice broke deep and sonorous, utterly absurd as it came from that frail, withered body; like the voices of Chinese mandarins or Indian chiefs raised from the lips of housewife mediums. Or reminiscent of that ancient revenants' tale of necromancers revivifying a corpse to speak secrets of the dead.

"I am near to death," the voice continued after a few moments. I listened in a state of excitement and wonder. "The physician has been with his leeches and his foul smelling potions, but I am beyond his skills. I have been ill so . . . so very long. I do not wish to die . . . God help me I fear death . . . and yet . . . the thought of release from this pain . . . from this horrible pain . . . aah!" He paused again, then his voice dropped to a rasping whisper, as if to impart some great secret. "Last night . . . last night I did see her. *Helena!* She has been dead these three years and yet I know I did see her. I beheld her once before . . . soon after she died, and yet all said it was brain sick-

ness caused by my grief and fever. But . . . I swear
. . . last night I do swear I saw her. She came to my
chamber and awoke me. The servant who attended
me slept. She laid her hands on me to cool and ease
the heat. She held me . . . so cold . . . she spoke. She
said . . . she said I must die . . . but that I should not
be afraid for in death I should be with her. I believe in
truth it was her spirit I saw. That she comes to carry
me into death. And now I fear it less."

"Enough, now," I told him gently, stammering
slightly. There was nothing to be gained from hearing
the rest of this. I must take him further forward.
The hold I had gained over his mind was, I feared, a
tenuous one, suspended like the sword of Damocles
by a thread that might snap at any moment. I must
learn all I could as quickly as possible. "Go forward
now, to that time when you and Helena parted. Tell
me why you parted. Tell me what happened between
you."

He was quiet for a few moments, but then he went
on.

"I have left Helena. I have left her . . . I can no
longer exist as she would wish. I cannot forever deny
my needs as she does. My nature is too strong and
eternity . . . eternity is too great an adversary.
Helena seeks through restraint and contemplation to
find peace with herself; a constant evolvement of
thought and perception to guard her mind against
the passing of ages, and the degeneracy and mental
decay to which our species becomes susceptible. But
so blind and vague are these efforts. The loneliness
and frustration they bring become wearisome as

decay itself. And as destructive. I can no longer seek for understanding inside myself, where I am no more convinced it is to be found. But" – again his voice fell and grew so faint that I drew closer to him – "there is among revenants a persistent legend. Helena related it to me once. No doubt she heard it from that one who was her initiator." His breathing grew sharp for a moment. "It is professed by some that there exists one ... one who first sought and discovered this power of endless life. The first of revenants. The Master-Revenant. And we are all his progeny."

"What?" I sat upright with a start. "No! That is only a myth. A fable for unholy children."

William went on, paying no heed to my interruption.

"Many things are said of this Master. It is claimed by some that he was never wholly of mortal birth, but that he was conceived of a witch through her copulation with a powerful devil. But I doubt this is any more than base superstition. Yet it is said ... it is said that he still lives, this perpetrator of our kind, somewhere on earth. I am determined to learn the truth of this, to seek him out. Helena says she will not accompany me. She says I am a fool. She treats the matter with greatest scorn and claims to believe none of it. But she cannot know. And this is not her true reason. Her reason is that she fears what she might find. And that she may learn what she truly is. I am myself not insensible to these fears, and yet ... to see him. To learn from our progenitor from what we are come ... the genesis of our kind ... the reason for our existence. The mysteries of life and

death. This is purpose indeed. Purpose far beyond the feeble strivings of Helena."

My mind was spinning in my efforts to absorb all this. It seemed like utter madness, and yet I must reflect that there was no real reason why William's astounding belief could not be true. If indeed there had been a first one of our kind, there was no reason why he should not still exist. Somewhere.

"And so," I said, keeping that same flat tone, quelling my urgency only with greatest difficulty, "you set off on this search. This quest. What did you discover? Did you ever learn the whereabouts of the Master? Remember!"

There was a long silence, then in desperation I urged and coaxed him some more. When at last he spoke his voice was different, tired and lacking its former strength and resolve.

"I . . . I have journeyed far and sought long . . . long . . . long time. Aaah! I have sometimes sought out other revenants, scattered far apart, living usually in pairs or small groups. Their numbers seem few in spite of our longevity. But they are always secretive and never easy to find, and they will often attack intruders of their own kind. Of the Master I have followed countless vague rumours and false trails, but withal I have learned little of real value; only details which further my conviction that his existence is a reality. It is said that he came first from the East. He journeyed with his followers into eastern Europe, where for long ages he remained. But as certain men in these lands learned of his cult and suspected his presence he departed, travelling on, settling at last

in a land in the West. But I know not whereabouts. I know not." A long pause. "I . . . I grow weary. I fear I must search forever. And that . . . that is how long I have."

Now he gave a deep sigh and fell silent again. There was much I might have asked him, but I dared not risk the slightest digression. I must press the subject of the Master while the chance remained. But before I could say anything more he spoke out, his voice charged suddenly with power and excitement.

"I believe my search is near over. That at last the knowledge I have so long sought is close to my possession. I have encountered a revenant. He is old and infinitely strange, though he has the face of a young man. He is unlike any I have known before. Something about him . . . but it is beyond anything I am able to define. His two children guarded him, in the ruined tower which was his lair, and flew screaming at me, yet they were young and I fought them and scattered them. I showed them my strength. Then I burst in upon him and demanded knowledge. He did not seek to fight me, though he did not fear me. But he has the knowledge I seek. How he gained it he will not say. He speaks of these things only obscurely, and I sense they bring him pain. There is, I believe, a part of him that wishes to make the journey with me, but something else that lacks resolve. I must win what I would have by persistence." There was a brief pause, and then: "He has relented. He has told me where the Master will be found. He will accompany me there, he says,

and make at last his own pilgrimage to the oracle of revenants. *At last*!" A cry of triumph. "The end is in my sight!"

"*And where*?" I broke in, incapable of restraining myself any longer. "Where is he to be found? Repeat to me what this revenant told you."

"In Ireland," he said. "A place in Ireland." And then he launched into a long and frantic babble of strange sounding names and places that meant nothing to me, but that I tried desperately to fix in my mind that I might remember them later.

Then a voice behind me said:

"I know these places."

I turned. Niall stood wide eyed at the door. In the passageway behind him was Elizabeth. I had no idea how long they had been there. I had been too firmly preoccupied with William.

"They are all not far from my home," Niall went on, walking forward, kneeling beside me and staring at William.

William went on, as if reliving at immense speed the final stage of his great odyssey, and Niall listened intently. He talked of villages with obscure sounding names, of hills and paths and of certain landmarks. Then he spoke of an ancient cairn of stones, and of a great cavern.

"Do you understand this?" I said at last to Niall. "Does it mean anything? Do these places exist? Could you find them?"

He looked up at me, grim faced, then he nodded.

"Yes," he said quietly. "I know these places. Ever since I was a boy."

He was about to say more but I motioned for silence.

"And finally," I said to William. "What did you find? What of the Master? Did you see him? Did you prove his existence? What did you learn? Tell me now."

"I . . . I . . ." at once his tone changed again. He grew frantic, and uttered nothing but choking, incoherent sounds.

"Enough!" Niall whispered to me. "Let him rest."

"I dare not!" I hissed back at him. "We will lose him." I grasped at William's bony shoulders now, pinning him to the bed and shouting: "*Speak! Remember!*"

He was screaming now, his sunken eyes rolling in terror, struggling with amazing strength, clawing at me with shrivelled fingers.

And then he was quiet. He sank back. His body appeared to shrink and collapse beneath me, as if his bones at once dissolved into water. His eyes glared while his breath rose quick and harsh.

"Too late!" I said, and released my grip on him, burning at once with anger and frustration.

We said nothing for several moments, each collecting our thoughts, then Niall spoke.

"What do you make of all that? Do you think it could be true?"

"Of course!" I replied. "It is clear that William went to this place in Ireland. Whether he found what he sought there, whether it truly exists, we cannot know. But something, some terrible accident must have befallen him there. He must have escaped it

with the last of his strength, made his way for a short distance until he could go no further. And then, driven just by instinct perhaps, he made an accomplice of you, Niall, to help him and bring him back here, his old home, and to Helena, seeking in his madness to obliterate his horror and pain, and the memory of what had happened to him. Seeking sanctuary in the past. I cannot say that I have never done it myself."

"Accident. What kind of accident?" Elizabeth spoke now from the doorway.

"How should I know?" I said. "But what would happen to us if we were to drown? Or to burn? To suffer any of a hundred things no normal creature could survive." I pointed to William. "Is this the effect it might have? This slow bizarre battle. Life and death struggling for dominance."

We fell silent again, until at last I said:

"There is one way to find out. These and other things. We must go to Ireland."

"You want to go there?" Niall said. "Even after what happened to William?"

I looked at him in surprise. It had not for a moment occurred to me that I should not pursue this chance for discovery, regardless of all possible danger or disappointment.

"I know this," I said. "That I have been as a dead thing these many years. But that tonight in this room I have felt alive again. Do you see what this means? Several nights ago, Niall, you came to me and asked me to tell you what you have become, and why. But I could give you nothing save

my bitterness and fury. All my life I have tried without success to understand these things. To overcome the endless conflicts that rage in me. Until at last nothing has meaning. Nothing. And all I know is that if it is even possible that he exists – this Master-Revenant – and there is any chance to find him and learn what we are, and what we may hope to be, then I must grasp at it. Because, do you see, it is my only hope. It is all that remains for me."

"And so," said Elizabeth, moving before me and scowling, "you want to chase off on the word of a raving mad-thing to find some fount of wisdom that probably doesn't exist. You fool. You're even madder than he is. If you ask me congenital idiocy runs through your whole family. And then what if he does exist, this Master? Aren't you afraid of what you might find? Like dear sweet Helena was?"

I turned from her. Indeed I was afraid. Even as she spoke I felt the fear within me. But that was nothing. I refused to accept that my fears must be true, and would not abandon this new hope that expiation of some sort might be possible in my own mind.

"My decision is fixed," I answered abruptly. "I will go."

"Then so will I!" Elizabeth said, "if only to laugh at you when you discover the knowledge that there is no knowledge to find. That there is neither good nor evil and pretensions to either are false. That we simply exist and we are all jungle animals. But . . . if there is anything to be learned. *Death!*" She looked

over at William and her voice became harsh. "I must learn about death!"

I would not have chosen for Elizabeth to accompany me, but I saw now that for her own reasons she was intent upon doing so. And for all her levity and disdain I believed that she was secretly intrigued.

I glanced at Niall. He seemed still uneasy.

"You will help us to find this place, then?" I said.

"If you want," he replied, "I'll help you." But then he shook his head slowly and said: "But we have a problem."

"Problem?"

"William." He nodded to the wheezing form on the bed. "What do we do with him? We can't take him with us."

"No. And we cannot leave him here." I turned away with a rush of fury. I had in my excitement forgotten William. I felt an urge to say "Kill him, it will be a merciful act". But instead I pulled the bed curtains about him and said: "You are right. He is a problem. We must consider it."

The next evening when I woke I was no nearer to a solution. The matter seemed impossible. I went to the master bedroom where William still lay. Niall was already there. He had pulled one of the bed curtains open slightly, and stood staring down. As I entered he looked up at me, then beckoned me over, pointing towards the bed. I looked, then recoiled slightly from the awful stench, uttering a gasp of mixed revulsion and wonder. All that remained was a brown shapeless mass of putrescence. And for

several minutes we stood silent, the two of us, in awe and something approaching reverence at the sight of this centuries old life that had finally ended. Truly ended.

"Last night," Niall said eventually. "It was too much for him. But then, it would have happened anyway, in the end. He couldn't have lived."

Presently we wrapped up the remains in the worn bed-covers and pulled them into an old clothes trunk. Then we carried the trunk downstairs. Elizabeth stood watching us in the hall below. She frowned but said nothing. I could tell that the sight unnerved her.

We went out into the garden, across the back lawns to the old tomb. There we placed the remains finally in the lead coffin where they were first laid to rest nearly three centuries before.

As we walked back to the house we said nothing. There was but one thought which ran through my mind. That the obstacle had been removed, almost miraculously it seemed. That the journey could begin.

XIV

We set off the next evening, making our journey to the Welsh port of Holyhead, where we booked a late passage to Dun Laoghaire aboard a huge ferry boat. Along the way we must stop and take our rest in a hotel room, explaining that we had travelled all night and wished to sleep uninterrupted through the day – always dangerous with the chance that we might for some reason be discovered in our sleep, yet the risk was inescapable.

At last we left Holyhead and I stood on deck upon a bleak winter night, gazing at the harbour lights until they shrank away and were lost, then out into the dark sea. After a while Niall came and stood beside me. From the start I had sensed about him something that was strange and uneasy, though he had never spoken of it, and all along I had been too preoccupied to pay it much attention. I did not touch on it directly now, but I asked him questions about that place which was our destination.

"It is a bad place," he answered at once. "Up in the hills, several miles from my village. No one ever goes up there. My grandma came from one of the villages near to it. She told me stories about it when I was young. She said that it had always been known as the home of faeries, phantoms and devils. The place of the dead. And of the *dearg-dul*."

He glanced at me and I nodded. Actually I had never heard of the *dearg-dul*, but from the tone of his

voice I could guess. Each country and race of men finds its own name for such as we.

"The *dearg-dul!*" he went on softly. "My God, I used to laugh at those stories. But there was nothing unusual in them. Weird, remote places and strange old superstitious tales. They're all pretty common in my country. But once, when I was a kid, I went up into those hills with a couple of friends. We did it for a dare, really. But I can tell you, we didn't stay there long."

"Why? What happened?"

"Nothing. Nothing *happened*. Nothing needed to happen. It was just that place. It had a feeling like I can't tell you, even in the daytime. Brooding. Quiet as death. Frightening. The most God-forsaken place I've ever been. When I was up there ... well, all those stories ... they just didn't seem stupid any more. I could believe everything I'd ever been told about it. It wasn't just me. We all felt it. None of us spoke a word all the time we were there. It was like ... like we were afraid of awakening something. I was pleased as hell to get away. And even now ... even now I don't like the thought of going back up there."

His hand rose swiftly. I believe he was about to cross himself, but then his hand wavered and fell back to his side, a look of stupefaction on his face. Something in his mind was yet unable to break free of its human bonds, to accept finally that he had become something he had once disbelieved in, but yet still feared.

"These things you tell me," I said. "Perhaps, if anything, they should encourage us."

He stared at me for a moment, then smiled faintly and nodded. I could see that he was not convinced. And certainly neither was I.

There was a delay disembarking when we reached Ireland. Some trouble on board the ship. It was whispered on deck that one of the passengers had gone missing. The crossing had been somewhat rough, and it was supposed he had somehow gone overboard. His distraught wife was being cared for below. Elizabeth was flushed and smiling when she found me.

We made our way to Dublin where our rooms had been prearranged, and the next evening began our journey across country. For the next two nights we pushed west, in trains and hired cars, as the countryside grew more wild, more silent and ominous: the woods more dense, the hills taller and grander. And darker. And as I passed through it all, pressed deeper into it, it came to seem right to me that this Master-Revenant – if he existed here or indeed existed at all – should exist here. If, as so many believe, there are other worlds and strange dimensions that border and sometimes intrude on our own, then they did so here – as they did in my own native Cornwall – in this mystical and legend-haunted land of prehistoric tombs, remote megaliths and ivy covered stone ruins. There was ancient power and mystery here that possessed me and rendered me silent and thoughtful. The awesome sense that I was lost, but yet somehow found. I might have become absorbed in my surroundings to the exclusion of everything else had it not been for my pressing and obsessive sense of purpose.

On the third night we arrived at Niall's home, a cottage on the outskirts of a remote village: a dwelling which had already begun to take on the appearance of a place abandoned. For the last hour before dawn I paced back and forth in a near frenzy of anxiety and restlessness, until at last sheer exhaustion overcame me.

What could be found in such a place as this? I asked myself. Knowledge and direction, or simply greater horror? I thought of William. Had he ever reached this place? If so, what had he discovered? Had it anything to do with his condition when he came to me? With his death? Something so terrible, so shocking that even his ancient and blood-soaked mind could not support it. But these thoughts were no use to me now. I must put them from my mind. Yet every feeling of fury and despair which the discovery of William's unnatural existence had raised in me seemed at once overwhelming as I sank into sleep.

Early the next evening we set out on foot. In the cover of darkness we went swiftly, leaving the main roads, following Niall through fields and woods, gazing always up at the bleak hills which towered beyond the trees ahead. In silence we approached our gloomy destination, and I felt more powerfully than ever a fierce ambivalence. As we climbed the smaller hills toward the looming peaks beyond, every sense of anticipation was turning to feelings of apprehension, and even aversion. I could not really account for this, and in my excited state I resigned all attempts to try. But I came slowly to understand what Niall had told me about this place. There was something

here: an oppressiveness that came to grow stronger as we went. There came upon me a strong imagining that even without Niall's guidance I might have found my way here: as some migratory creatures must seek their place of birth, and also often death, caught up in a whirlpool of sheer instinct, pulled to its centre by a wild force that makes a fleeting blur of every other thing. And surrounding me was an almost primeval barreness and stillness that suggested we were intruders, and that to speak in the slightest whisper would be to disrupt a silence that had reigned always unchallenged. Even Elizabeth seemed at once subdued by it, as she had seemed ever more subdued since our arrival in this country.

This remoteness was not in itself disturbing to me: indeed it rather intrigued me. But still, when I looked behind me at the twinkling lights of lonely cottages and hamlets far below, and the larger brighter patterns of villages and towns still more distant, I – even I – began to know a powerful sense of isolation, and of strange uncertainty.

A half-moon broke from the clouds as we scrambled over the great rocks scattered atop one of the higher hills and gazed down into a precipitous valley. On top of a small hill on the other side was a pile of ragged boulders, that seemed as some ancient tribute to a long forgotten deity; like a crude, crumbling pyramid that stood near to final collapse.

"The cairn!" Niall said solemnly, pointing towards it, his hand trembling slightly. Then he added: "It was always a custom in this country to pile stones on

the grave of a witch or sorcerer. To stop them from rising again."

I grew angry. The stones were surely in fact nothing more than a huge and haphazard natural structure. Niall's superstitious ramblings were becoming tiresome, and a little odd. I drew close to him and whispered:

"You need not come with us further. If you are not ready. Just help us find the cavern."

We began our descent, grasping at the rocks that jutted from the hillside to steady us as we flung ourselves forward. When we reached the hill beneath the cairn we began to circle about it, staring at the huge slabs of stone that formed the base itself. And as we searched about them I could not help but observe grimly how desolate this place was: how scorched and shrivelled and lifeless, like some remote desert region, harsh and alien in this green fertile country. As if ruined then abandoned by nature herself. Then Elizabeth spoke.

"There is nothing here!" She turned on me. "I told you this was madness. You should have listened to me. Even if there was a Master of our kind, how could he exist here? Why would he exist here? Why would *anything* exist here?"

"*We* are here!" I said firmly. "We cannot give up now. Keep looking."

She made to answer me, but then gave a start and gasped, her eyes wide with shock. For there came at once a sound: an eerie banshee wail echoing throughout those unearthly hills. Whether it came from near or far, whether it was some bird or animal, I did not

know. But it was the first sound of any kind I had heard since venturing into these hills, and it served to increase my frantic sense of energy. But more: it served to show me the true depths of Elizabeth's fear.

The silence fell again, and seemed deeper and more stifling than ever as I continued to clamber over the rocks, and the sparse mosses which were all that grew about them. Although now there came over me a strange sensation. A humming in my ears with a dizziness which increased as I searched. I do not know what led me now beyond the cairn, only that these sensations grew as I went until I stood looking down at a small crevice between two vast stones nearby. It was barely big enough to squeeze through, looked as if it could lead to nothing, and yet without hesitation I moved forward to see that beyond it the ground fell sharply and the crevice formed into a passageway just large enough to admit a man. I can hardly describe my feelings as I discovered this. I was numb, and my brain swam as the humming in my ears grew with such sudden intensity that my whole head became filled with it. Yet through my excitement I felt so great a thrill of nameless fear and foreboding that I stood, swaying and trembling for long moments before taking one unsteady step forward then calling to the others in a low hoarse voice I barely recognised as my own. Elizabeth came quickly. She was alone.

"Niall?" I said.

"Gone." She shrugged. "He just disappeared."

"Yes." I muttered. "It is not yet his time. He will

need every belief and illusion slowly shattered first. But he will come back. He will understand finally that there is nowhere else to go."

And this was true. My own fear bit like ice into my heart, but it was nothing. Gazing down I knew there was no other path left on earth for me to take.

Elizabeth stared at me. Her gathering terror was in some way wholly clear to me, while she fought to conceal it.

"There is nothing down there," she said, pointing to the ground. "It is just a crack in the rock. It leads nowhere."

"You feel it," I said, staring at her steadily. "You feel it as I do. All around us."

"I feel *nothing*!" she spat at me, her teeth clenched.

"Come then," I said. "If nothing is there, there is nothing to fear."

She tore her eyes from mine, looking down. And I saw now that part of me was mocking her, taking some satisfaction from her fear, from finding at last this weakness in her. Yet there was no courage here on my part. Only the same fear and dread, pushing me forward as it held her back.

Moving down now between the rocks, I pushed through the narrow fissure and went forward slowly, Elizabeth close behind me, as the passageway beyond rapidly widened. I had brought a pocket torch and drew it now from my coat, for the darkness at once became absolute. After a short distance we emerged into what seemed like a vast chamber. And ahead within the narrow beam of the torch, where light and darkness merged into the pale and spectral

semblance of vision, I saw amidst the weird bubbling formations of coloured rock what was a structure of several great stones that lay in the shape of a crude and ancient altar.

As I walked I began to realise that my steps became unsteady. Everything about seemed distant and unreal as my head buzzed now with relentless fury. Elizabeth spoke behind me, though her voice seemed very far away.

"I am going back!" she said. "I will not stumble about in this miserable pit. *We are blind here!* We may get lost. Have you thought of that? These passages could stretch for miles. We must turn back." Her voice broke finally in her terror. "*I do not like this place!*"

Her voice faded and was lost in the confusion of my senses. I staggered forward, stumbling against the cavern wall for support, for my body seemed weak and unco-ordinated. By gradual stages the humming in my brain had changed, become broken and irregular, no longer monotonous and constant. It came to sound like a strange diffuse mumbling whose words drifted just beyond my reach and understanding. It horrified me, this strange and brooding place. My senses seemed barely my own any longer, but reached out beyond me as if to touch some monstrous level of perception that circled and closed upon me from the gloom all around. What it might reveal I hardly dared contemplate. My every instinct urged me to Elizabeth's counsel, to run and distance myself, as a sense of panic and breathless claustrophobia came upon me. Yet I stood rooted, petrified as

the twisted walls of stone that circled me like primal giants, reaching out to be swallowed up in the nebulous vastness of the cavern. I felt tiny, helpless and alone. As if I stood on the brink of eternity itself – black, empty and endless – waiting to engulf and leave me lost and drifting forever within it.

Though all about me was still and silent there was now a fearful certainty that I had found the place I sought. The heart of the labyrinth whose twisted paths I had wandered since the beginning. The end of the dark quest of a century and more. This unhallowed underground place that spoke to my every understanding of something imminent and infernal. And finally I did not want to see whatever might exist here. The thought of it brought me horror beyond imagining. There was nothing to be found here that might offer knowledge or hope. Only the very core of the evil I knew too well. And finally I feared to face it.

At once I started, staring hard into the blackness, and dread twisted through my nerves as I sensed now that something infinitely stealthy moved out there. Then from behind me there came a voice.

"Father! It is done. The one I went seeking, the matriarch, the founder of the tribe, is lost into darkness. But I bring two who are of her line. They are old and strong. They will serve."

I turned in alarm to see Niall, standing high atop a great stone near to the mouth of the passageway by which we had entered, and yet I might barely have known him, for his old mask of fearfulness and uncertainty was gone; instead his face burned with

twisted fervour, his eyes with maniacal brightness. Elizabeth gave a cry of shock beside me as I turned back, for now far ahead, beyond the stone altar, a flame sprang up and filled the cavern with yellow light. A burning torch was held aloft and carried forward by a figure clad in stained, decaying robes of crimson which looked to be the tattered remnants of some ancient, priestly vestments.

But the creature itself! Tall and powerfully made, his features and form, though entirely of human proportion, were yet so alarmingly inhuman that he might never have passed for a living man. The face, crowned with wild, profuse black hair, was so motionless and unyielding that it might have been a thing carved from stone. But for the flesh! The flesh seemed soft and hideously swollen, replete with a mottled, vibrant redness that rippled beneath the skin, and imbued it with its only suggestion of living tissue. This was a creature utterly bloated and bursting with blood. The blood of many mortal men.

As he drew nearer I saw at last that his lips did move, almost indiscernibly, and that he appeared to intone something in whispers too faint to be understood. Yet I was at once aware that his intonations rose and fell in perfect accord with that monstrous humming which raged now within my head. I stood frozen, in thrall, beyond thought as this terrible figure came to stand at the stone altar, regarding me for a moment, then turning to prop his flaming torch upright in a cleft in the rocks. Now he raised both arms high above his head as if in some gesture of supplication, so that the loose sleeves of his robe

dropped to uncover his forearms. Then he brought them down, both arms, to cross them together on his breast. And then drawing them slowly apart. As he did so, I watched in astonishment, for I observed his long fingernails seek and tear into the flesh of his own forearms, down to the very wrists, and the blood burst out, gushing and pouring through his opened fingers as he outstretched both arms toward the ground before him.

It was now that I saw them. They crawled from out of the lurking shadows, too many for me to judge their number. A horde of the undead, for I can call them nothing else. Each one a revenant, but all in varying stages of physical and mental degeneration: each a blighted thing such as William had been. And the Priest-Revenant seemed to smile upon them now, as one by one they crept forward on hands and knees; a ragged, decaying, stenching pack of drooling idiot-things that made small frantic noises as they struggled to gulp at the fountains of spurting blood, or fell down to lap at it where it formed into glistening pools in the rock, or fought to grab up small spattered stones and lick them dry.

How long I stood, incapable of thought or motion, observing these things I cannot say. I was roused finally from my paralysis by Elizabeth, who clasped my arm desperately and screamed:

"Run, you fool, run now!"

And she was gone, hurtling away as I stood rooted to the spot and spoke after her with words that were barely yet formed in my mind.

"We cannot run from this. There is nowhere to run. *This is what we are!*"

A blurred figure sprang down upon Elizabeth as she ran, knocking her to the ground, sprawling and shrieking. Niall was grabbing her, holding her fast as she fought and clawed at him. Without thought I was upon him, gripping his shoulders, wrenching him backward as Elizabeth tore at his face. But then I was grabbed from behind, and struck a blow of such massive force that it flung me far across the cavern, slamming me into the wall, and my senses were lost as I crashed to the ground. For fleeting moments I was dimly aware of the Priest-Revenant, his face looming before me, and I recognised within the glaring eyes all his ancient power and madness, filling my head so that I lay half-conscious, to witness what followed as a distant nightmare.

Elizabeth was fighting with the Priest and his acolyte Niall as they dragged her to the great altar and flung her upon it; and the Priest raised his wrist to tear open again the wound there, pressing the flow of his blood down over Elizabeth's mouth, forcing her to drink while she shuddered, then grew still. In the same moment Niall took her arm, biting down into her own wrist. And so they lay, motionless and locked together in the wavering torchlight. Then rapidly that unnatural ruddiness in the face of the Priest was dwindling away, so that finally he began to resemble something that might once have been human; and as the blood flooded into the limp body of Elizabeth, so it was drained relentlessly onward into the crouching figure of Niall.

I understood little of this. Only that William had also been the victim of these two creatures, and that from William they had drawn the knowledge of others to be sought out, to be deceived and lured here, as many had been lured before. Others who were old and strong enough to serve their purpose – whatever that might be. But my own purpose was lost, swallowed up in this bleak revelation of insanity. Helena had warned me long ago that revenants were prone to madness, which grew with the passing ages. I saw now in this ancient Priest all that we might truly become. Yet for all his great power I did not believe him to be the Master-Revenant. He was simply a monster among monsters: a deranged killer of his own unnatural kind. Except that his victims did not die, but were condemned here to become his children in an idiot and soulless half-life.

My head was bursting now with surging waves of energy which rose up from about the altar. And at once, in what seemed like a single movement, the Priest-Revenant and Niall tore themselves away from Elizabeth, their faces almost as mirror images of fury. The Priest fell back, bizarrely shrunken and seemingly exhausted, while Niall, his flesh vivid with new colour, cried out:

"There is nothing in this one! Only fear and darkness. Only emptiness. *She does not serve!*"

He struck out at the inert form that was Elizabeth, sweeping her from the altar so she crashed to the ground. She crawled there, turning her head to gaze for a moment at me. At first I believed that her look was one of reproach. But then she gave a

piercing cry, and I saw that in her eyes was simply nothing. They bulged without thought or reason. Already the skin grew shrivelled, discoloured. In a way similar to William, and those others, those undead. She gave another shrill cry, and crawled away blindly, scrambling into the shadows.

I looked on, numb with shock. My greatest evil had been to bestow the power of the Revenant upon Elizabeth, for whose dark birth Helena had died. But finally it was I, with all my ruthless desires and self-deception, who had led both of them to destruction. I had been the true evil from the start. From this despised truth I had sought refuge in torment and despair, and a brooding semblance of conscience, and in the twisted fantasy of a Master-Revenant who might offer me hope of redemption; when really I knew that long ago I had abandoned my soul to darkness. And all my sufferings were but the illusory pains of a phantom soul. Only the terms I had made for my own damnation.

With supreme effort I gathered myself and began to rise, and as my hand scrabbled across the ground it closed upon a jagged lump of stone, which I gripped and held as tightly as I could. Niall was standing close by, and he grinned as he watched me, blood still drooling from his lips. He expected me to run, to attempt to escape, but my last words to Elizabeth had been the truth: there was nowhere left in the world to run. I glanced over at the Priest, lying up against the side of the altar, as motionless as the stone itself, his eyes fixed dreamily upon me. Then I saw something else, lying upon the altar, glinting

faintly. It was Elizabeth's silver crucifix, torn from about her neck during the struggle. And the sight of it seemed instantly to focus every lost part of myself into a swelling of pure rage.

Beyond myself I sprang out at Niall, with a speed he could not elude, clenching the rock in my hand as I smashed at him, again and again, battering his head and face while he fell back and sought to fight me. Then I held his collar, pulling him close, striking still as his face became a mangled eruption of blood.

Then he dropped to the ground at my feet, and I was held from behind, my arms gripped by hands that were immensely strong. The head of the Priest was resting upon my shoulder, and he lifted me effortlessly, while I struggled to fight him, determined now that I should not become one of those ravaged things that crawled in the shadows, but that I would fight until he tore me to pieces.

Such was my fury that in spite of his strength he fought hard to hold me, but then his hand was on the back of my head, forcing me down towards the fallen body of Niall, who raised his arms to clasp me as my face was pressed to the gashed and bloody mask of his. I was conscious at once of the taste of human blood, still faintly warm, pulling me irresistibly downward as I felt now the bite of the Priest in the back of my neck. And in those fleeting moments before I was utterly lost, I truly felt myself human again. I felt the very quickening of death.

I was drifting now, carried upon strange and relentless tides, my thoughts and senses drawn rapidly into the blood vortex, spinning deeper into the

darkness beyond, while my body grew pained and weak. All physical sensations were quickly lost as my mind was swept onward into the death-visions. Now I felt them, the minds of the others joined to my own, clinging to my wild and expanding perceptions, and our thoughts seemed as one. Then I understood. This was all madness, but not simply madness. Now I knew its purpose.

I knew then that as we are joined in death to a human soul, and that soul to us, so we may know the feelings of mortal death, which is denied us and so truly our deepest desire. And as time passes we may journey ever farther in our growing strength into the forbidden realm, and each death is different: beautiful, terrible and unique. But the human heart is weak and soon lost to us. It gives us but the first moments of death.

Yet to join with one of our own kind! To infuse that one with blood and life even while that life is drawn away. To form this great circle, and link with a heart so strong that it *will not die* . . . clinging to the mind of that damned and powerful being while driving it deep into the death-quest, filled with fear and knowledge of its own immortal destruction. The truth of it was upon me now. This was a journey into Hell.

I felt now that I was flung crazily along black and dismal pathways, while around me the memories of my life were summoned into form to torment me. I saw myself a child again, and the people of my childhood for whom I felt now a love that could only dishonour them. I saw the dream which had been the

start of it all, and Helena . . . my Helena . . . beautiful and sad . . . but then mutilated and destroyed, her cold eyes weeping tears of blood. I saw Elizabeth, human again, so alone and so alluring. And then her brother, holding up his cross and cursing me, his face twisted with hate. And beyond it all the cries of the dead who shrieked for vengeance.

Yet what I knew now was how it had always been. Hurtling lost along this grim labyrinth, lured onward by something that lurked ahead, just beyond the grasp of my senses. The evil that had lived in me, whose power my life had served. I had sacrificed my human self to it, and these long years sought to justify this with lies and deceit. Now I was closing on it, and soon I would reach its lair. And whatever it was, a devil from Hell or a horror from some pit of my own being, my mind could not survive its coming. For its power was my own, freed from all thought or control, wholly pure in its malevolence. The power of Death. It would wither and crush the life in me, reclaiming all it had given, leaving me empty, blasting me into corruption, insanity and annihilation as it had everything I had ever known and touched. It would show me the final truth of myself.

But beyond these things I was still aware of those others, those revenants, who clung to me and fed from the very essence of myself; their minds and senses holding to mine, vile and intrusive as they fed ravenously from every thought and memory I possessed; driving me onward into realms of madness and horror beyond imagining. I felt their great heart beats bursting and exploding against me, and my

being was again filled with overpowering *rage!* Then distantly I was finding strength and awareness of my body to fight them: to struggle and strike and tear at them, while these physical actions seemed like a remote and disjointed dream. And it felt that we were rolling, locked together, battling frantically as we sprawled into the dark recesses of some deep distant place; and I was tearing myself free from them, hurling and kicking them back as I slid and tumbled over ragged ground. Then the ground fell sharply and I was sliding downward, and I grabbed at the rocks to halt myself. While I could see nothing at all, there came upon me now the vivid sense and mental image that I clung precariously to the tip of a great crag, which loomed incredibly above a vast and hellish abyss. So real and immense was this image that my head was spinning and I pressed myself hard down against the ground, clutching at it frantically or I should fall and be lost. But even as I held it the stone was crumbling, breaking up beneath me, and I was scrabbling, slipping down towards the Pit.

I knew now the reality of Hell. A dreadful closing of the mind to the world beyond. To be confined to the inner madhouse where all our guilt and fear are chained shrieking alongside us in a pit of eternal *self-loathing* . . .

Then in my turmoil there broke from inside me a frail, childlike voice I barely knew. A voice from long ago. Not the cry of a doomed unholy thing, but of a *man.* A mortal soul in mortal dread whose heart was not hopeless and dead. I cried out to God.

Something rose in an instant above me, and my

senses reeled as I saw it grow. At first a baleful, yellowish light that permeated and billowed within the intense dark, gathering shape until I saw manifested the withered talon of a hand which reached out to claim me. It emerged now from the blackness, and yet truly it was the blackness, for it advanced like a fog that swirled and shifted to find form, then opened like a winding sheet which unravelled and fell to expose the face.

It stood, an obscene hybrid of man and devil, its visage so wasted it was skull-like, framed in dark matted hair and beard, with eyes that seemed no more than empty sockets but for a watery gleam deep within. It was beyond anything I might have conceived, its horror so alien, so *absolute* that it bore the mark of every unspeakable blasphemy and iniquity that had ever been. Its breath was hoarse and grunting as the white, almost transparent flesh about the mouth seemed creased into a snarl of feral rage, yellow teeth bared in bloodless lips as it looked ready to tear the soul from this heretic who had come to question and defy its power. My strength was gone, my mind slipping away, awareness hanging by a thread. Now my grip was lost and I was falling, dropping down into the dark certainty of that hellish abyss. But the claw-like hand closed about my wrist and I was raised up into a loathsome embrace, clinging to that dreadful form beneath a tattered robe as skeletal arms entwined and held me. And beyond my disgust there came with its touch the awful thrill of some secret and half-known desire.

It spoke. Or so it seemed, though its voice was but

a whisper of thought that flowed and merged with my own.

"Your deliverance lies here," it said. "Let go your fear, which is death within life. For I am the *true redeemer*! I am the Master. Upon whom the evils of the world were cast. Who died yet was raised up from the tomb. I am resurrection and life, and who follows me shall *never die . . .*"

A noise welled up in me, a cry against this final impossible insanity, but no words found form, for it seemed my throat was filled, my mouth overflowing, and that I was drowning in a torrent of blood!

". . . and who eats of my body and drinks of my blood shall find eternal life. For the blood of my covenant will cleanse him of all *sins*!"

The words were simple and clear, yet so perverse, so profane, that I might not dare imagine them. Yet as I stared at its face, resting near to mine, I saw that the shrunken eyes shone with a sheer passion.

Deliverance! Yes. What it gave might be truly that. Deliverance from inner darkness, guilt and sin. For what are these things but the shadow of human death? And where death itself might die, so too might the child of death which is the knowledge of evil. The Master stood at the gateway to a dark Eden; to a pure and perfect innocence so profound it was beyond recognition of depravity or wickedness, finally blind to its own monstrosity. Yet it was still worse. It was to impose our own face upon the image of God. And to make the damned into the blessed.

So I hung there, my senses drifting down into that bleak vision of the Pit, and clung tighter in dread to

my terrible saviour. Until the figure rose above me
and I saw its hands reach out to clasp my head.

"Know me now!" it cried, its face wild with exult-
ation. "I am . . . *Absolution!*"

My sight blurred as I watched the figure sink back,
fading like a dream until its face was transformed
into another that was ravaged and drained almost
beyond recognition or life. It was the face of Niall,
and I flung his shrunken frame back where it fell
limp and still; then staggered to my feet, looking
dazedly back into the depths of the cavern where the
torch light dwindled away. Beside me, laying
sprawled in a stupor deeper than my own, was the
Priest, his great strength dissipated and gone. Yet his
eyes gleamed and he sighed as he raised his arms to
me in a trembling motion of triumph and embrace.

I stared at him aghast for several moments before I
turned and fled that accursed place.

* * *

Since that time I have wandered alone, growing more
aware how deeply I am affected. I do not know what
I truly confronted in that cave in Ireland. Perhaps it
is better I do not. Yet from my very concept of the
Master-Revenant – who dwells deep inside us all – I
know now that I can be reconciled to my existence;
drawing from him what I need to justify and placate
myself. Why walk in Hell amongst the lost, seeking
truth, when truth may be whatever I wish to make
it? But I no longer carry Hell within me. I see it
beyond me. There are times now when the human
creatures who swarm about me as I walk in the world

are made transparent to me in their thoughts and preoccupations. Faces filled with rage, greed, hate, fear: with darkness in its every form. Then I ask myself: for what other reason can I exist as I do, but as an angel of divine retribution, feeling nothing as I prowl through perdition? And at these times I am no longer certain whether what I have is damnation or divinity. That long threatened madness moves to possess me. To crush my last will to resist and make me one like all the others – the cold and self-serving monster who alone can keep me from suffering. I no longer fear that madness, nor feel its shadow on me, and that is how I know it must triumph. Yet while I still have reason enough left to see these things, there remains one last alternative.

I have returned now to my house in Cornwall. There is nothing for me here any more, but still we suit each other well: two ruined things haunted by shades of the past. It is fitting that we should lay our ghosts together. One thought preys upon my mind. When William died here, might it secretly have been by Niall's hand? Perhaps Niall knew some sure way to do it, to end an immortal life and remove the obstacle to his plans that William had become. If not, might William have survived? *And in what form?* I must leave nothing to chance. I must find the strength to destroy a monster. To destroy him totally.

Fire purifies, it is said. I pray it may be so. And now . . . I have written enough.

Epilogue

There the manuscript ended. With trembling hands he gathered it up, then placed it in a drawer, shutting it out of sight.

He was very tired. He rose, but felt that his legs would not even carry him upstairs, and slumped into the armchair. The narrative had completely unnerved him, plunged his mind deeper into darkness. The night silence and his own sense of lonely isolation obstructed his efforts to convince himself that it must be some elaborate, deranged hoax.

Sleep was bearing down on him gradually. He felt afraid, knowing that it would bring no peace, just restless insane nightmares; yet slowly he began to imagine that he might not escape those nightmares by remaining awake. His eyes closed. Before he knew it his thoughts were floating away.

Sleep crept over him like a pall, and somewhere deep in his drowsiness he felt a vague sense of panic, as if he were being smothered. Far away, beyond the reach of his near dormant mind, he could hear something. A rattling, a scratching, as if something outside was trying to reach him. He felt himself stir and cry out faintly. There was another sound. Something animal and frightening. A rasping breath that rose above the faint persistent scratchings. There came then the overwhelming sense of something pained and mad: a shadowy thing deformed and driven by nothing more than a

mindless instinct to survive. Desperately he tried to will himself awake.

And as he began to emerge from sleep, the noise seemed to die mercifully away. And yet the sense remained, the stifling sense that he was no longer alone. Until at last, on the brink of consciousness, despite his fear of the memory, his wish to shut it out, his thoughts drifted back to when he had stood by the smouldering shell of the old house. It had been as he finished reading that first page of the manuscript that he was startled by a sudden crash from inside the ruin. The picture formed vividly in his mind. A pile of fallen masonry, lying far away, had suddenly collapsed. And as he pictured it he saw more clearly that which at the time he had dismissed as a trick of the dull light amongst the many blackened shapes in all the burned debris. Now he knew better. Now he knew his eyes had not deceived him. That what he had glimpsed, propped between the fallen rubble, really had been a horribly charred and twisted body, its head sliding down with the rest of the toppling remains. But then rolling upward, contorting at an unnatural angle, coming to face him as the black burned skin on one side of the face appeared to disintegrate, revealing greyish bone and a single discoloured eye that seemed to stare at him as he turned and hurried away into the gathering daylight.

THE END

The Acts of the Apostates – **Geoffrey Farrington**

'His was the most monstrous crime a man could commit. In this land it was an act of desecration without parallel'

In the last days of the Emperor Nero's dark reign, in a closely guarded room in the palace, a man tells his story. Neophytus, Imperial dream interpreter seer, has returned to Rome from Judea in flight from the death grip of ancient cult. He has not returned alone, for his nightmares have followed him into the palace.

The Acts of the Apostates is an odyssey undertaken by mystics, charlatans and sorcerers through occult mysteries and madness.

£6.99 ISBN 0 946626 46 4 272pp B. Format

The Dedalus Book of Roman Decadence – **edited by Geoffrey Farrington**

'concentrates on the outrageous behaviour of the ruling class of the Roman Empire, as described in passages selected from the prose, poetry and history of the period. Their murder plots, sexual deviances, orgies, cruelty and incessant intrigue put our politicians and their peccadillos on a play school level.'
> *Time Out*

'devoted to the juicier bits of Tacitus, Suetonius, Juvenal, Apuleius and Seneca (the stuff that, as Gibbon put it, should be veiled in the decent obscurity of an ancient language). But you have to admit it's fun.'
> Nicholas Lezard in *The Guardian*

£7.99 ISBN 1 873982 16 X 240pp B. Format

The Arabian Nightmare – **Robert Irwin**

In a city of sultans, seductresses and apes, Balian of Norwich is pursued through a maze of stories by the Father of Cats, Fatima the Deathly, Shikk the half-man and many others. *The Arabian Nightmare* pervades the darkness of medieval Cairo. It haunts the labyrinth of its streets. It is a dream without awakening, a flight without escape, a tale without end and a guide to the Orient of the mind.

'Robert Irwin writes beautifully and is dauntingly clever but the stunning thing about him is his originality. Robert Irwin's work, while rendered in the strictest, simplest and most elegant prose, defies definition. All that can be said is that it is a bit like a mingling of *The Thousand and One Nights* and *The Name of the Rose*. It is also magical, bizarre and frightening.'
> Ruth Rendell

'Robert Irwin is indeed particularly brilliant. He takes the story-within-a-story technique of the Arab storyteller a stage further, so that a tangle of dreams and imaginings becomes part of the narrative fabric. The prose is discriminating and, beauty of all beauties, the book is constantly entertaining.'
> Hilary Bailey in *The Guardian*

£6.99 ISBN 1 873982 73 9 266pp B. Format

Memoirs of a Gnostic Dwarf – **David Madsen**

'David Madsen's first novel *Memoirs of a Gnostic Dwarf* opens with a stomach-turning description of the state of Pope Leo's backside. The narrator is a hunchbacked dwarf and it is his job to read aloud from St Augustine while salves and unguents are applied to the Papal posterior. Born of humble stock, and at one time the inmate of a freak show, the dwarf now moves in the highest circles of holy skulduggery and buggery. Madsen's book is essentially a romp, although an unusually erudite one, and his scatological and bloody look at the Renaissance is grotesque, fruity and filthy. The publisher has a special interest in decadence; they must be pleased with this glittering toad of a novel."

> Phil Baker in *The Sunday Times*

'not your conventional art-historical view of the Renaissance Pope Leo X, usually perceived as supercultivated, if worldly, patron of Raphael and Michelangelo. Here, he's kin to Robert Nye's earthy, lusty personae of Falstaff and Faust, with Rabelasian verve, both scatological and venereal. Strangely shards of gnostic thought emerge from the dwarf's swampish mind. In any case, the narrative of this novel blisters along with a Blackadderish cunning.'

> *The Observer*

'Some books make their way by stealth; a buzz develops, a cult is formed. Take *Memoirs of a Gnostic Dwarf*, published by Dedalus in 1995. The opening paragraphs paint an unforgettable picture of poor portly Leo having unguents applied to his suppurating anus after one too many buggerings from his catamite. Then comes the killer pay off line: "Leo is Pope, after all." You can't not read on after that. I took it on holiday and was transported to the Vatican of the Renaissance; Peppe, the heretical dwarf of the title, became more real than the amiable pair of windsurfers I'd taken with me.'

> Suzi Feay in *New Statesman & Society*

£8.99 ISBN 1 873982 71 2 336pp B. Format

Confessions of a Flesh-Eater – David Madsen

'Admirers of David Madsen's extraordinary first novel *Memoirs of a Gnostic Dwarf* will not be disappointed by his second. *Confessions of a Flesh-Eater*, in which, once again, erudition is combined with eroticism to create a book both highly diverting and drolly informative. An unmissable treat about a stylish monster.'

> *Gay Times Book of the Month*

'Set in the present, the tale has all the grim foreboding of a genuine Gothic work. Its tone and emphasis owe much to James Hogg's *Confessions of a Justified Sinner* and Mary Shelley's *Frankenstein*, except that the touch is lighter . Fans of body horror will find more visceral lusciousness here than in most synthetic US nasties. One of Crispe's talents is the ability to call up synaesthesia: the mixture of sense impressions. I liked the comparison of beef to brass in music and to "the sexual potency of young men before it had been squandered". Orlando Crispe's gusto for copulating with carcasses retrieved from his restaurant's cold store, then serving them, is only rivalled by his heartfelt loathing for female flesh itself. Women are more fondly regarded by the chef as marinades for his masterpieces.'

> Chris Savage King in *The Independent* –
> *Book of the Week Choice*

'The pleasures of the flesh loom monstrously large in this defiantly scurrilous feast of baroque bad taste. Several degrees kinkier and queerer than its cult predecessor, *Memoirs of a Gnostic Dwarf*, it details the culinary, erotic and homicidal exploits of Orlando Crispe; mother-fixated chef, philosopher and cannibal. It was when he embarked on drooling fridge-side sex with a carcass of meat dressed in his mother's lacy underwear (the meat, that is) that I began to suspect he might be more than a couple of wafers short of the full Communion.'

> Phil Baker in *The Sunday Times*

£7.99 ISBN 1 873982 47 X 223pp B. Format

Pfitz – Andrew Crumey

'Rreinnstadt is a place which exists nowhere – the conception of a 18th century prince who devotes his time, and that of his subjects, to laying down on paper the architecture and street-plans of this great, yet illusory city. Its inhabitants must also be devised: artists and authors, their fictional lives and works, all concocted by different departments. When Schenck, a worker in the Cartography Office, discovers the "existence" of Pfitz, a manservant visiting Rreinnstadt, he sets about illicitly recreating Pfitz's life. Crumey is a daring writer: using the stuff of fairy tales, he ponders the difference between fact and fiction, weaving together philosophy and fantasy to create a magical, witty novel.'
 Sunday Times

'a well crafted and ingenious box of post-modern tricks in the European mode.'
 Jonathan Coe in *Books of the Year* in *The Observer*

'Built out of fantasy, Andrew Crumey's novel stands, like the monumental museum at the centre of its imaginary city, as an edifice of erudition.'
 Times Literary Supplement

£7.99 ISBN 1 873982 81 X 128pp B. Format

The Other Side – **Alfred Kubin**

'Expressionist illustrator Kubin wrote this fascinating curio, his only literary work in 1908. A town named Pearl, assembled and presided over by the aptly named Patera, is the setting for his hallucinatory vision of a society founded on instinct over reason. Culminating apocalyptically – plagues of insects, mountains of corpses and orgies in the street – it is worth reading for its dizzying surrealism alone. Though ostensibly a gothic macabre fantasy, it is tempting to read *The Other Side* as a satire on the reactionary, idealist utopianism evident in German thought in the early twentieth century, highly prescient in its gloom, given later developments. The language often suggests Nietzsche. The inevitable collapse of Patera's creation is lent added horror by hindsight. Kubin's depiction of absurd bureaucracy is strongly reminiscent of Kafka's *The Trial*, and his flawed utopia, situated next to a settlement of supposed savages, brings to mind Huxley's *Brave New World*; it precedes both novels, and this superb new translation could demonstrate its influence on subsequent modern literature.'

Kieron Pim in *Time Out*

£9.99 ISBN 1 873982 69 0 252pp B. Format